JAPANESE DESIGN

An Illustrated Guide to Art, Architecture and Aesthetics in Japan

PATRICIA J. GRAHAM

TUTTLE Publishing

Tokyo │Rutland, Vermont│ Singapore

contents

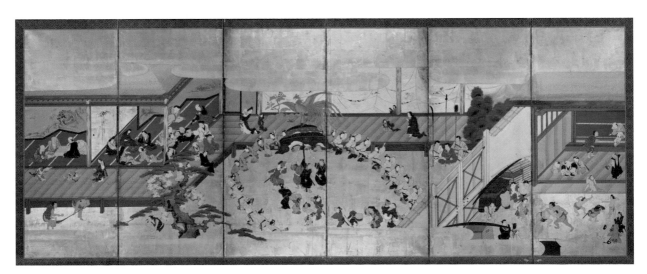

PREFACE
The Enduring Allure of Japanese Design

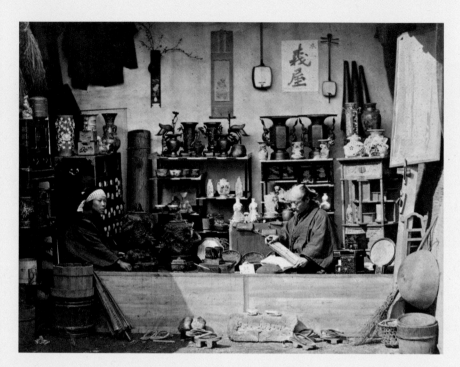

Felice Beato (Italian, 1832–1909), *Japanese curio shop*, 1868. Hand-colored albumen photograph, 20 x 26 cm. New York Public Library, Photography Collection. Beato produced what are now considered iconic photographs of the people, places, and scenery of Japan during his stay in Yokohama between 1863 and 1884. He was the most commercially successful of the early photographers in Japan, many of whom compiled photos into albums to sell to foreign tourists.

Everything Japanese is delicate, exquisite, admirable.... Curiosities and dainty objects bewilder you by their very multitude: On either side of you, wherever you turn your eyes, are countless wonderful things as yet incomprehensible. But it is perilous to look at them.... The shopkeeper never asks you to buy; but his wares are enchanted, and if you once begin buying you are lost. Cheapness means only a temptation to commit bankruptcy; for the resources of irresistible artistic cheapness are inexhaustible.

Lafcadio Hearn, *Glimpses of Unfamiliar Japan*[1]

The journalist Lafcadio Hearn (1850–1904) wrote these comments in an essay reflecting on his first day in Japan in 1890. They encapsulate the continued attraction of Japanese arts and crafts for Westerners, from his time to the present day.

Hearn was but one of innumerable Westerners of the nineteenth century who fell in love with Japan's material culture and with the spirit of the country's people. He and other admirers recognized that Japan's diverse arts and crafts, buildings, and gardens, from small trinkets to imposing architectural marvels, even those created centuries apart from greatly varying media, possessed special qualities that made them attractive, and as he said, irresistible to the Western public. As we now have come to understand, the appeal of these

Japanese arts is based on a very specific set of design sensibilities that have a basis in fine craftsmanship tied to the particularities of the culture that instilled certain values in their makers.

This book is intended to supplement the large existing body of literature on Japanese design and related aesthetic concepts, mainly for audiences unfamiliar with discourses on these subjects within Japan or the scholarly community, framing the topic from a slightly different perspective than that of previous writers. It does not present a historical overview; many writers, both Japanese and foreign, have already done that. Nor does it give emphasis to any particular artistic medium or discuss the development of Japanese art styles within a chronological framework or introduce lineages of artists in any detail. Instead, its chapters explore three interrelated issues: the components that comprise Japan's design aesthetics, including their formal characteristics; the cultural factors that led to their creation; and the individuals, both foreign and Japanese writers, who have been responsible for creating worldwide awareness of this significant Japanese contribution to world cultural heritage.

The first chapter clarifies the meaning of the most significant and widely used Japanese language aesthetic and design terms today, most of which only became common terminology in Western literature from the 1960s. It also includes a visual survey of the ten most significant formal elements of Japanese design, using contemporary arts to illustrate how centuries-old design principles continue to inform the appearance of many types of contemporary Japanese arts. The second chapter identifies the cultural parameters of Japanese design, revealing how the structure of Japanese society has contributed to the formation of cultural values that impact the appearance of Japan's design aesthetics and how Japanese society impels its artists, crafts makers, and designers to approach the production of their arts the ways they do. The last chapter highlights the evolution of understanding of Japanese design from the nineteenth century to the present, its ever-growing, widespread, popular appeal, and emphasizes how important Japanese design has been to ongoing theoretical conceptualizations of global design history. The chapter discusses the varied, and sometimes divergent, perspectives of twenty-eight individuals who wrote about the subject—artists and art educators, scientists and physicians, industrial designers and architects, art historians and art critics, and philosophers—both Japanese nationals and foreigners, from the nineteenth century to the first half of the twentieth century. These writers were the first to promote Japanese art, crafts, gardens, and architecture, primarily in the West.

This book culminates many years of thinking about ways to introduce Japanese arts and design to college students, museum visitors, and travelers to Japan unfamiliar with Japanese language and cultural history. My approach has its genesis in my study of the Japanese art collection of the Nelson-Atkins Museum of Art, initially assembled in the early 1930s by Langdon Warner (1881–1955), one of the early writers about Japanese design whom I profile on page 144, and by subsequent Asian curators there—Laurence Sickman (1907–1988) and Marc Wilson. I first studied that collection as a graduate student in the late 1970s, lectured about it to docents and the general public from the mid-1980s through the 1990s, and formally surveyed, and then re-installed it in the museum's permanent Japanese screen gallery between 1998 and 2001. Sections of Chapters One and Two were also published earlier, in greatly modified form, in an essay for a textbook on Asian art for use in college classes about Asian studies produced by the AsiaNetwork Consortium. I am grateful to the late Joan O'Mara for involving me in that project which encouraged my expansion of that essay into this book.[2] My hope is that *Japanese Design* will entice readers to explore the subject further on their own.

Patricia J. Graham

CHAPTER ONE
THE AESTHETICS OF JAPANESE DESIGN

Emerging from the devastation of World War II, Japan entered an intense period of reconstruction in the 1950s. By the early 1960s, the country's economic ascension was assured, propelled in large part by international successes in design-related industries.[1] At that time, Japan's long engagement with fine design and its sophisticated aesthetic concepts were attracting the interest of scholars, journalists, and museum curators in the West, who consistently used Japanese aesthetic terminology to describe the subject in books, popular magazines, and engaging exhibitions. This trend continues today. Usage of these Japanese words has proliferated for several reasons: many of the post-war foreign authors possess deeper knowledge of Japanese culture and linguistic competence than most of their predecessors; they have close connections with leading individuals in Japanese design communities; or they conduct research in collaboration with Japanese scholars who write about design issues.

This new post-war spirit of international cultural cooperation is nowhere more evident than in the mission of the International House of Japan, a non-profit organization headquartered in Tokyo. The I-House, as it is affectionately known, was founded in 1952 with support from the Rockefeller Foundation and other groups and individuals to promote "cultural exchange and intellectual cooperation between the peoples of Japan and those of other countries."[2]

This chapter introduces the most important and frequently deployed expressions describing Japanese design principles. It begins with a discussion of the omnipresent influence of the Katsura Imperial Villa in the early post-war period. Subsequent sections on individual words describe the history and continued evolution of their usage, introduce several overarching frameworks to help make sense of Japan's wide variety of design principles, and offer a visual primer of contemporary arts that encapsulate the principles of these terms.

Plate 1-1 (right top left) *Butterfly Stool*, 1956. Designed by Yanagi Sōri (1915–2011); manufactured by Tendo Mokko Co., Tendo, Japan. Plywood, rosewood, and brass, 37.9 x 42.9 x 31.8 cm. Saint Louis Art Museum. Gift of Denis Gallion and Daniel Morris, 82: 1994. This iconic stool epitomizes the melding of East and West design sensibilities in the early post-war years. The stool form and its material (bentwood plywood) are Western in derivation but the elegant, arching shape derives from a Japanese proclivity for fluid, playful forms. Its designer, Yanagi Sōri, was the son of Yanagi Sōetsu (see page 138), founder of the *mingei* movement. Like his father, he championed the beauty of functional, everyday objects.

Plate 1-3 (right bottom) *International House of Japan, Tokyo, Japan*. Designed by Maekawa Kunio (1905–1986), Sakakura Junzō (1901–1969), and Yoshimura Junzō (1908–1997); originally completed in 1955; expanded in 1976 using Maekawa's design; extensively restored and updated in 2005 by Mitsubishi Jisho Sekkei Inc. Photo courtesy of the International House of Japan. The adjacent garden, which predates the building, was completed in 1929 by famed Kyoto garden designer Ogawa Jihei VII (1860–1933), also known as Ueji, for the building that formerly sat on the site, a Japanese-style mansion built by samurai feudal lords of the Kyogoku clan. The 1955 building, although constructed of modern materials, was designed, in the spirit of pre-modern Japanese residences to harmonize with its garden. One of its most unusual features is its "green" rooftop, plantings that integrate the garden and the building.

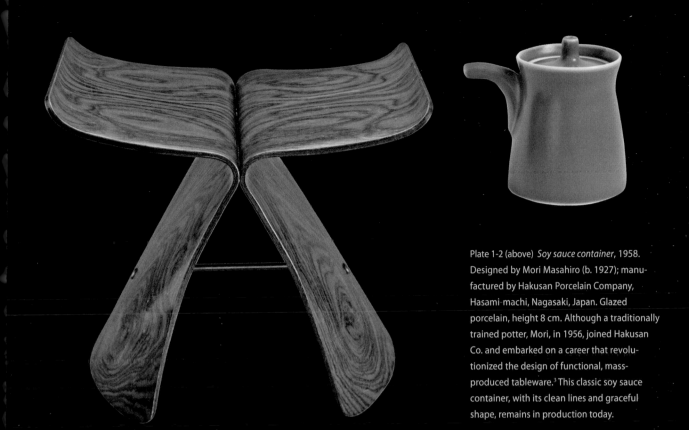

Plate 1-2 (above) *Soy sauce container*, 1958. Designed by Mori Masahiro (b. 1927); manufactured by Hakusan Porcelain Company, Hasami-machi, Nagasaki, Japan. Glazed porcelain, height 8 cm. Although a traditionally trained potter, Mori, in 1956, joined Hakusan Co. and embarked on a career that revolutionized the design of functional, mass-produced tableware.[3] This classic soy sauce container, with its clean lines and graceful shape, remains in production today.

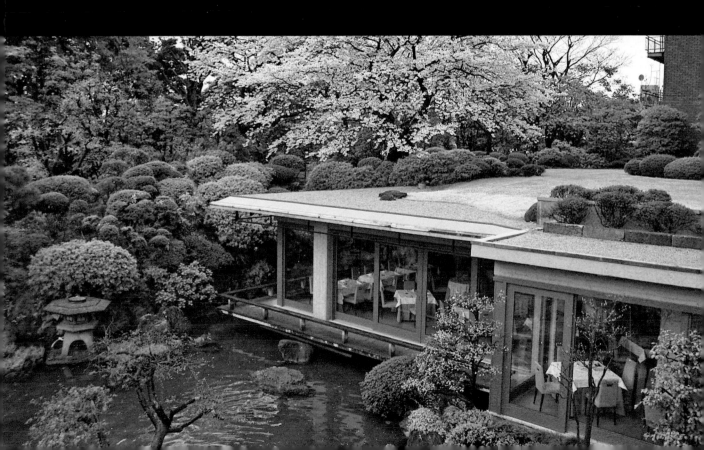

KATSURA
REFINED RUSTICITY IN ARCHITECTURAL DESIGN

The Katsura Imperial Villa, near Kyoto, provides an excellent path into an understanding of principles of Japanese design. It is widely regarded as the quintessential embodiment of the culture's highly refined and understated aesthetic sensibility. The buildings and surrounding grounds radiate a quiet, graceful presence that demonstrates how attuned the Japanese are to the beauty of nature, and how they are able to transform that beauty to their own purposes. Its finely constructed parts reveal the Japanese artisans' careful attention to detail and sensitive, but calculated, use of natural materials. The complex was built over a fifty-year period by two princes of the Hachijō family, Toshihito (1579–1629) and his son Toshitada (1619–1662), son and grandson of an emperor and advisors to the then current imperial monarch. Toshitada's marriage into the wealthy and powerful Maeda warrior clan enabled him to continue improving the estate after his father's death. Katsura consists of a series of

interconnected residential buildings in a formal style called *shoin* (literally "study hall"), originally a chamber designed as a study or lecture hall in a temple or private mansion that by the early seventeenth century had evolved into a formal reception room in a great house (Plates 1-6, 3-16), and several detached tea houses in an informal style known as *sukiya* (literally "the abode of refinement"), a small, private place for contemplation and participation in the *chanoyu* tea ceremony (Plates 1-5 a & b). The buildings were all sited within a beautifully manicured Japanese stroll garden. Katsura is the culmination of a style of residential retreat first constructed in the late fourteenth century by samurai rulers and aristocrats (the Kinkakuji Pavilion, Plate 3-31, is a forerunner), and though it was not the last such abode to be erected (another example is the Rikugien Garden, Plate 3-14), it is undoubtedly the finest and the best preserved because of its association with the imperial court.

Beginning in the 1930s, both Japanese and foreign architects who adopted modernist design principles began to appreciate traditional Japanese residential design. Publications and lectures at that time by Bruno Taut (1880–1938; see page 130) promoted

Plate 1-4 (below) *Central gate at the Katsura Imperial Villa*, complex completed ca. 1663. Photo: David M. Dunfield, December 2007. The rustic rush and bamboo fence that leads to a humble looking thatched gate was probably once the compound's main entrance.

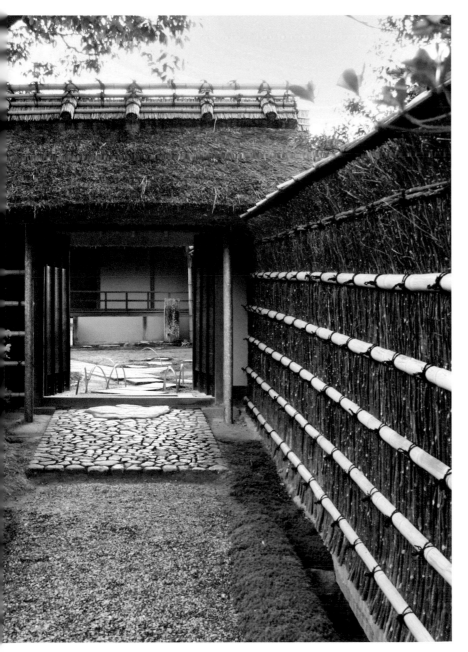

it as the archetype of traditional Japanese residential architectural design. These architects particularly admired the flexibility and compactness of its spaces, the finely crafted details and structural elements made from natural materials, the modular design of building parts, the integral relationships between the buildings' forms and their structures and between the buildings and surrounding gardens.

It was not until the immediate post-war period, however, that appreciation for Katsura truly took hold, largely through photographs in a seminal English language publication of 1960, jointly authored by architects Walter Gropius (1883–1969) and Tange Kenzō (1913–2005).[4] The book features beautiful, and now iconic, black and white photographs taken in 1953 by American-born photographer, Ishimoto Yasuhiro (1921–2012). These images interpreted Katsura in abstract geometric forms fitting the authors' modernist ideology. Tange famously cropped them to suit his architectural vision.[5] Ishimoto first visited Katsura in 1953 when he was accompanying Arthur Drexler (1926–1987), architect and long-time curator of the Department of Architecture and Design at the Museum of Modern Art, New York, on a fact-finding trip to

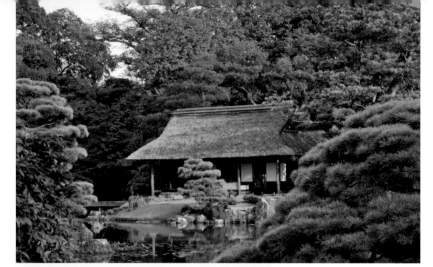

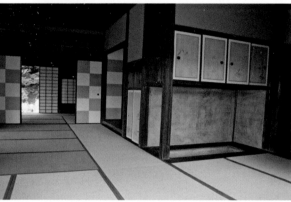

Plate 1-5 a & b (left above and below) *Interior and exterior views of the Shokintei Teahouse at the Katsura Imperial Villa*, complex completed ca. 1663. Photograph above © amasann/photolibrary.jp. Photograph below © Sam Dcruz/Shutterstock.com. This structure is a classic example of the *sukiya shoin* architectural style.

Plate 1-6 (below right) *Moon viewing platform of the old shoin buildings at the Katsura Imperial Villa*, complex completed ca. 1663. Photograph © shalion/photolibrary.jp. The moon viewing platform in the foreground extends from the open veranda to join the old *shoin* to the adjacent garden.

Japan in preparation for a landmark exhibition of Japanese architecture at MoMA in 1955. For that exhibition, Yoshimura Junzō, one of the architects of the International House of Japan, who accompanied Ishimoto and Drexler to Katsura, was commissioned to design a traditional Japanese residential building for MoMA's courtyard (the building, Shofuso, now resides in Philadelphia's Fairmount Park), funded by John D. Rockefeller, III.

Katsura has continued to attract the interest of younger Japanese architects, and one of the profession's post-war leaders, Isozaki Arata (b. 1931), a disciple of Tange, has authored two books on the subject. The first, published in Japanese in 1983 and in English translation in 1987, included new color photographs by Ishimoto that presented Katsura in a very different light.[6]

His more recent publication reassesses previous studies and includes reprints of major essays by Taut, Gropius, Tange, and others.[7] He noted that Katsura "does not have a dominant form or style that can be clearly defined in both its architecture and garden, a number of methods are intermingled. Therefore, any discourse on Katsura finally confronts the task of expounding on the significance of the ambiguity created by the mix."[8] Isozaki concluded that Katsura needs to be appreciated "not as a transparently and systematically organized space in the sense of the modernists, but as a contingent, confused, ambiguous, over-layered, and opaque composition [that] induces a gorgeous pleasure in the space. The pleasure goes beyond or perhaps swallows all kinds of discourses. The secret of Katsura's myth-provoking function exists there."[9]

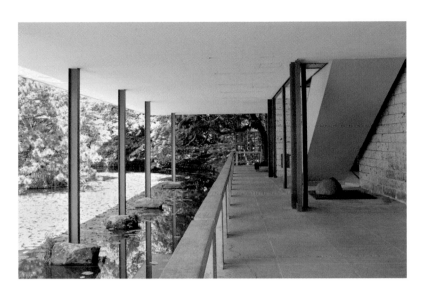

Plate 1-7 (left) *View of the veranda of the Museum of Modern Art, Kamakura (Kanagawa Kenritsu Kindai Bijutsukan),* 1951. Designed by Sakakura Junzō (1901–1969). Sakakura had worked for Le Corbusier in the 1930s. Despite its construction out of the modern materials of stone, concrete, and steel, Sakakura's admiration for the Katsura Imperial Villa is evident in this building's deep veranda and slender pillars set into stone supports. This museum building was the first significant public architecture in Japan after World War II.

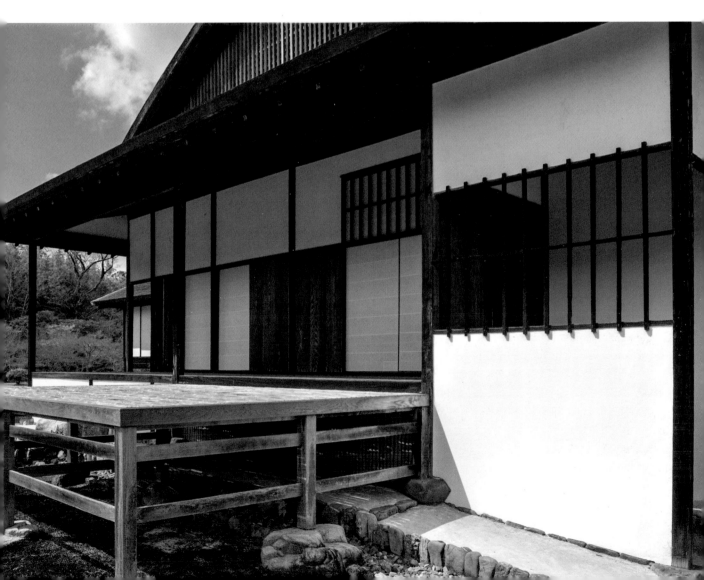

SHIBUI
SUBTLE ELEGANCE

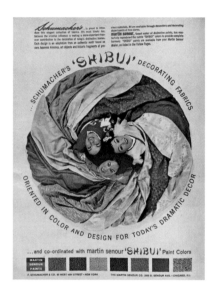

Plate 1-8 (above) *Advertisement for Schumacher's Shibui decorating fabrics and coordinated paints by Martin Senour*, published in *House Beautiful* 102/9 (September 1960), p. 66. Elizabeth Gordon encouraged selected home furnishing and paint companies to manufacture "*Shibui*" lines of products.

Shibui, **the adjective form of the noun** *shibusa* **or** *shibumi,* has the literal meaning of something possessing an astringent taste. Its usage dates back to the Muromachi period. By the seventeenth century, the term had come to describe a distinct sense of beauty, understated and well crafted, exquisite but not overly sweet, the opposite of showiness or gaudiness. The word conveys a sense of elegance and refinement, sophisticated simplicity, tranquility, natural imperfection, and modesty. It is closely associated with the *wabi-sabi* aesthetics of the Japanese tea ceremony of *chanoyu*, and is often used interchangeably with the word *suki* that is used to describe the aesthetic of tea rooms (*sukiya*).

Katsura figured prominently in the mind of Elizabeth Gordon (1906–2000), editor-in-chief of *House Beautiful* magazine from 1941 to 1964, when she set out to explain the beauty of Japanese design and its relevance to the modern American lifestyle in two issues of her magazine (August and September 1960). In fact, she used images of the complex on the cover of both these issues, declaring in the caption for the photograph of the main *shoin* buildings on the first issue's cover

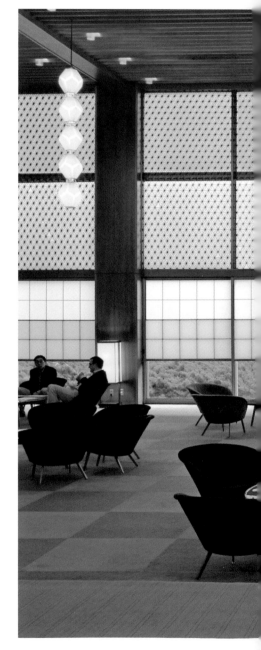

Plate 1-9 (below) *Lobby of the Okura Hotel, Tokyo*, 1962.
Designed by Taniguchi Yoshiro (1904–1979). Unchanged
since the time of its design, this quietly elegant room, with
its white paper *shōji* screens accented with finely textured
and patterned latticework, and pale wood ceiling and wall
surfaces, reflects a contemporary interpretation of the *shibui*
aesthetic in Japanese architectural design of the 1960s,
influenced by interest then in the Katsura Imperial Villa.

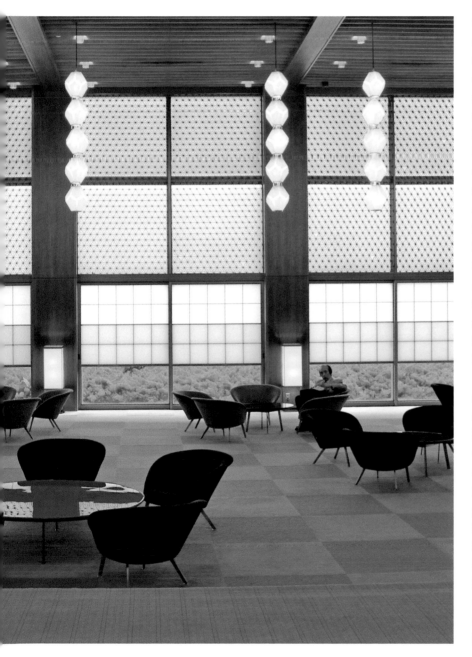

that Katsura was "a distillation of all that is most beautiful in Japanese architecture, gardening, and interiors—a fitting first glimpse of an issue devoted to an interpretation of Japan and its centuries-old concepts of beauty expressed in all facets of daily life."[10] Gordon used the Japanese word *shibui*, which she described as "easy-to-live-with beauty," as her overarching theme for these issues, titling the first, "*Shibui*—The Word for the Highest Level of Beauty," and the second, "How to Be *Shibui* with American Things." Following on the success of these issues, she organized a traveling exhibition on *shibui* that toured eleven American museums between 1961 and 1964.

Because Elizabeth Gordon was responsible for making this word, and related aesthetic concepts, the linchpin of the Japanese aesthetic vocabulary in the West, it is worth discussing why she chose to feature *shibui* and Japanese aesthetics generally in her magazine. Her initial interest in Japanese design followed her exposure to Japanese furnishings in the homes of Americans who had been in Japan during the early postwar Occupation period and the concurrent permeation of Japanese goods into the American marketplace. As

The Sumiya, located in Kyoto's historic Shimabara entertainment district, is the finest extant example of an Edo period *ageya*, an elegant restaurant and banquet hall where the highest ranking geisha (*taiyū*) entertained affluent male clients. Originally constructed in 1641, it was greatly expanded in 1787. Elizabeth Gordon prominently featured many illustrations of its rooms and architectural details in her August 1960 *House Beautiful* issue on *shibui*, though there she described it as "a famous Kyoto residence … now open to the public … a good example of the *shoin* style of architecture."[18] Although related aesthetically to Katsura, the Sumiya's greater opulence derives from its function. In fact, it combined in a single structure both *sukiya* and *shoin* elements, which are seen in separate buildings at Katsura.

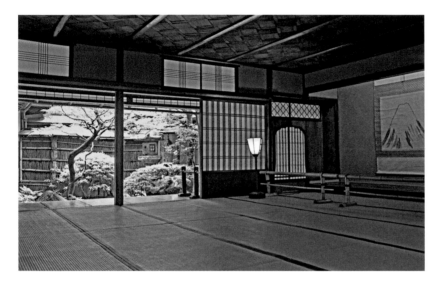

Plate 1-10 (left) *Interior of the Ajiro no Ma (Net Pattern Room) on the first floor of the Sumiya banquet hall, Shimabara licensed district, Kyoto.* The room takes its name from the interlocking lattice pattern of the wooden ceiling planks.

editor of a prominent magazine for style-conscious readers, she wanted her magazine not only to reflect current fashions but to set them. A staunch advocate of a more comfortable alternative to the rigid anonymity of orthodox modernist architecture, Gordon initiated a "Pace Setter House" program in 1946 to showcase modern-style houses that she deemed humanistic and livable.[11] Her attitude was much influenced by Frank Lloyd Wright (1867–1959; see page 130) and his concept of organic architecture. Indeed, two key members of her editorial team when she produced her Japan issues, Curtis Besinger (1914–1999) and John DeKoven Hill (1920–1996), were disciples of Wright.

Gordon's highlighting of *shibui* was also tied to critiques of postwar American affluence raised by economist John Kenneth Galbraith (1908–2006) in his popular book, *The Affluent Society*.[12] Just months after that book's release, Gordon editorialized about it in the November 1958 issue of *House Beautiful*, maintaining that "[t]aste, discrimination, and a maturing sense of appropriateness" was what she saw in the "homes of America."[13] As Robert Hobbs has observed, "[o]ver the next few years, her magazine embarked on an educational campaign to teach its readership to "discern differences between ostentation and true value."[14] This was the conceptual basis for her emphasis on *shibui*.

Gordon's presentation of *shibui* was remarkably sophisticated, derived from her steadfast study of Japanese culture over a five-year period preceding her magazine's feature issues in 1960. Her research included four field trips to Japan during 1959 and 1960, totaling sixteen months.[15] She became acquainted with or quoted many authorities in her magazine, including Lafcadio Hearn (1850–1904; see page 133) and Yanagi Sōetsu (1889–1961; see page 138), whom she met in Tokyo in December 1959 and whose definition of *shibui* she paraphrased at length.[16] She also met or corresponded with a number of high-profile Japanese design professionals, including architect

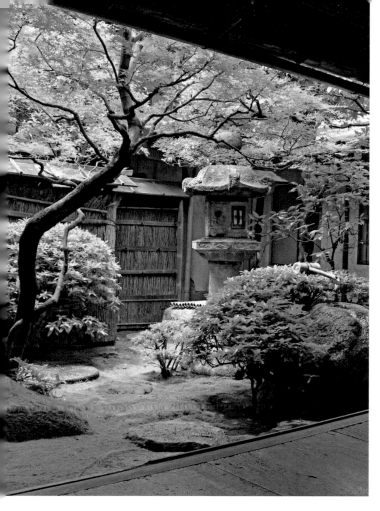

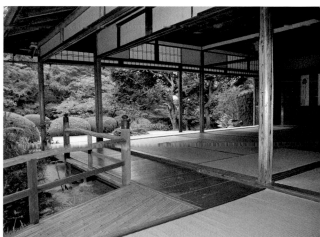

Yoshimura Junzō, one of the designers of the International House of Japan.

Although she titled her *House Beautiful* issue "*Shibui*," she also introduced many other related Japanese aesthetic terms that she described as either dependent upon *shibui* (*wabi-sabi*, for example) or as expressing what she described as less exalted forms of beauty: *hade* (bright and exuberant beauty), *iki* (chic and sophisticated beauty), and *jimi* (somber and proper beauty).[17]

Plate 1-11 (above left) *The inner courtyard garden adjacent to the Ajiro no Ma at the Sumiya.*

Plate 1-12 (above right) *View of the main room and garden at the Shisendō, the former residence of the scholar Ishikawa Jōzan,* constructed in 1641. As described in *House Beautiful*, when opened for the summer to its adjacent garden, the exposed framework of this *sukiya shoin*-style house reveals how the interior rooms function as one large open space.[19]

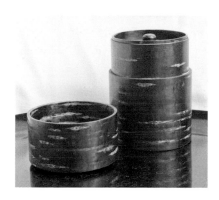

Plate 1-13 (top) *Transom (ranma) partition in the Matsu no Ma (Pine Viewing Room) at the Sumiya banquet hall, Shimabara licensed district, Kyoto.* Elizabeth Gordon commented on this wooden grille attached to the ceiling, a common interior architectural element that allows for ventilation and light between rooms. Note the elegant cloud-shaped metal nail-head covers at the post-and-beam junctures.

Plate 1-14 left) *Sakura (cherry) bark tea caddy, made in Kakunodate, Akita, Japan.* Beech wood covered with waxed cherry bark, height 11.5 cm. The lustrous natural wood finish of this traditional craft of northern Japan radiates a quiet beauty much admired by Elizabeth Gordon, who included several of these caddies in her *House Beautiful* issues on *shibui*.

WABI AND SABI
RUSTIC AND WITHERED ELEGANCE

The words *wabi* and *sabi* have been closely linked to the aesthetics of the *chanoyu* tea ceremony since the time of Murata Shukō (1421?-1502). He described his preferences for using as tea wares inexpensive, locally made utilitarian vessels (instead of more finely wrought Chinese objects) as *wabi-suki*, an expression that, by the seventeenth century, had evolved into the phrase *wabi-cha* (poverty tea). His followers, Takeno Jōō (1502–1555) and Sen no Rikyū (1521–1591), perfected and popularized this tea aesthetic, which remains closely associated with *chanoyu* today.[20] Objects used for *wabi*-style tea ceremonies, although seemingly simple and humble in appearance, are among the most costly and desirable tea ceremony products of all.

The origin of the *wabi* style of *chanoyu* is usually described as emerging from Zen Buddhism's philosophy of worldly detachment, simplicity, purity, and humility.

Indeed, all the early *wabi* tea masters were devout Zen Buddhists. However, aesthetic values implicit in *wabi* and *sabi* already existed prior to Zen's introduction to Japan. The word *sabi* appeared in Japan's earliest native language (*waka*) poetry anthology of the eighth century, the *Manyōshū* (Collection of Ten Thousand Leaves), where it described a wistful melancholia for exquisite beauty that vanished with the vicissitudes of time. By the eleventh century, this sentiment came to be expressed with the term *mono no aware* (the "pathos of things"). A fourteenth-century Kamakura period courtly poet and Buddhist hermit, Yoshida Kenkō (1283?–1350?), made this aesthetic the basis of his influential *Tsurezuregusa* (Essays in Idleness), and his writing was well known and quoted by the early *chanoyu* tea masters.

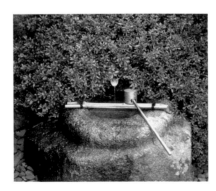

Difficult to translate, *wabi* and *sabi* are today acclaimed, along with *shibui* and *suki*, as the "essence of Japanese beauty."[21] *Wabi* means desolate or lonely, and embodies appreciation of a rustic beauty in natural imperfections, and celebrates the noble spirit of poverty and humility. *Sabi* means rusted, lonesome, or dreary, and aesthetically evokes sorrow for the fragility of life.

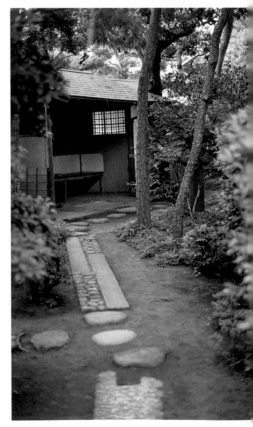

Plate 1-15 (opposite right) *Machiai (waiting shelter) in a tea house garden*, early 20th century, Toyama Memorial Museum, Kawashima, Hiki-gun, Saitama Prefecture. Guests reach the tea house by passing through a garden laid out along a path (*roji*) designed as a transition space between the everyday world and the sanctuary of the tea room. The main architectural feature within these gardens is a small rustic shelter (*machiai*), a bench protected by three walls, and an open front. There, guests wait to enter the tea room or rest during gaps between tea services.

Plate 1-16 (opposite left) *Stone water basin in the garden of the Jōnangu Shrine, Kyoto*. Within tea gardens, guests stop to purify their hands and mouth at a stone water basin (*chōzubachi*), often of a type placed low to the ground (*tsukubai*) and sometimes, as here, formed from a natural boulder. In addition, this basin features a bamboo pipe (*suikinkutsu*) through which water courses and hits the basin with a pleasing, splashing sound, creating an aural component to the experience.

Plate 1-17 (right) *Tea room at the Rakusuien, Fukuoka*, 1995. Tea gardens lead guests along a path to the tea house where they enter via a *nijiri guchi*, a small "crawl door" through which they must bow to enter.

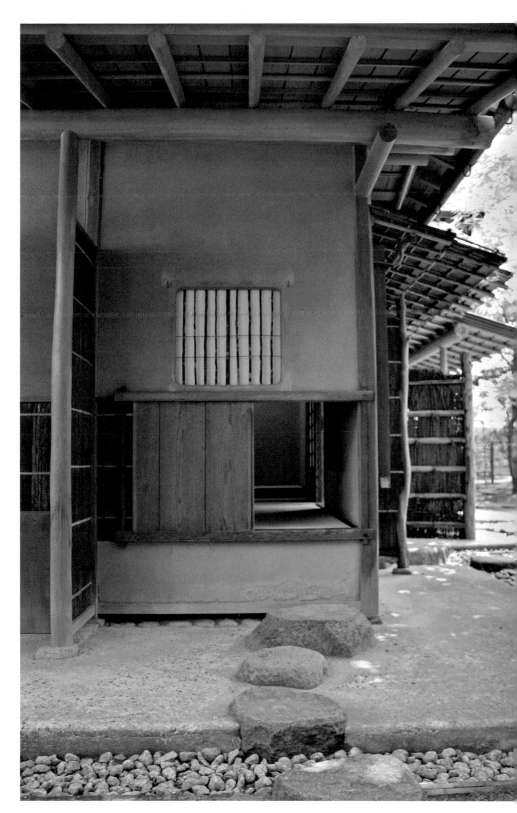

Plate 1-18 a & b (right, above and below) *Two views of the four and a half tatami mat tea room in the "Kitchen House" of artist Jinzenji Yoshiko, Kyoto, Japan,* 2008. Designed by Ms Jinzenji. This small contemporary tea room evokes purity in keeping with the principles of *wabi* and *sabi*, evident in the muted coloration of the earthen walls, the unpainted wooden ceiling slats and posts, and a naturally twisted tree trunk to the right of the *tokonoma* alcove. The weathered looking leather-covered *zabuton* cushions and the light streaming through the paper-covered *shōji* sliding doors impart an air of modernity.

Plate 1-19 (below) *Karatsu ware tea bowl of the Okugōrai (Old Korean) type,* late 16th–early 17th century. Glazed stoneware, 7.6 x 14 cm. The Nelson-Atkins Museum of Art, 32-62/6. Photo: Joshua Ferdinand. Yanagi Sōetsu described the *wabi-sabi* beauty found in tea bowls as "the beauty of the imperfect and the beauty that deliberately rejects the perfect … a beauty lurking within."[29] *Chanoyu* tea bowls endowed with *wabi-sabi* aesthetics generally lack decorative embellishment and emphasize the tactile forms of the bowls themselves with natural or minimal application of glazes in subdued, earthy colors. The understated beauty of Karatsu tea bowls are among those most revered by *chanoyu* tea masters. The long, natural drip of glaze at the front of this magnificent bowl is particularly cherished. (For other tea bowls, see Plates 2-30 and 2-37.)

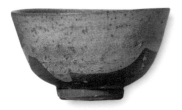

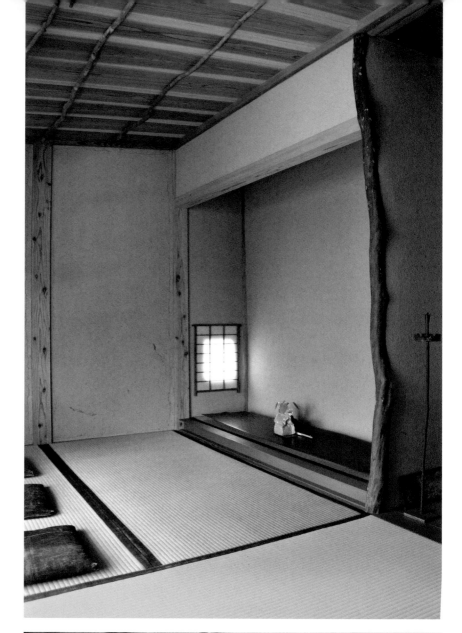

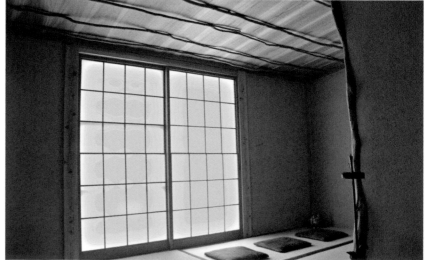

Plate 1-20 (right) *Detail of the perimeter wall at Shōfukuji, Fukuoka,*
Japan's first Zen temple, founded in Japan in 1195. Made of mud
embedded with old broken clay tiles and rocks for structural
support, walls like this are a common sight at Japanese Zen
temples and traditional residences, especially in the Fukuoka area,
when they were first made during the late sixteenth century as
part of reconstruction efforts after Japan's conflicts with the
Korean peninsula. Their incorporation of old and broken pieces
of roof tiles expresses the aesthetic of *sabi.*

Plate 1-21 (far right) *Moss-covered garden lantern at the Ōkōchi
Sansō Villa, Arashiyama, Kyoto.* This lantern, old at the time it was
installed in its present location in the garden surrounding the villa
of the Japanese film actor Ōkōchi Denjirō (1898–1962), helps to
infuse the estate grounds with the spirit of *wabi* and *sabi.*

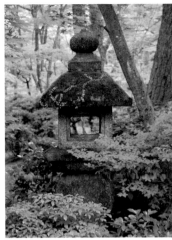

Westerners first became enamored
with the aesthetic concepts of *wabi*
and *sabi* through the writings of
Okakura Kakuzō (see page 136),
especially *The Book of Tea* (1906),
in which he explained how *chanoyu*
owed its values to Zen Buddhist
monastic practices. Okakura did
not use the words *wabi* and *sabi*,
however. Instead, he described these
aesthetics as "Zennism." Writing
several decades later, D. T. Suzuki
(1870–1966; see page 137) avowed
these same values in his book, *Zen
and Japanese Culture*, where he
defined *wabi* as "the worshipping of
poverty" and *sabi* as "rustic unpre-
tentiousness or archaic imperfection,
apparent simplicity or effortless-
ness in execution, and richness in
historical associations."[22] Yanagi
Sōetsu (see page 138), champion of
Japan's folk art aesthetics, also wrote
about *wabi* and *sabi*, describing them
as a hidden "irregular," and imper-
fect beauty, and also linked them to
shibui.[23]

Influenced by Yanagi, Elizabeth
Gordon helped to popularize the
concepts through her inclusion of a
short article about them in her *House
Beautiful* magazine *Shibui* issue,
where she explained *wabi* and *sabi*
as underlying principles of *shibui.*[24]
Gordon noted the presence of *sabi* in
gardens that possess a "tranquil and
serene atmosphere," and *wabi* as a
design concept in which "nothing is
over-emphasized or extravagant or
exaggerated." She further noted that
"the humility in *wabi*, the hint of
sadness in the recognition of
perfection in any human achieve-
ment, springs from the knowledge
that with the bloom of time comes
the first embrace of oblivion."[25]

The words *wabi* and *sabi* are
perhaps the most familiar, and also
overused, Japanese aesthetic terms
in the present day. Leonard Koren
(b. 1948), a consultant and prolific
writer specializing in design and
aesthetics, helped to popularize these
words in his 1994 book *Wabi-Sabi*
*for Artists, Designers, Poets and
Philosophers*, which contrasted
Japanese and Western ideals of
beauty.[26] They "became a talking
point for a wasteful culture intent
on penitence and a touchstone for
designers of all stripes, including
some makers of luxury goods."[27]
More recently, these words have
been applied to a wide variety of
crafts, fine arts, commercial prod-
ucts, architectural designs, and
even interpersonal relationships.[28]
Clearly, usage of these terms has
strayed far from their original
meanings. Nowadays, it has become
popular to associate *wabi-sabi* with
virtually anything having abbrevi-
ated and suggestive qualities, and
products created from rustic and
tactile, seemingly old, natural
materials.

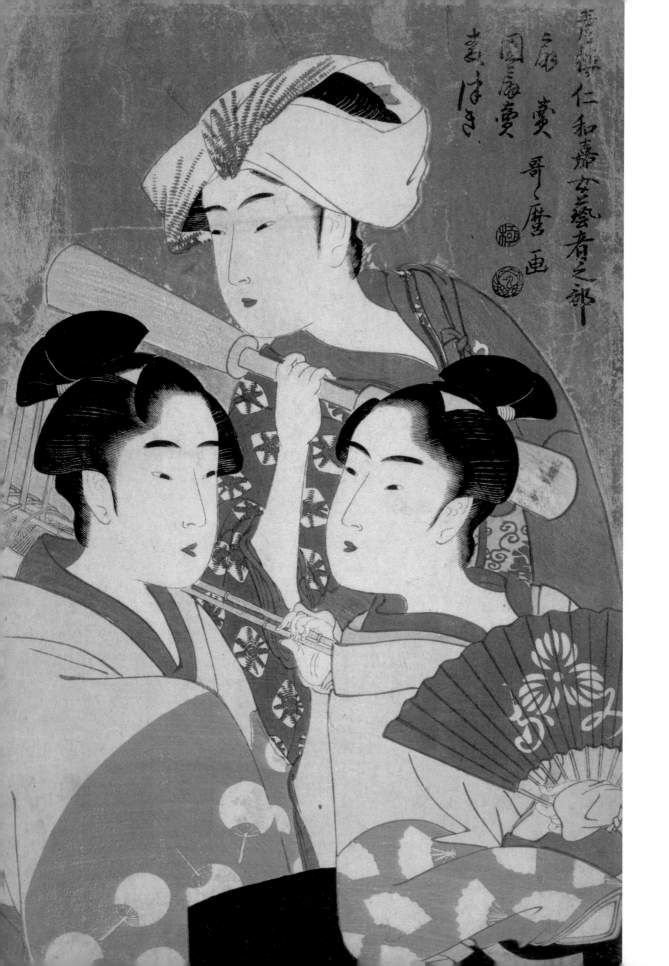

IKI
STYLISH, SOPHISTICATED ELEGANCE

The aesthetic of *iki*, first noted in writings of the second half of the eighteenth century, described the taste preferences of the most sophisticated men and women participants (clients, geisha, and Kabuki actors) of the thriving entertainment quarters, called the Ukiyo or "Floating World," of Japan's urban centers, particularly Edo (Tokyo), Osaka, and Kyoto (see also Plate 3-6). It celebrated the dynamic sense of coquetry that defined their amorous but strained interrelationships, and captured the boldness and *joie de vivre* attitude with which they lived under the specter of a politically repressive military regime. This sensibility was manifested visually in their tasteful, finely made clothing, refined accoutrements, and the elegantly appointed banquet halls and tea rooms they frequented,

Iki was one of the aesthetic words briefly mentioned by Elizabeth Gordon in her *shibui* issue of *House Beautiful*, which she described as "stylish, à la mode, smart…, [the Japanese] equivalent of France's chic."[30] It has more recently been translated as "urbane, plucky stylishness."[31]

Although Gordon regarded *shibui* as the highest category of

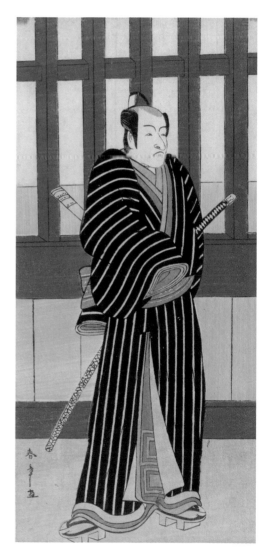

Plate 1-22 (opposite) Kitagawa Utamaro (1753?–1806), *Folding Fan Seller, Round Fan Seller, Barley Pounder* (*Ogi Uri, Uchiwa Uri, Mugi Tsuki*), from the series *Female Geisha Section of the Yoshiwara Niwaka Festival* (*Seiro niwaka onna geisha no bu*). Polychrome woodblock print, ink and color on paper with mica ground, 37.5 x 24.8 cm. The Nelson-Atkins Museum of Art, Kansas City, Missouri. Purchase: William Rockhill Nelson Trust, 32-143/139. Photo: Mel McLean. In this print, a genre known as *mitate* (humorous visual allusions to classical themes in *ukiyoe* prints), a group of geisha entertain attendees at a festival by parodying various types of merchants.

Plate 1-23 (right) Katsukawa Shunshō (1726–1792), *The Kabuki Actor Ichikawa Danjūrō V in the Role of Gokuin Senuemon*, 1782, from a set of five prints showing actors in roles from the play *Karigane Gonin* (Karigane Five Men). Polychrome woodblock print, ink and color on paper, 30.8 x 14.8 cm. The Nelson-Atkins Museum of Art, Kansas City, Missouri. Purchase: William Rockhill Nelson Trust, 32-143/71 A. Photo: Tiffany Matson. Kuki Shūzō commented that purely geometric designs, especially those featuring parallel lines which created patterns of vertical stripes, as seen in the kimono design of this actor, express the essence of *iki*.[32]

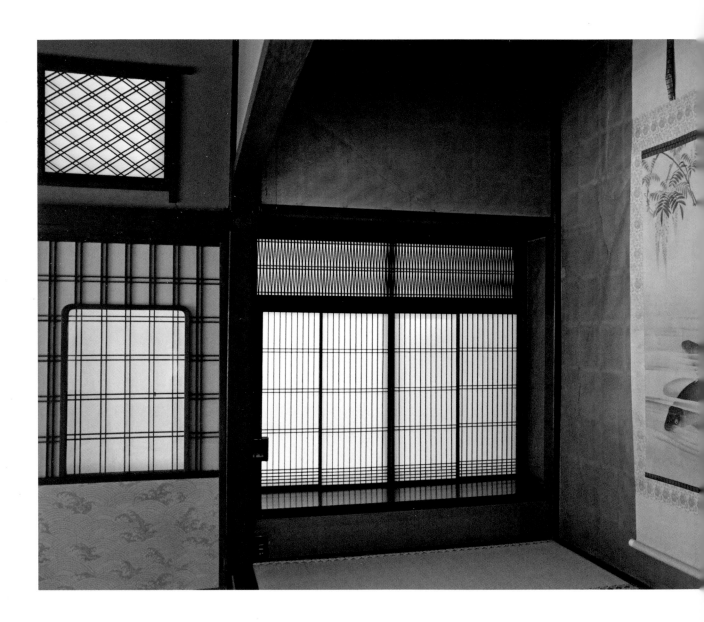

refined beauty, not all critics agree. Widespread Japanese intellectual interest in promoting *iki* as an aesthetic that represented the essential spirit of the Japanese people had arisen in the early twentieth century, initially through the writings of philosopher Kuki Shūzō (1888–1941), whose father, Kuki Ryūichi, a high-ranking Meiji government official

in charge of cultural institutions, had served as mentor to Okakura Kakuzō (see page 136). Kuki Shūzō's mother, a former geisha who eventually divorced his father, had carried on a romantic relationship with Okakura, and this enabled her son to develop a close spiritual bond with him that influenced the trajectory of his philosophical inquiries.

Kuki Shūzō wrote his seminal work, *The Structure of Iki* (*Iki no kōzō*), while living in Paris in 1926 and published it in Japan in 1930. It is no coincidence that the European intellectual climate in which he immersed himself in Paris influenced his choice of emphasis and the manner in which he discussed this aesthetic, as did his exposure there

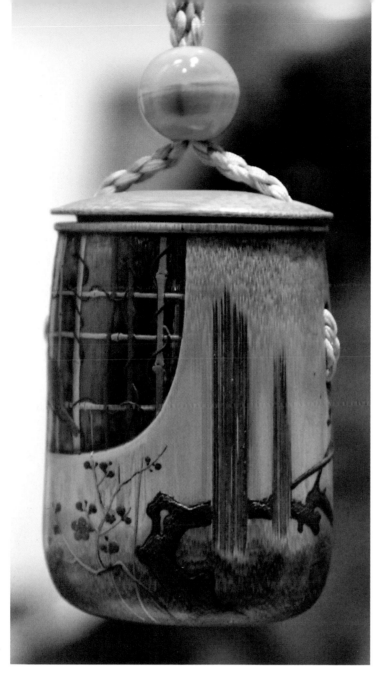

Plate 1-24 (opposite) *Tsuke shoin (writing desk alcove) adjacent to the tokonoma of the Matsu no Ma (Pine Viewing Room) at the Sumiya banquet hall, Shimabara licensed district, Kyoto,* 18th century. Kuki Shūzō observed that *iki* in architecture features a "dualistic opposition" in subtle juxtapositions of textures and colors, for example, in pairing wood and bamboo structural components, and in suffusing space with subdued, indirect lighting.[35] The interplay of the textures and colors of the walls, windows, and post-and-beam architecture, and the subdued lighting infuse this room with an elegant tension characteristic of the aesthetic of *iki*.

Plate 1-25 (left) Shibata Zeshin (1807–1891), *Inrō with design of prunus blossoming outside a latticed window.* Bamboo, lacquer, porcelain, agate. The Walters Art Museum, 61.203. This elegant object, a tour de force of virtuosity, embodies the essence of *iki*.

to *ukiyoe* prints, which celebrated the Edo period pleasure quarter sophisticates who were his mother's social forebears. Kuki Shūzō especially admired the prints of Kitagawa Utamaro (1753?–1806), which he described as embodying a "high-class feminine taste that revealed a 'heroic affinity' with modernity."[33] As Westernized modernization was quickly and drastically altering daily life and cultural attitudes in Japan, Kuki sought to define an identifiably Japanese aesthetic that highlighted both his own culture's past and its unique sense of the modern. In the beginning of the book, he introduced other words used in the Japanese language to describe taste, to tease out their subtle differences.[34] Because of his scholarly prestige, interpreting the meaning of *iki* through the lens of Kuki has remained a topic of much discussion among writers of Japanese aesthetics to the present day, both in Japan and abroad.

MIYABI AND FŪRYŪ
OPULENT AND STYLISH ELEGANCE

The flip side of the understated and restrained beauty of *shibui, wabi, sabi,* and *iki,* is a more opulent elegance associated with Japan's élites and intellectuals. Formal aristocratic culture of the Heian period (794–1185) gave rise to the first flowering of this aesthetic in Japan, then described as *miyabi,* "courtly elegance," a word that expressed the pinnacle of refinement and beauty wistfully contemplated in the expression *mono no aware.*

Closely related to *miyabi* is *fūryū* ("blowing with the wind"), a word that was also first clearly articulated in the Heian period. Originally a Chinese term (*fengliu*), it entered the Japanese vocabulary in the eighth century when it more simply described the gracefulness and propriety of courtiers. By the Heian period, *fūryū* had become an aesthetic term describing things and events out of the ordinary, such as poetry competitions, unconventional displays of flowers in a garden,

opulent decorative arts, lavish banquets, and spectacles associated with court and religious festivals.[36]

By the late sixteenth century, multiple meanings of *fūryū* proliferated, depending on the context. For example, the *wabi* aesthetic of the *chanoyu* tea ceremony became described as a *fūryū* activity. In this sense, *fūryū* implied a conspicuously

rusticated elegance closer to *shibui.* Meanwhile, influenced by the later Chinese evolution of the word among literati of the Ming dynasty (1368–1644), *fūryū* came to be used to describe the aesthetic preferences of Japanese intellectuals and artists who abhorred the repressive policies of the Tokugawa military regime and held great admiration for Chinese

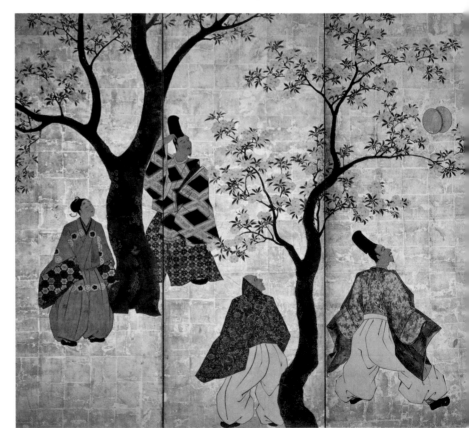

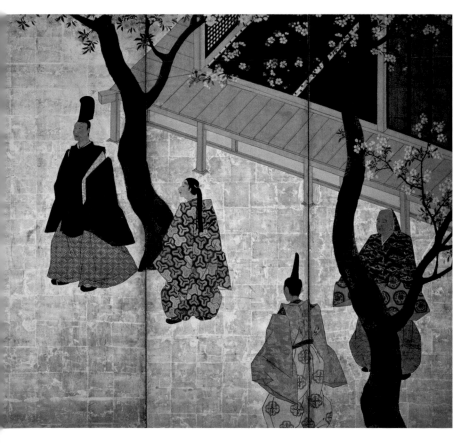

Plate 1-26 (above) *Section of the Lotus Sutra*, Heian period, mid-12th century. Handscroll mounted as a hanging scroll, ink on paper with gold leaf ruled lines, gold leaf and silver leaf decoration, gold and silver dust, and painted decoration in margins, 24.8 x 40.6 cm. Collection of Sylvan Barnet and William Burto. The aesthetic of *miyabi* permeates this sumptuously decorated sacred text.

Plate 1-27 (left) *Kemari scene from the Tale of Genji,* 18th century. Six-panel folding screen, ink and color on gold leaf, 159.9 x 378.2 cm. Gift from the Clark Center for Japanese Arts & Culture to the Minneapolis Institute of Arts, 2013.29.12. *The Tale of Genji,* a novel penned around the year 1000 by Murasaki Shikibu, a lady-in-waiting to the court, dwells on the aesthetic pastimes and romantic entanglements of courtiers. In this idealized scene from the novel, courtiers, dressed in fine Heian period style multilayered silk brocade robes have gathered in a palace courtyard to participate in a traditional New Year's game of kickball (*kemari*). The robes, cherry trees, and palace veranda, reflect the spirit of *fūryū*.

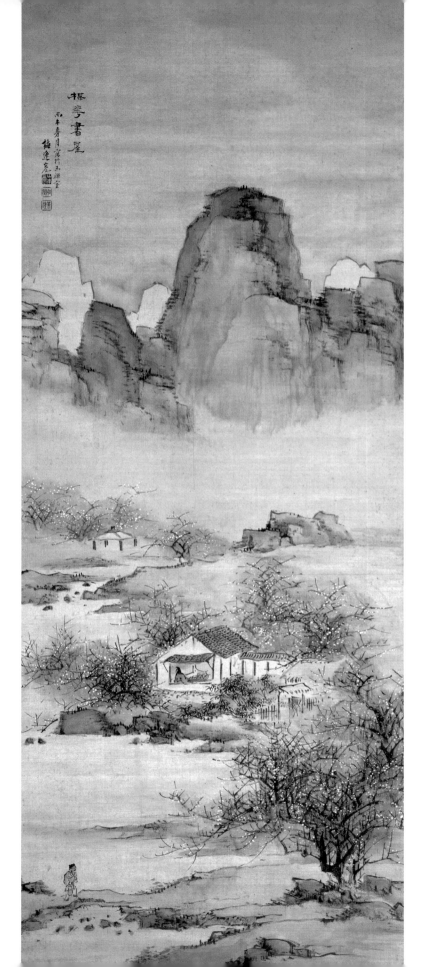

literati recluses who in troubled times had secluded themselves in rustic retreats in the mountains to pursue elegant pastimes. Prominent among the pastimes of these intellectuals was participation in a more informal Chinese-style service of steeped green tea (*sencha*).[37] *Fūryū* became the aesthetic term that defined the *sencha* tea ceremony, in contrast to *wabi*, which was closely identified with *chanoyu*.

Contemporaneous with the Chinese-influenced meaning of *fūryū*, the word carried a wholly different connotation among those who frequented the pleasure districts. To them, it continued to evoke the rarified courtly taste of the distant Japanese past, fused with a sense of fashion consciousness.

Plate 1-28 (left) Yamamoto Baiitsu (1783–1856), *The Plum Blossom Studio*, 1846. Hanging scroll, ink and light color on satin, 133 x 51.4 cm. The Nelson-Atkins Museum of Art, Kansas City, Missouri. Purchase: Edith Ehrman Memorial Fund, F79-13. Baiitsu here depicts the idealistic *fūryū* lifestyle of the Chinese scholar-gentleman. Baiitsu was one of the key participants in the Chinese-style *sencha* tea ceremony.

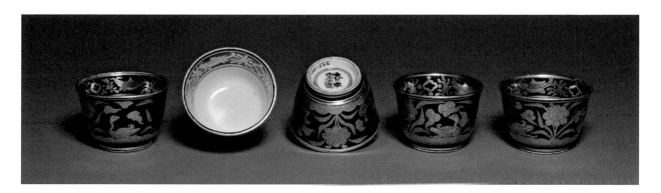

Plate 1-29 (above) Eiraku Hozen (1795–1854), *Set of five teacups for steeped tea (sencha)*, mid-19th century. *Kinrande*-style porcelain with overglaze red enamel, underglaze blue, and gold leaf, height 3.8 cm. Saint Louis Art Museum. Museum Shop Fund, 355: 1991.1-5. Designed for use in the Chinese-style tea ceremony of *sencha*, Eiraku's teacups are suffused with an elegant Chinese *fūryū* taste in vogue among sophisticated admirers of Chinese culture.

Plate 1-30 (below) Kikugawa Eizan (1787–1867), *The Jewel River in Ide, Yamashiro Province*, from the series *Fūryū seirō hijin mutamagawa uchi (Elegant beauties of the green houses matched with the six Jewel Rivers)*, ca. 1810. Color woodblock print, horizontal *oban* format, 23.8 x 34.7 cm. Helen Foresman Spencer Museum of Art, University of Kansas, 1964-0040. The beauty of geisha was sometimes described as *fūryū* and many prints that portray them, like this one, feature titles using the word. Here, the allusion to Heian period aesthetics is underscored through the subject of the Jewel (Tama) River, popular among ancient courtly poets.

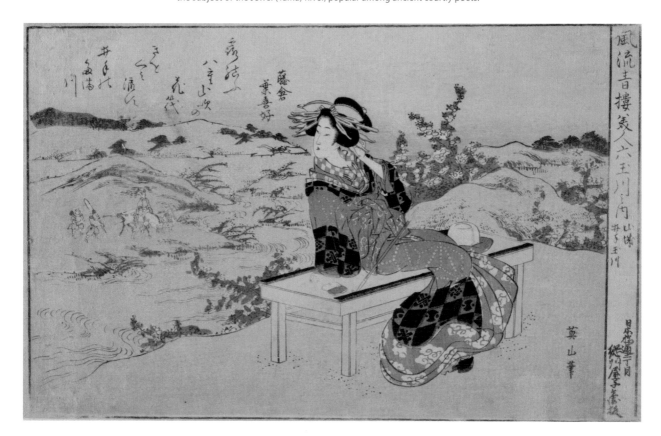

KAREI
SUMPTUOUS ELEGANCE

Throughout the medieval and early modern periods (roughly the fourteenth through mid-nineteenth centuries) the formal, public life of Japanese aristocrats and élite warriors required the use of luxurious objects and clothing befitting their status. These objects are described with the aesthetic expression *karei* (literally "flowery beauty") that connotes a sumptuousness and elegance most evident in styles of clothing and theatrical costumes, residential furnishings, including gold leaf ground folding screens and lacquer objects made for trousseaus and other official gifts, and accoutrements and garments for military display, court pageantry, and Shinto rituals. Befitting the association of *karei* with pomp and ceremony, the word entered the Japanese vocabulary during the ninth century, a time of great opulence in the performance of court rituals (see Plate 2-49, a screen of an ascension ceremony for a seventeenth-century empress that exudes this aesthetic). The ambiance of *karei* persists into the present in imperial court and public festivals, especially those celebrated in Kyoto, the old imperial capital, that recreate court life in the ancient Heian era.

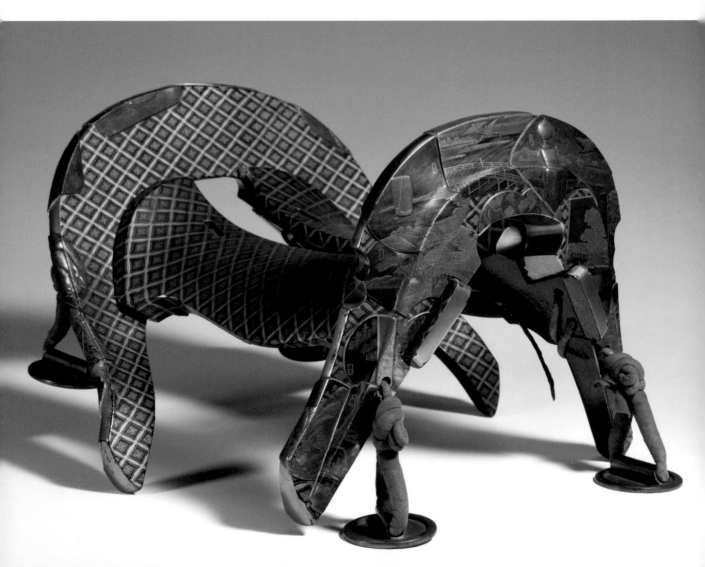

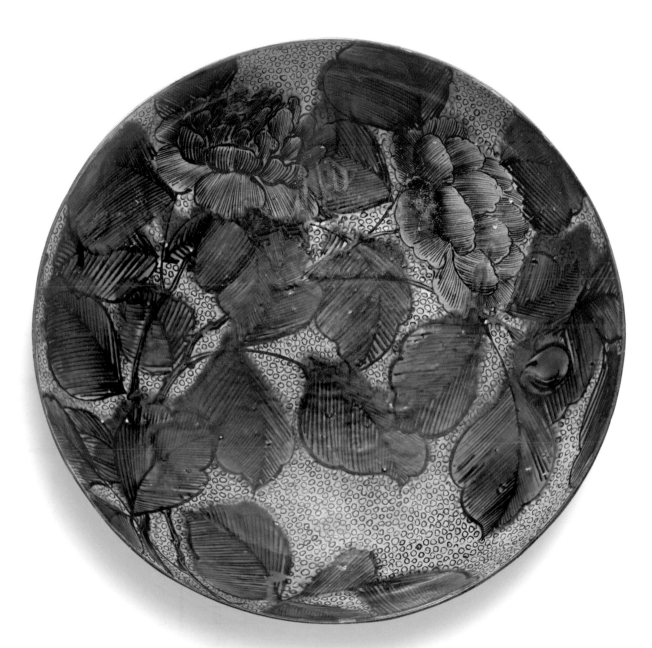

Plate 1-31 (left) Motoyoshi (active late 16th–early 17th century), *Lacquer saddle with scenes of some the 53 stations of the Tōkaidō Road*, Momoyama period, dated 1606. Gold lacquered wood, length 40 cm. The Nelson-Atkins Museum of Art, Kansas City, Missouri. Purchase: William Rockhill Nelson Trust, 32-202-13 O. Photo: Tiffany Matson. This saddle features small scenes, each carefully identified, of the individual way-stations along the Tōkaidō, the highway that linked the political capital of Edo (Tokyo) with the imperial capital of Kyoto, in what is possibly the earliest known representation of this subject, made famous later in woodblock prints by Utagawa Hiroshige.

Plate 1-32 (above) *Arita ware, Kutani-style dish with design of peonies*, late 17th–early 18th century. Porcelain with polychrome overglaze enamels, diameter 32.7 cm. The Nelson-Atkins Museum of Art, Kansas City, Missouri. Gift of Samuel Hammer, 63-33. Photo: Joshua Ferdinand. Bold, brightly colored designs like these against a golden background reflect the same *karei* taste as gold leaf ground folding screens.

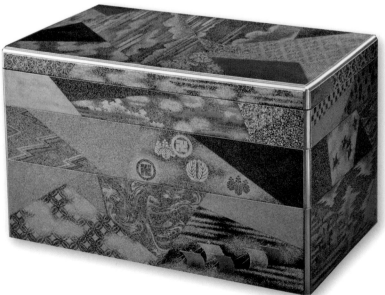

Plate 1-33 (left) *Kosode robe with designs of fans, bamboo, plums, and pines*, early 18th century. Gold figured satin ground with stencil tie dyeing, silk and metallic thread embroidery, with an orange plain silk lining, 139.7 x 111.8 cm. The Nelson-Atkins Museum of Art, Kansas City, Missouri. Purchase: William Rockhill Nelson Trust, 31-142/21. Photo: Tiffany Matson. Many *karei* designs on women's robes juxtaposed unlikely motifs. Here, purely decorative folding fans are scattered amongst plants known as the "three friends of winter," Chinese Confucian symbols of perseverance and integrity.

Plate 1-34 (right) *Nuihaku-type Nō robe with paulownia vine design and horizontal stripes*, 18th century. Gold leaf covered silk ground with silver foil and silk thread embroidery, 157.5 x 147.3 cm. The Nelson-Atkins Museum of Art, Kansas City, Missouri. Purchase: William Rockhill Nelson Trust, 31-142/1. Photo: Jamison Miller. The glittering beauty of this Nō robe contributed to the stately *karei* atmosphere of the Nō theater.

Plate 1-35 (left) Iizuka Tōyō (active ca. 1760–1780), *Tiered stationery box (ryoshi bako)*, ca. 1775. *Makie* lacquer over wood core, gold and silver inlays, and colored lacquer, 21.6 x 34.9 x 21 cm. The Nelson-Atkins Museum of Art, Kansas City, Missouri. Purchase: David T. Beales III Fund, F78-23. Photo: E. G. Schempf. This boldly decorated box expresses the elegant *karei* taste of the upper echelons of the samurai class. Its varied minute designs, including family crests, cranes, and sailboats, as well as patchwork areas of pure abstraction, were created using a multitude of lacquer techniques that required many months of patient effort on the part of the artist to complete.

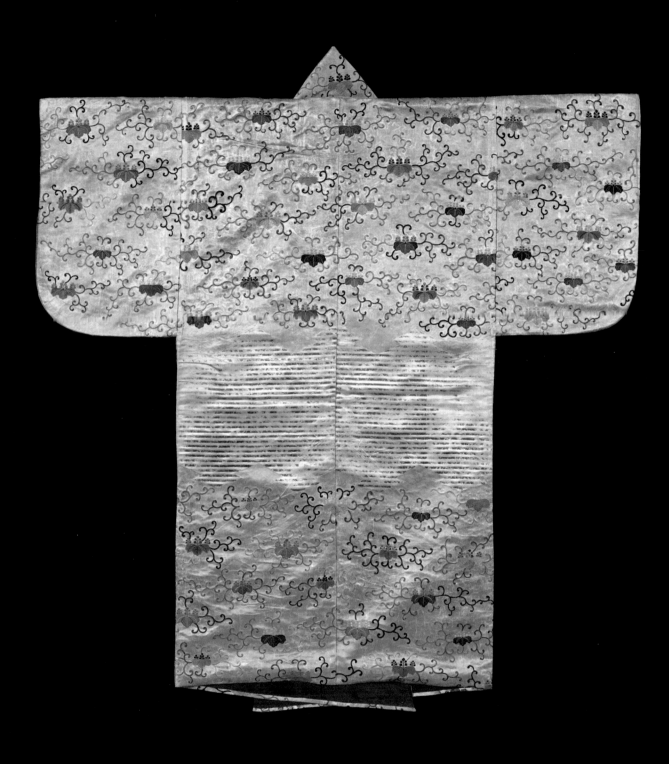

KABUKU AND BASARA
OUTLANDISH ELEGANCE

After the Tokugawa warriors took control of the country in the early seventeenth century, urban commoner culture flourished as never before. Participants in this new culture included warriors forced to become masterless samurai (*rōnin*), who fought on the losing side of the recent civil wars, and commoners displaced by the conflicts. These individuals became subsumed into the ranks of the newly emerging urban commoner classes who participated en masse in popular Shinto shrine festivals, attended Kabuki theater performances, and partook

of other leisure activities, many of which took place in new red light districts of Japan's burgeoning urban centers, where banquet halls like the Sumiya, were constructed. Their reckless attitude became identified with a new type of extravagant *fūryū* elegance known as *kabuku*, literally "twisted, out of kilter, or outlandish."[38] This word implied "rebellion against conventional social and artistic attitudes, with a strong suggestion of a clash with norms of sexual behavior comparable to that carried today by words such as 'gay' or 'queer.'"[39]

The distinguished Japanese art historian Tsuji Nobuo (b. 1932) was the first scholar to recognize a broad range of arts and artists whose works seem to have been inspired by a sense of heterodoxy and playfulness implicit in the word *kabuku*. He traced this aesthetic from the dawn of Japanese history to the present day, and noted that it reached its apogee during the Edo period in the work of artists he has famously described as eccentrics.[40]

Influenced by Tsuji's writings, recently another older expression for this bold aesthetic, *basara,* has been

Plate 1-36 (below) *Elegant Amusements at a Mansion*, second half 17th century. Pair of six-panel screens, ink, colors, and gold leaf on paper, each screen 106.7 x 260.35 cm. The Nelson-Atkins Museum of Art, Kansas City, Missouri. Purchase: William Rockhill Nelson Trust, 32-83/14,15. Photo: Tiffany Matson. This imaginary view of a mansion portrays the wide variety of *kabuku* spirit leisure activities, some refined and others boisterous, enjoyed by affluent warriors and merchants in the privacy of their walled-off residences or in the houses of entertainment and assignation that they frequented.

revived by the neo-Nihonga (modern Japanese painting) artist Tenmyouya Hisashi (b. 1966). He claims to have made this aesthetic the basis of his art because it expresses the current climate of social upheaval in Japan. Tenmyouya organized an exhibition titled *Basara* for the Spiral Garden Gallery in Tokyo in 2010. In addition to showcasing his own work, the exhibition featured pre-modern Japanese art that inspired him. In the catalogue, he described *basara* as:

the family of beauty that

Plate 1-37 (above) *Mino ware, Oribe-type set of five serving dishes with persimmon design,* 1600–1620s. Stoneware with underglaze iron oxide design and copper green glaze, each 9.8 x 5.7 x 6.4 cm. Collection of John C. Weber, New York. Photo: John Bigelow Taylor. Tea ceremony aesthetics also succumbed to the influence of the new *kabuku* aesthetic, as seen here in newly popular Oribe wares, whose style is characterized by the application of bright green, spontaneous looking glazes and quirky, playful asymmetrical designs.

Plate 1-38 (right) *Suit of Armor (marudō tōsei gusoku type)*, made for daimyō Abe Masayoshi (1700–1769). Suit ca. 1730–1740; helmet bowl by Neo-Masanobu, early 18th century. Lacquer, silver, gold, whale baleen, silver gilded *washi* (paper), silk, *rasha* (textile), bear fur, leather, iron, copper alloy, gilt copper, silks, *shakudō* (alloy of copper and gold patinated to a rich black), wood, crystal, doe skin, gilded metal, ink stone. Crow Collection of Asian Art, 2013.1. The best craftsmen of the day created this armor for a samurai of refined taste, who wore it during formal processions. It typifies the outlandish warrior (*kabuku* or *basara*) taste. Intricate floral scroll patterns and family crest designs cover the surface. A red lacquered wood dragon perches between gilded wood hoe-shaped decorations atop the helmet (*kabuto*). The face mask projects a fierce expression, while in contrast, the breast plate features delicate maple leaves. The forearm sleeves hide hinged compartments for medicines and writing implements.

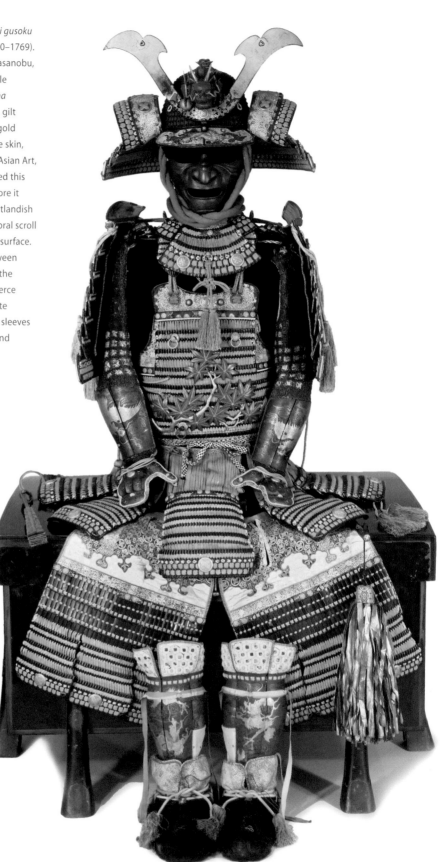

stands on the opposite end of the spectrum from wabi sabi and zen…. The term basara originally referred to social trends that were popular during the Nanbokucho Period (1336 to 1392), and people with an aesthetic awareness that wore ornate and innovative wardrobes and favored luxurious lifestyles. The term comes from the name of the 12 Heavenly Generals [Buddhist guardians] and originally means "diamond" in Sanskrit. Just as diamonds are hard and can break anything, the term was taken to mean people that rebel against authority in an attempt to destroy existing concepts and order. At the same time, they were persons with a superior aesthetic sense that favored chic and flamboyant lifestyles in addition to elegant attire…. BASARA art has continually flowed through the channels of Japanese street culture—from the furyu of the Heian period … being delivered to modern times.[41]

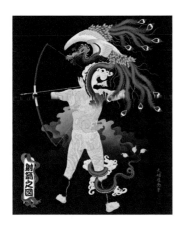

Plate 1-41 (below) Kano Kazunobu (1815–1863), *Five Rakan Saving Sinners from Hell,* 1862–1863, scroll number 23 from a set of *One Hundred Scrolls of the Five Hundred Rakan*, Zōjōji, Tokyo. Hanging scroll, ink, gold, and colors on silk, 172.3 x 85.3 cm. This graphic, gruesome scene of sinners trapped in an ice-filled pool is one Tenmyouya included in his *basara* exhibition. It exemplifies the penchant for violence during the mid-19th century.

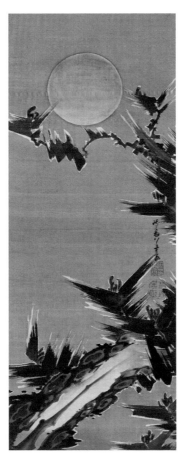

Plate 1-39 (above) Tenmyouya Hisashi (b. 1966), *Archery*, 2008. Acrylic on wood, 90 x 70 cm. Photo © Tenmyouya Hisashi, courtesy of Mizuma Art Gallery. In this painting, Tenmyouya has created a personification of the *basara* aesthetic by combining the fierce stance of the warrior with the tattooed body of a gangster, juxtaposed with a vibrantly-colored bird and snake.

Plate 1-40 (right) Itō Jakuchū (1716–1800), *New Year's Sun*, late 18th century. Hanging scroll, ink and color on silk, 101 x 39.7 cm. Gift from the Clark Center for Japanese Arts & Culture to the Minneapolis Institute of Arts, 2013.29.9. Jakuchū's art, the epitome of eccentricity, is exemplified in this painting by the artist's bold, dramatic brushwork, asymmetrical composition, and truncated view of his subject.

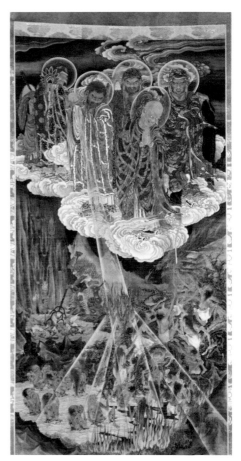

MA
AN INTERVAL IN TIME AND SPACE

The term *ma* has become a popular buzzword for defining a whole cluster of Japanese aesthetics in the post-war period among Japanese architects and cultural critics. Literally translated as "an interval in time and/or space," *ma* describes the partiality in Japanese design for empty spaces, vagueness, abstraction, asymmetrical balance, and irregularity.

The earliest reference to *ma* in Japanese occurs in the eighth century *Manyōshū* anthology. There,

poets used it to express the misty spaces between mountains and as a marker of the passage of time. By the eleventh century, the word defined the gaps between pillars in Japanese rooms and the in-between spaces of verandas that separated the interiors of buildings from their adjacent gardens. By the nineteenth century, it described the pauses in action in Kabuki theatrical performances. Until the post-war period, it had never been used as an aesthetic term.

Soon after World War II, Kawai

Hayao (1928–2007), Japan's first Western-trained Jungian psychoanalyst, incorporated Buddhist values into his ideas about psychology, describing the key to understanding the Japanese psyche as a "hollow center," a reference to the Buddhist concept of *mushin* (emptiness). Kumakura Isao, writing in 2007, equated Kawai's concept with the word *ma*, although he does not make it clear if Kawai actually used the word.[42] Architect Isozaki Arata is largely responsible for the current

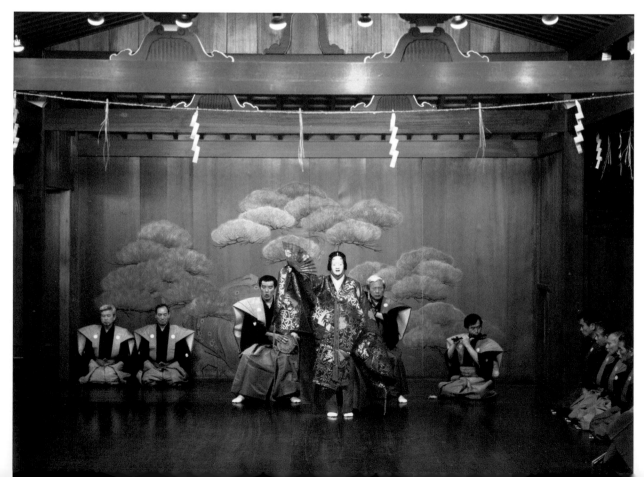

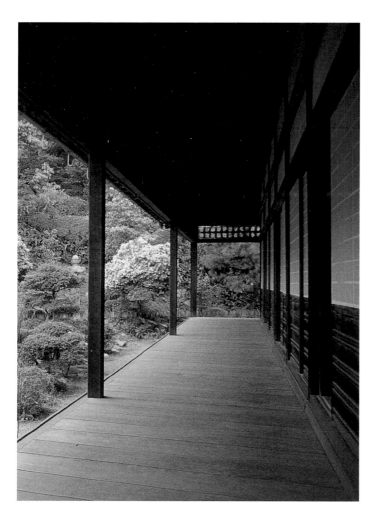

popularity of *ma* as an aesthetic trope, which began in the late 1970s following a major exhibition on modern Japanese design he organized, titled *Ma: Space-Time in Japan*.[43] The exhibition situated *ma* within the context of other traditional Japanese aesthetic terms, among them *sabi* and *suki* discussed above, and presented it as a shorthand explanation for describing the "Japan-ness" of a wide variety of contemporary avant-garde Japanese performing, martial, and visual arts, music, fashion, and garden and architecture design.[44] The exhibition explored *ma* in relation to the cosmology of *kami*, the unseen deities of Japan's indigenous Shinto religion, and in the acting style and stage set of the stylized Nō theater. It is important to note though that in pre-modern times neither Shinto nor Nō theater was ever described with the word *ma*. Nō, for example, in traditional aesthetic terminology is always described as infused with the

Plate 1-42 (above) *Veranda of the Mani'in subtemple at Kongōji, Osaka Prefecture*, 14th century. Photo: David M. Dunfield, 1991.

Plate 1-43 (left) *Prefectural Nō Theater, Kanazawa, Ishikawa Prefecture*. Photo © Ishikawa Prefecture Tourist Association and Kanazawa Convention Bureau/© JNTO. Nō theater is characterized by the stylized dance movements and gestures of its actors, hypnotic music, recitation, and chanting, all set against a bare stage set featuring a lone pine tree. The interplay of these elements creates a sedate yet emotionally charged aura (see also Plate 2-15).

Plate 1-44 (right) *View of the Inland Sea from Mount Mikasa, Itsukushima*. Photo: Patricia J. Graham, October 2006.

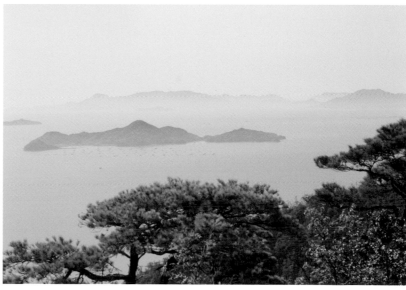

Buddhist spirit of *yūgen* ("mysterious beauty"), discussed further in Chapter 2).

Isozaki explained that he chose *ma* as the exhibition's unifying theme because the concepts behind it represent the foundation of almost all aspects of Japanese life. He saw it as a uniquely Japanese perception of spatial and temporal reality that resonated with contemporary theories of the universe as defined by quantum physicists who understand space and time not as separate categories but as interdependent dimensions.[45] As Gian Carlo Calza has recently observed, this idea had first been suggested by Werner Heisenberg (1901–1976), the Nobel laureate theoretical physicist who

Plate 1-45 (above left) Issey Miyake (b. 1938), *Blouse and pants with laser-beam printed geometric design in graduated colors*, 1977. Printed on cotton. Collection of Mary Baskett, Cincinnati. Photo: Katy Uravitch, The Textile Museum, Washington, DC. This outfit was published in 1978 in a pioneering book on Miyake's designs, *Issey Miyake, East Meets West*.[48] Miyake was one of a number of prominent avant-garde contemporary artists and designers who contributed to the landmark 1978 exhibition about *ma*.

Plate 1-46 (above) Jun Kaneko (b. 1942), *Dango*, 2006. One of a group of seven sculptures for the Water Plaza at the Bartle Hall Convention Center in Kansas City, Missouri. Glazed ceramic, height ca. 230 cm. Kaneko is famous for his large-scale, boldly glazed sculptures called *dango*, named after the Japanese word for "steamed dumpling," that he fabricates with seemingly endless variations of scale and surface design. Kaneko has said that *ma* "defines his entire practice as an artist—as painter, sculptor, designer, ceramicist … a term that derives from what one might call the metaphysics of Shinto."[49]

pioneered the study of quantum mechanics. Heisenberg wondered if Japanese scientists' great contributions to theoretical physics stemmed from philosophical ideas of the Far East.[46] Calza also echoed Isozaki in his observations that "it is precisely this kind of aesthetic model—flexible, open, attentive to every change and variation, full of symbolic references and allusions, and not given to concretizing description—that encouraged the rapid advance of Japanese art into the avant-garde."[47]

In 1933, at a time when Western-influenced modernity was beginning to exert profound influences on the Japanese way of life, novelist Tanizaki Jun'ichirō (1886–1965) wrote a short essay about what he considered the essential character of the Japanese aesthetic psyche. Titled *In Praise of Shadows*, the essay was only translated into English in 1977, and immediately became an inspiration to foreign enthusiasts of Zen-influenced Japanese aesthetics. Not surprisingly, Tanizaki's essay

Plate 1-47(above) *Writing table (bundai)*, Meiji period, late 19th century. Black lacquer on wood with gold sprinkled powder (*makie*) and engraved gilt bronze fittings, 14.4 x 63.8 x 36.4 cm. The Nelson-Atkins Museum of Art, Kansas City, Missouri. Gift of Mrs Jack Rieger in memory of Mrs Hortense P. Lorie, F76-30/1. Photo: Jamison Miller. In describing the beauty of Japanese lacquer, Tanizaki Jun'ichirō wrote that "lacquerware decorated in gold is not something to be seen in a brilliant light, to be taken in a single glance; it should be left in the dark, a part here and a part there picked up by a faint light. Its florid patterns recede into the darkness, conjuring in their stead an inexpressible aura of depth and mystery, of overtones but partly suggested."[50]

Plate 1-48 (below) *Tokonoma alcove in the tea room at the Sesshūin subtemple, Tōfukuji, Kyoto*. Tanizaki Jun'ichirō eloquently noted of these essential spaces in tea rooms that "Of course the Japanese room does have its picture alcove, and in it a hanging scroll and flower arrangement. But the scroll and the flowers serve not as ornament but rather to give depth to the shadows."[51]

was acclaimed at the same time the word *ma* came into fashion, because it describes aesthetics sympathetic with *ma*. In his essay, Tanizaki railed against the garishness of the electric light bulb and argued that Japanese objects and rooms possess a mysterious beauty dependent on their being visible only in spaces permeated with the diffused light of *shōji* screens or the flickering of candles or oil lamps. In short, he promoted an aesthetic centered on beauty emerging from the darkness of the void-like space of *ma*.

NŌTAN
THE DARK–LIGHT PRINCIPLE

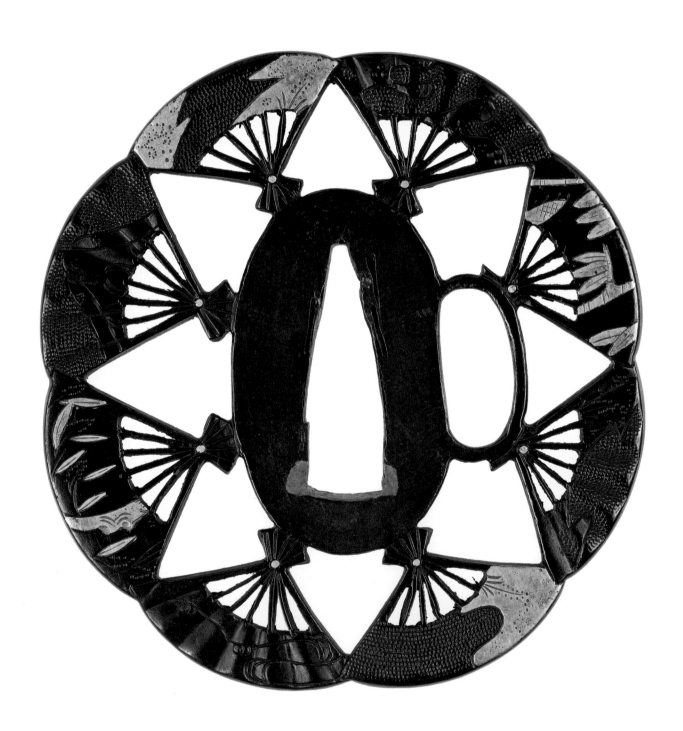

Plate 1-50 (left) *Stencil with undulating vertical lines with cross hatchings at intervals.* Late 19th–early 20th century. Mulberry paper, persimmon tannin, 18.1 x 38.8 cm. Santa Barbara Museum of Art. Gift of Virginia Tobin, 1994.48.9. Japanese stencils, with their bold, flat, contrasting patterns, are generally regarded as the pre-eminent Japanese art form in which the principle of *nōtan* is most clearly apparent (see also Plate 3-8).

Nōtan, the dynamic interaction between dark and light values in a two-dimensional image, is a Japanese aesthetic term wholly invented by modern-day Westerners, used mainly by artist educators and designers. The two Japanese words, "dark" and "light," that comprise this term were never joined together as aesthetic terminology in Japan. However, it has been widely used in the international design community since the early twentieth century and therefore merits consideration. Arthur Wesley Dow (1857–1922; see page 121) was

Plate 1-49 (left) *Sword guard (tsuba) with eight folding fans*, Edo period. *Shakudo*, gold, and copper, 6.9 x.6.5 x .42 cm. The Walters Art Museum, 51.140. The design for this *tsuba* relies on the strength of its positive and negative *nōtan* elements. Folding fans encircle the perimeter and the eye reads the empty spaces where they intersect as a bold star-shaped pattern.

responsible for its initial wave of popularity. In the 1920s, artist Rudolph Schaeffer (1886–1988), then a professor of the California School of Fine Arts, began using it to teach design principles. Later, he founded the Rudolph Schaeffer School of Design in San Francisco, which was influenced by Asian aesthetics and philosophies. One of his students in the 1920s was artist Dorr Bothwell (1902–2000), who in 1968 co-authored an influential book on *nōtan* for design educators, *Notan: The Dark–Light Principle of Design.* Her book featured practical exercises for instilling understanding of *nōtan* in students, and it remains in print to this day.[52] The book's foreword described *notan* as "the basis of all design" and noted that the mirror-image circular symbol for the Eastern philosophical concept of the opposing values of *yin* and *yang* embodies its principles.[53] The book explained

how to create dynamic designs on flat surfaces by emphasizing positive/negative spaces including symmetrical and asymmetrical balance, relative placement of dark and light areas, and spatial distortions. Its acknowledgements section credits Ernest Fenollosa (1853–1908; see page 134) as probably the first to *introduce* (my italics) the term to the US in the 1890s and Dow as the first to apply it to Western art design.[54] This description reflects the misunderstanding of many artists and art educators who regard it as an authentic Japanese design term, not one invented by Fenollosa and used by Dow, as was actually the case.[55] Regardless of its derivation, the term remains widely used. American artist Sharon Himes, founder of the early Internet artists community ArtCafe, recently authored an article about it in her widely read online journal, "Notan: Design in Light and Dark."[56]

MINGEI
JAPANESE FOLK CRAFTS

Plate 1-51 (above) *Kettle hook (jizaigaki)*, late 19th–early 20th century. Zelkova wood, height 33.7 cm, width 30 cm, diameter 7 cm. Photo courtesy of Toyobi Far Eastern Art. The central room of traditional Japanese commoners' houses featured charcoal fires in open hearths where an iron kettle hung from an adjustable wooden hook attached to a rope slung over the roof structure's cross beams. The robust form of this hook is more than merely a practical object. Its inverted V shape intentionally recalls the shape of the hat worn by Daikoku, one of the Seven Gods of Good Fortune, protector of the home.

Early *chanoyu* tea masters were the first to recognize and admire a definitive aesthetic, defined by rusticity and unpretentious ruggedness, associated with the dwellings and functional objects used by Japanese farmers. Medieval period tea masters incorporated this aesthetic into their new *wabi*-style tea ceremony in preferences for rough, unglazed stoneware ceramic tea utensils and unpainted, wood-framed, thatched-roof tea houses. But tea masters only valued arts that resonated with their ideas about *chanoyu*. It was Yanagi Sōetsu (see page 138) who rediscovered and promoted appreciation for a much wider variety of inexpensive, utilitarian, handmade crafts by and for commoners that extended from Japan's prehistory to his own time. In 1926, he coined the phrase *mingei* ("people's arts"), which he translated into English as "folk crafts," purposely avoiding the word "art." He believed that the anonymous artisans who made these objects utilized natural materials and pre-modern production methods to create practical, functional products imbued with an unconscious spiritual beauty that revealed an elevated moral or social consciousness superior to objects created as luxury goods for the wealthy and élites

of society. He considered these arts reflective of the true aesthetic expression of the Japanese people. Although he spearheaded appreciation for these crafts, many of which would otherwise have been lost to history, his insistence that they be classified as separate from other types of fine arts and crafts has led to their marginalization from many mainstream art museums and collections of Japanese art.

Although Yanagi called these products "folk crafts," and although some *mingei* artists are self-taught and their arts have a rusticated appearance, these crafts are far from primitive. *Mingei* products are sophisticated in both design and technique. Their varied appearance stems from the fact that the definition of commoners in pre-modern Japan encompasses a wide range of individuals, from rural peasants to urban dwellers, with varied tastes, income levels, and access to different types of raw materials. The common denominators for these crafts include their reliance on locally sourced materials (for example, local clays, wood species, cotton, and plant dyes), their utilitarian function (including clothing, tableware, furniture, and even crafts and statuary made for religious devotions), the anonymity of their makers (who often

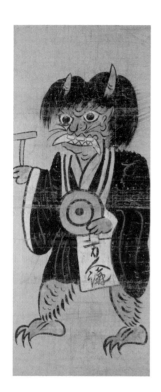

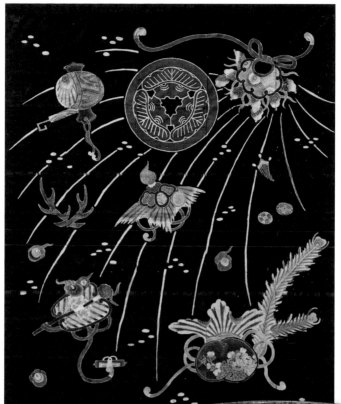

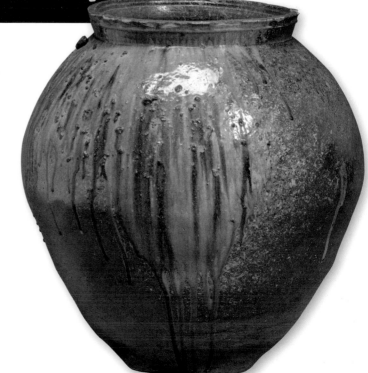

Plate 1-53 (left) *Futon (bedding) cover with pine crest and auspicious motifs*, late 19th–early 20th century. Plain weave handspun, handwoven cotton cloth with *tsutsugaki* (freehand paste-resist dyed) decoration in colors on dark indigo ground, 197 x 160 cm. Portland Art Museum. Gift of Terry Welch, 2009.25.44. Flaming jewels, a magic mallet, and peacock feathers were among the auspicious emblems blessing the person who slept under this cover.

Plate 1-52 (above) *Demon Reciting Prayers*, 18th–early 19th century. Hanging scroll, ink and color on paper, 53.0 x 20.4 cm. Gift from the Clark Center for Japanese Arts & Culture to the Minneapolis Institute of Arts, 2013.29.47. These charmingly humorous talisman pictures (Ōtsue) were popular souvenirs that travelers purchased from makers in the town of Ōtsu, a way-station along the Tōkaidō highway. This one portrays a demon dressed as a monk, an image that was believed to prevent infants from crying at night.

Plate 1-54 (right) *Massive Echizen ware water jar*, 16th century. Stoneware with natural ash glaze, height 72.4 cm. The Nelson-Atkins Museum of Art, Kansas City, Missouri. Purchase: Edith Ehrman Memorial Fund, F92-32. Photo: Jamison Miller. This sturdy pot is a classic example of Japanese folk ceramics of the sort appreciated by *chanoyu* masters. It is distinguished by its irregular shape, derived from a combination of coil and wheel-thrown techniques, and a thick-walled surface embedded with coarse grains, augmented with a naturally occurring ash glaze that drips down its sides, an effect later potters cultivated.

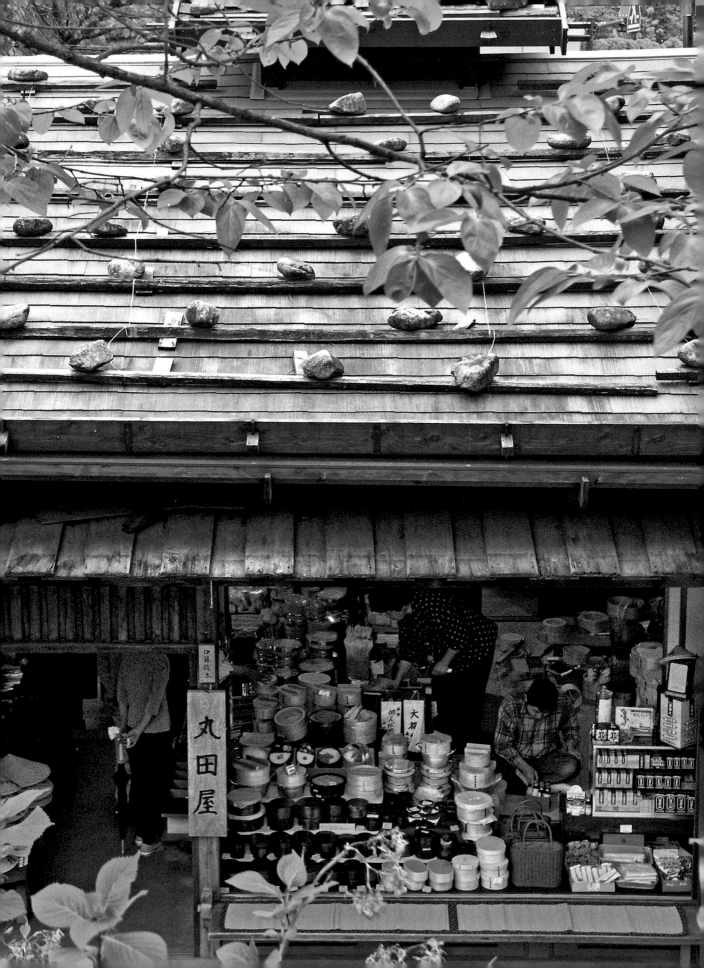

work together in a communal spirit to produce crafts for the people of the area in which they live), and their handmade production techniques (see also Plates 2-57–2-61, and 3-22).

Many types of traditional *mingei* featured auspicious emblems to offer their owners protection from diseases, injury, and other calamities, and as prayers for health, wealth, safe childbirth, and the like (see Plate 2-10).

Yanagi did not single-handedly create appreciation for *mingei*. He developed his theories together with artist-friends, potters Hamada Shōji (1894–1978; see Plate 2-21) and Kawai Kanjirō (1890–1966), whose works reinterpret *mingei* aesthetics for the modern world.

Today in Japan, the word *mingei* is widely used to refer to many types of local crafts, often produced for tourists, but based aesthetically on traditional, regionally made handicrafts.

Plate 1-55 (left) *Mingei crafts shop in the town of Tsumago, Nagano Prefecture*. Photo: David M. Dunfield, May 2003.

Plate 1-56 (right) *Interior view of the Takishita House, Kamakura*, renovation dating to 1976; originally constructed early 19th century; moved and restored by architect Takishita Yoshihiro (b. 1945). Takishita has made a career of saving old *minka* (farmhouses) from demolition by moving those that cannot be preserved in situ and using their skeletal framework to create comfortable modern houses for himself and clients worldwide. Originally a village chief's house from a town in Fukui Prefecture, this large *minka* features posts made of *keyaki* (Japanese zelkova) and massive curved beams from giant old pine trees.

Plate 1-57 (above) Munakata Shikō (1903–1975), *In Praise of Flower Hunting*, 1954. Woodblock print mounted as a hanging scroll, 150.5 x 169.4 cm. Art Institute of Chicago. Anonymous Donor, 1959.584. The prints of Munakata, a self-taught artist famous for carving his own woodblocks at a feverish pace, first attracted the attention of Yanagi Sōetsu and Kawai Kanjirō in the 1930s for his art's sincerity and unpretentiousness. These qualities accorded with Yanagi's beliefs that the beauty of folk crafts derived from the makers' inherently Buddhist attitude of selflessness. This print, produced well after Munakata met Yanagi and Kawai, portrays hunters shooting flowers, not arrows, a Buddhist reference to compassion and connectedness. The sharp, energetic lines and bold contrasts between dark and light areas characterize Munakata's style.

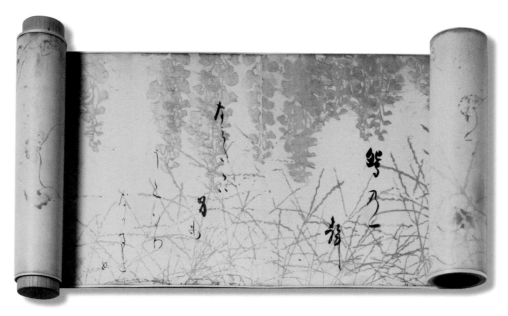

Plate 1-58 (above) Hon'ami Kōetsu (1558–1637), *Poems from the Shinkokin wakashū (New Collection of Japanese Poems from Ancient and Modern Times)*. Handscroll in ink, gold, and silver on woodblock printed paper, 33.8 x 830 cm. Philadelphia Museum of Art, 125th Anniversary Acquisition. Purchased with funds contributed by members of the Committee on East Asian Art, 1999-39-1. The aesthetic appeal of this handscroll relies on the collaboration between the calligrapher Kōetsu and an unknown craftsman who first created beautiful stencil designs of ivy, grasses, and wisteria in gold and silver ink on the paper.

RINPA
DECORATIVE ART OF THE KŌRIN SCHOOL

The artistic style known as Rinpa emerged in the old imperial capital of Kyoto during the early seventeenth century through the efforts of a small group of independent-minded individuals. Their leader was Hon'ami Kōetsu (1558–1637), a calligrapher from a well-connected samurai family of sword polishers who immersed himself in various arts at an artists' colony he founded, and his less well-recorded collaborator, the painter Tawaraya Sōtatsu (d. ca. 1640). The subjects and styles of Rinpa art recalled the courtly culture of the Heian period and often featured ancient *waka* poetry, yet its greater abstraction and bolder colors imparted a modern flair to these arts.

Beginning with Kōetsu, artists of the Rinpa tradition worked in multiple media, including lacquers, ceramics, and textiles, in addition to paintings in various formats. Many, like Kōetsu, collaborated with specialized craftsmen such as dyers, lacquer makers, or paper makers. Unlike the more familiar atelier system of artistic production in Japan, the Rinpa tradition has endured due to efforts of individual artists inspired by the achievements of earlier Rinpa masters. Following the initial burst of activity under Kōetsu, Sōtatsu, and his immediate followers in the seventeenth century, the painter Ogata Kōrin (1658–1716) and his younger brother Ogata Kenzan (1663–1743) created a second wave of interest in Rinpa designs, which they modified to appeal to patrons of their own time.

The artist Sakai Hōitsu (1761–1828), whose well-to-do samurai family had, generations earlier, patronized Ogata Kōrin, initiated a third major revival of the Rinpa tradition. Hōitsu revered Kōrin as the greatest Rinpa master and worked tirelessly both to promote him and to emulate his style.

Although today the name Rinpa is widely used to designate artists whose work follows this tradition, that was not always the case. Since the time of Hōitsu and through the Meiji period it was called the "Korin School." Before that it had no name. Influenced by Ernest Fenollosa (see page 134), who revered Kōetsu as the founder of this artistic lineage, these artists were sometimes referred to as the "Kōetsu School" (see Plate 3-19). Some design qualities associated with the Rinpa artistic movement possess similarities with

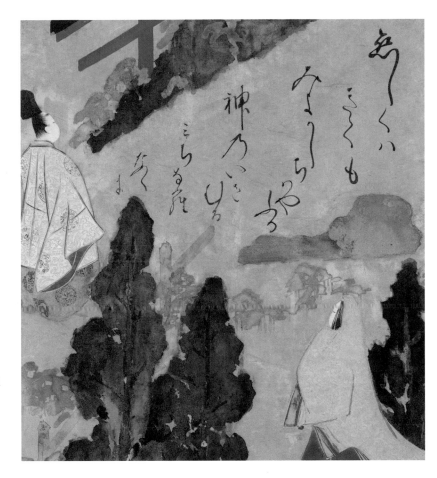

Plate 1-59 (above) Tawaraya Sōtatsu (d. ca. 1640) and an unidentified calligrapher, *Visiting the Shrine, A Scene from the Tales of Ise (Ise monogatari)*. Album leaf mounted as a hanging scroll, ink, color, and gold paint on paper, 24.4 x 21 cm. The Nelson-Atkins Museum of Art, Kansas City, Missouri. Gift of Mrs. George H. Bunting, Jr, 74-37. Photo: Jamison Miller. Like more conservative painters who portrayed courtly themes (see Plates 1-27 and 2-33), Rinpa artists preferred thick mineral colors but applied them more freely, omitting details to engage the viewer's imagination.

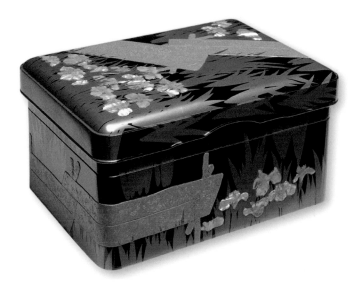

Plate 1-60 (left) *Copy of a lacquer box for writing implements by Ogata Kōrin with designs of the eight-plank bridge (Yatsuhashi)*, Meiji period, late 19th century. Lacquer with metallic and mother-of-pearl inlays, 27.6 x 19.9 x 14.7 cm. Collection of Edmund and Julie Lewis, Chicago. This box faithfully copies one of the most famous of all known works by Kōrin in the Tokyo National Museum. Such copies were created not as forgeries but as homage to their original creator. This subject was a favorite of Kōrin and subsequent Rinpa artists, a famous passage from the celebrated courtly prose-poem, the *Tales of Ise*.

Plate 1-61 (above) Ogata Kenzan (1663–1743), *Set of food dishes for the tea ceremony meal (mukōzuke) with designs of autumn leaves floating in the Tatsuta River*, 18th century. High-fired pottery, polychrome and overglaze, and gold pigment, height 3.4 cm, diameter 16.3– 18.1 cm, foot diameter 9 cm. Miho Museum, Shiga. The varied and abbreviated playful designs on each of these plates reveal Kenzan's creative genius.

Plate 1-62 (right) Kamisaka Sekka (1866–1942), *Snowcaps (Yuki bōshi)*, from vol. 1, p. 22, of the 3-volume set of albums, *Chigusa (All Kinds of Things)*, 1899–1900. Color woodblock print, 24 x 36 cm. Gift from the Clark Center for Japanese Arts & Culture to the Minneapolis Institute of Arts, 2013.29.61.1. Sponsored by the Japanese government, Sekka traveled to Europe to study the fashion for Japonisme. After returning, he spearheaded interest in reviving Rinpa designs as models for Japanese designers, fused with a new sense of abstraction influenced by his exposure to Western Art Nouveau styles.

bold designs described as *nōtan*, so it is no wonder that Fenollosa, who conceived the term *nōtan*, was one of the early promoters of Rinpa artists. Beginning in the early twentieth century, Japanese scholars reasserted the importance of Kōrin in naming this tradition, but linked him with Sōtatsu, whom they had recently

identified, and so the name "Sōtatsu-Kōrin School" came into vogue. By the post-war period, an abbreviated appellation of Kōrin's name (joining the second character of his name, "Rin" with the word for school, "ha") resulted in the tradition being renamed "Rimpa" (which is now more commonly spelled "Rinpa"). This name came into standard usage in the early 1970s following two popular exhibitions, one in the USA at the Japan Society (1971) and the other at the Tokyo National Museum (1972).[57]

In 2012, a landmark exhibition at the Metropolitan Museum interpreted Rinpa more broadly than ever before. As the exhibition's curator, John Carpenter adroitly explained in the catalogue:

> *The Rinpa aesthetic embraces bold, exaggerated, or purely graphic renderings of natural motifs as well as formalized depictions of fictional*

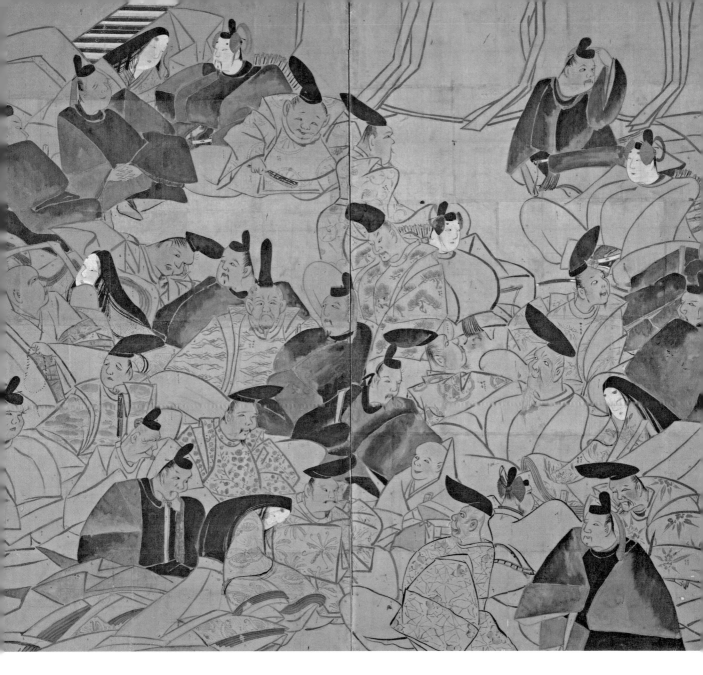

characters, poets, and sages. *Underlying Rinpa design sensibilities is a tendency toward simplification and abbreviation, often achieved through a process of formal exaggeration. Rinpa is also celebrated for its use of lavish pigments, conspicuous or sometimes subliminal references to court literature and poetry, and eloquent experimentation with calligraphy. Central to*

Rinpa is the evocation of nature as well as eye-catching compositions that cleverly integrate text and image.[58]

Carpenter's exhibition featured the core artists associated with Rinpa, but it also explored the influence of Rinpa aesthetic on arts as varied as textile pattern books, *fin de siècle* ceramics, cloisonné enamels of the Meiji period, and modern Japanese-style (Nihonga) artists.

Plate 1-63 (above) Sakai Hōitsu (1761–1828), *The Thirty-Six Immortal Poets*, ca. 1815. Two-panel folding screen, ink and colors on paper, 165.1 x 180.3 cm. The Nelson-Atkins Museum of Art, Kansas City, Missouri. Gift of Mrs George H. Bunting, Jr, 77-50. Photo: Jamison Miller. The thirty-six poets lived at various times between the seventh and eleventh century and so could never have gathered as a group. Hōitsu based this whimsical composition on one invented by Kōrin. It is actually not a finished painting but a preparatory drawing he kept in his studio as a model, indicative of how popular the subject was among patrons of Rinpa artists.

KAZARI
MODES OF DECORATION AND DISPLAY

As evident from the discussion above, the long and complex evolution of Japanese society stimulated creation of diverse design/aesthetic sensibilities. In recent decades, foreigners and Japanese writing on aesthetics have sought to create over-arching frameworks for discussions about Japanese design generally. They emphasize the gradual evolution of Japanese design traditions and recognize that often multiple modes of equal importance existed simultaneously within a plurality of social contexts. These varied modes can generally be described with the word *kazari*, translated variously as "decoration," "ornament," and "adornment." Although not all writers use this term, their interpretations share many fundamental principles, and all emphasize that finely made Japanese things were created as part of a sophisticated system in which objects became linked through a set of shared values.

Among the earliest Westerners to adopt this approach was Sherman E. Lee (1918–2008), the long-time director of the Cleveland Museum of Art (1958–1983), who pioneered appreciation for Japanese arts in his acquisitions and exhibitions at that museum. His *Japanese Decorative*

Style exhibition catalogue of 1961 attempted to define the special qualities of Japanese design by examining specific types of arts within their historical, religious, and cultural contexts in. He noted that

> *China often provided impetus and inspiration not even the most ardent Japanophile would deny. The traditional theory of alternating waves of Chinese influence and troughs of Japanese assimilation is certainly nearer a truth, but we must recognize additional*

Plate 1-64 (above) *Kōdaiji-style covered incense container with design of autumn flowers and sea shells*, 17th century. Lacquered wood with *makie* decoration, metal rim on interior, height 6.35 cm. Portland Art Museum. Gift of Richard Louis Brown, 2012.30.6. Possibly the same object is illustrated in Sherman Lee's *Japanese Decorative Style* catalogue (no. 125), owned at that time by a private collector in Cleveland.

Plate 1-65 (right) *Sutra wrapper (chitsu) from Jingōji temple, Kyoto*, with fittings in butterfly shape and temple seal on reverse, first half 12th century. Slender split black bamboo strips interwoven with dyed silk threads atop mica flecks, surrounded by a border of orange ground silk brocade, gilt copper alloy fittings, green silk twill weave lining, 45.5 x 31.1 cm. The Nelson-Atkins Museum of Art, Kansas City, Missouri. Bequest of John M. Crawford, Jr, 69-29/1. Photo: Tiffany Matson. Illustrated in Sherman Lee's *Japanese Decorative Style* catalogue (no. 4), this sumptuous object, the embodiment of Heian period *miyabi* aesthetics, once held sacred Buddhist texts.

Plate 1-66 (far right) Nishiaki Hisako (b. 1956), *Japanese quilt with family crest designs*, 2010. Hand-pieced and quilted cotton cloth with paste relief indigo dyeing (*tsutsugaki*). Sherman Lee included a large number of family crest designs in his book, *The Genius of Japanese Design*, arranged according to variations of particular motifs. Such designs remain popular among Japanese artists today. Many are abstractions of natural motifs.

Plate 1-67 (right) *Arita ware, Shoki-Imari type (probably Chōkichidani kiln), large dish with landscape design*, mid-17th century. Porcelain with matt-finished glaze and underglaze blue decoration, height 8.9 cm, diameter 44.1 cm. The Nelson-Atkins Museum of Art, Kansas City, Missouri. Bequest of Mrs George H. Bunting, Jr, 81-27/13. Photo: Joshua Ferdinand. As noted by Michael Dunn, among arts fashioned from the earth, ceramic production has a long history in Japan and its makers have continually endeavored to improve their techniques to the point where, at present, the Japanese ceramics industry and artists who specialize in this material are perhaps the most diversified and technically sophisticated in the world. Among the most important historical developments was the introduction of high-fired porcelain technology from China in the early seventeenth century. The bold design on this dish typifies the exuberant taste of affluent domestic users of porcelain in the earliest period (*shoki*) of production in Japan.

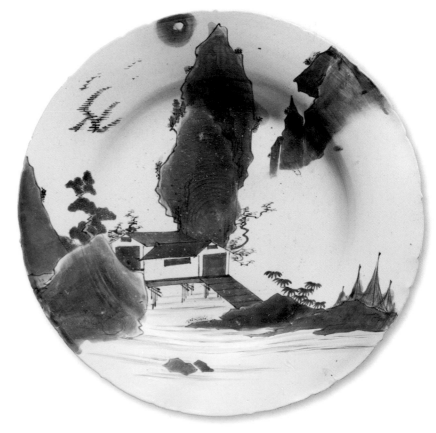

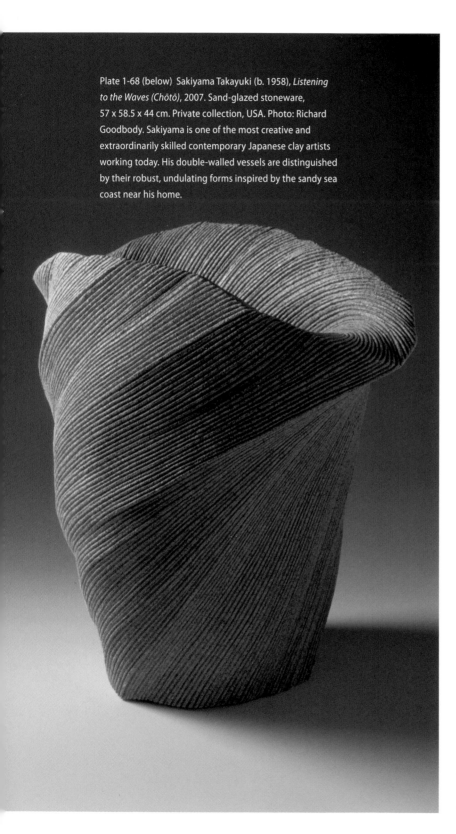

Plate 1-68 (below) Sakiyama Takayuki (b. 1958), *Listening to the Waves (Chōtō)*, 2007. Sand-glazed stoneware, 57 x 58.5 x 44 cm. Private collection, USA. Photo: Richard Goodbody. Sakiyama is one of the most creative and extraordinarily skilled contemporary Japanese clay artists working today. His double-walled vessels are distinguished by their robust, undulating forms inspired by the sandy sea coast near his home.

waves of intense creativity when Japanese made contributions as original and significant, if of a different order, as those made by the Chinese. Nationalistic critical efforts have attempted to isolate the uniquely "Japanese" qualities of the islands' art: loyalty and patriotism, purity and cleanliness, gracefulness and quietness, valor and activity, fatalism, intuition, sensitivity, love of nature, dexterity, simplicity, reticence, shibumi *(subdued and unpretentious) as embodied in* sabi *(aged, lacking the aggressiveness of the new), and* wabi *(the same concept applied to architecture). An objective study of the range of any art might well find such qualities, but certainly Japanese art reveals numerous works and schools which display none of these qualities, all encompassing as they seem to be. Many of these aberrations are the result of too much tea, and the tea ceremony is not the only historical expression of Japanese culture.*[59]

Lee's last point ("too much tea") is significant and may have been intended to counter Elizabeth Gordon's singular promotion of *shibui* in her magazine and in popular exhibitions that toured the United States at the same time Lee organized his exhibition. Yet, Lee shared Gordon's admiration for the Japanese predilection to create beautifully made functional objects, often by unknown makers. Lee also sought to define the essential characteristics

of Japanese designs, describing them as "composed of certain forms and combinations repeated with subtle and seemingly infinite variation. Like other decorative styles it relies heavily on the use of precious materials, particularly gold and silver, in juxtaposition with pure color. Its basic compositional devices are markedly asymmetrical…."[60]

In 1981, Sherman Lee authored a deluxe book, *The Genius of Japanese Design*,[61] which expanded upon his earlier catalogue. In it he emphasized the Japanese proclivity for patternization and sensitive use of natural materials, which he effectively highlighted in the book's back section, an encyclopedic primer that illustrated multiple variations on popular Japanese visual subjects, many drawn from imagery of the natural world.

Another writer to explore the multifaceted nature of Japanese designs is British expatriate Michael Dunn, a resident of Japan since 1968, who initially arrived as a businessman. His empathy towards traditional Japanese culture and art enticed him to become an art dealer, collector, and author of many eloquent articles and exhibition reviews for the *Japan Times* newspaper. Dunn also served as curator of a provocative exhibition for the Japan Society Gallery in New York in 2001, *Traditional Japanese Design: Five Tastes*. There, he explored Japan's design aesthetics through five representative "tastes" seen in arts of diverse types that share common characteristics, production processes

Plate 1-69 (left) *Negoro-style sake bottle (heishi) with pine and plum design*, late 16th–early 17th century. Wood coated with layers of black and then red lacquer, height 41 cm. The Nelson-Atkins Museum of Art, Kansas City, Missouri. Purchase: Edith Ehrman Memorial Fund, F78-17. Photo: Jamison Miller. Vessels with this distinctive combination of red and black lacquer, some decorated as here, others plain, are known as Negoro ware, and were originally made for use at Buddhist temples. Their patina embodies the essence of *wabi-sabi;* the wearing away of the red lacquer outer layer over time reveals more of the black lacquer underneath. This aesthetic helped to infuse the space of the sanctuary with an ambiance of Buddhist *kazari*. The decoration on this bottle, auspicious plants associated with winter (pine and plum), indicate it was probably featured in New Year's rituals.

Plate 1-70 (below) Teisai Hokuba (1757–1844), *Geisha Playing Cards*. Hanging scroll, ink and colors on silk, 54.8 x 72.6 cm. Feinberg Collection. Paintings of beautiful women geisha (*bijin*) reflect the sophisticated *kazari* taste (*iki*) of affluent urban merchants.

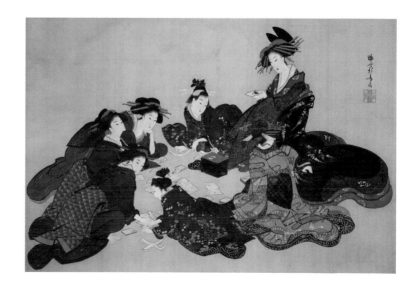

that underscore an unwavering concern for materiality and technique, and visually arresting designs.[62] The catalogue described these five tastes, most of which have already been introduced in this chapter, as "Ancient Times" (*kodai no bi*; an introductory section that featured archaeological materials created in the prehistoric period through the first century CE), "Artless Simplicity" (*soboku*; arts for commoners, essentially *mingei* aesthetics), "Zen Austerity" (*wabi*, arts in tea taste), "Gorgeous Splendor" (*karei*; arts for élites, aristocrats and high-level warriors), and "Edo Chic" (*iki*; arts reflecting the vibrant urban culture of affluent merchants of the Edo period).

In 2005, Dunn also authored a lavishly illustrated, meditative and wide-ranging volume, *Inspired Design: Japan's Traditional Arts*.[63] After ruminations on the Japanese sense of beauty that touched upon familiar themes of inspirations from nature and Zen Buddhism, his subsequent chapters echoed the admiration of many earlier writers for the Japanese artists' sympathetic use of materials that he used as his book's organizing framework with sections titled "art from fauna," "art from flora," and "art from the earth."

Like Lee and Dunn, Tsuji Nobuo has also spent many years investigating stylistic linkages among arts. He was the first to use the term *kazari* as an overarching framework for understanding Japanese design and aesthetics. In 2002, the British Museum and the Japan Society in

New York mounted an exhibition on this theme, inspired by Professor Tsuji's concept, grouped around six types of *kazari* popular in the early modern period (ca. 1600–1868), when various modes of decoration flourished simultaneously. Although conceptualized differently, the aesthetic typologies the catalogue introduced highlighted the design issues this chapter has addressed. The catalogue's editor, Nicole Rousmaniere, noted that "throughout pre-modern times *kazari* has had multifarious applications depending on context, whether religious or political, personal or communal, intellectually sophisticated or purely extravagant" and that it encompasses "the act of decorating or displaying," and "refers not just to the actual object and the decoration on it, but also to the use of that object and its transformation into something special or extraordinary."[64]

Italian art historian Gian Carlo Calza, whose 2007 book, *Japan Style*, serves as a contemplative introduction to the visual qualities that characterize Japanese arts, also emphasized the existence of multiple styles of artistic expression. Similar to Sherman Lee's interpretation, to Calza, Japan's characteristic "style" has no distinct appearance but encompasses diverse artistic traditions created over a long period of time. He argued that style is

the result of a complex process of personal and social transformation (and as such not attributable to a single person), one

that gives rise to images capable of representing values that are profound and enduring, not ephemeral like fashion which, by definition, must constantly be changing.[65]

Calza divided his book into three sections: "Irregular Beauty," "The Feeling of Nature," and "Masters of Art." Within this structure, he explored the appeal of Japan's wondrous sense of design in language reminiscent of both Elizabeth Gordon on *shibui* and

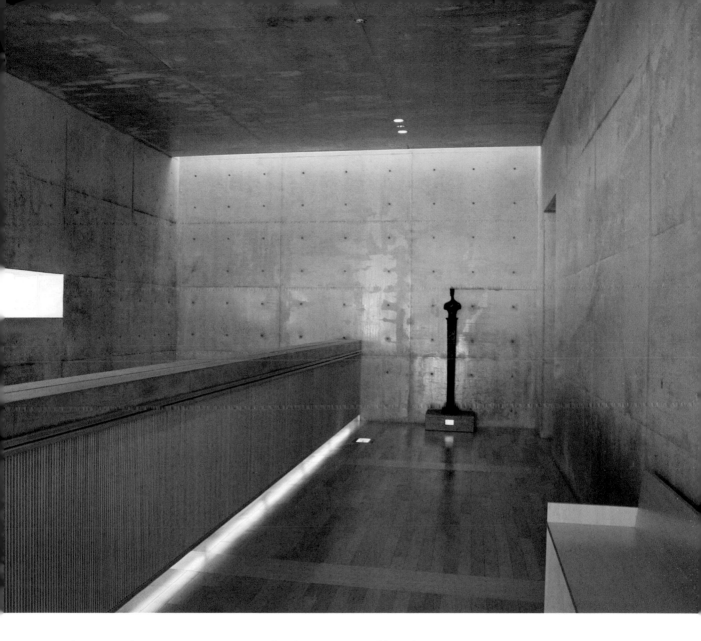

Isozaki writing about *ma*:

> *The reasons for the popularity of Japanese culture in the West are to be sought in this realm of the imperfect, the unresolved, the asymmetrical. Japan's 'western-ness', its modernity* avant la let-ter *(in addition, obviously, to its staggering present-day moder-nity), makes it more familiar than other Asian societies, and allows us to absorb more easily the more alien elements of its culture. But beneath this familiarity it is possible to detect messages that are unfamiliar and beguiling, that charm and disconcert, and at the same time offer a new, refreshing model of art and beauty; allusive, rather than descriptive, emotional rather than rational, averse to symmetry, preferring shadow to broad daylight, and determined to avoid perfectionism, which is pursued only through a total, absolute, and minute attention to the imperfect.*[66]

Plate 1-71 (above) Andō Tadao (b. 1941), *Lobby of the Park Hotel, Benesse House, Naoshima*, 2006. Photo: Patricia J. Graham, October 2006. While using modern materials of concrete and glass, Andō effectively captures the emphasis on minimalism, materiality, asymmetry, and the power of darkness that distinguishes much of Japanese design, both old and new.

JAPANESE DESIGN
A VISUAL PRIMER FEATURING CONTEMPORARY ARTS

The previous sections of this chapter have introduced the most important Japanese aesthetic concepts and principles of design which have inspired the work of Japanese artists and designers over the centuries. Despite their diversity, they share formal design principles that continue to inform the work of many present-day Japanese artists, as the examples here reveal.

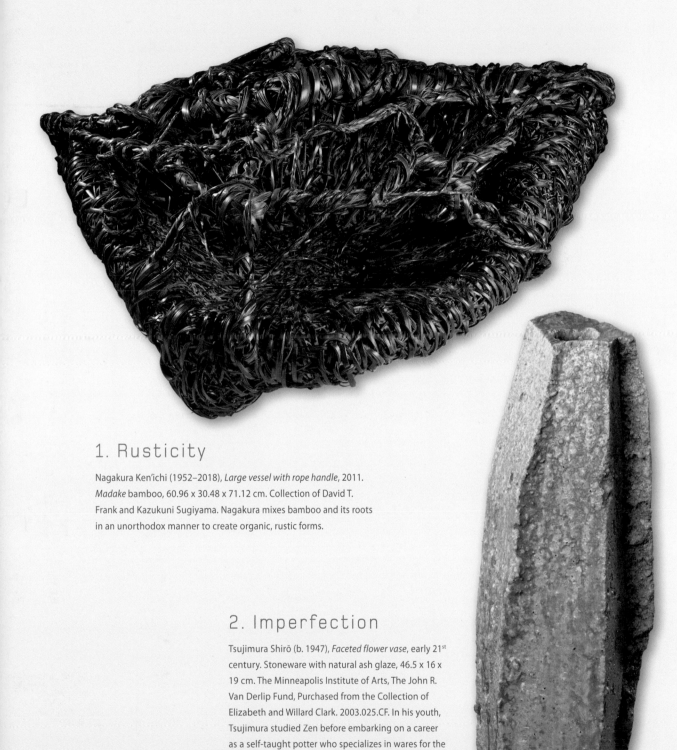

1. Rusticity

Nagakura Ken'ichi (1952–2018), *Large vessel with rope handle*, 2011. *Madake* bamboo, 60.96 x 30.48 x 71.12 cm. Collection of David T. Frank and Kazukuni Sugiyama. Nagakura mixes bamboo and its roots in an unorthodox manner to create organic, rustic forms.

2. Imperfection

Tsujimura Shirō (b. 1947), *Faceted flower vase*, early 21st century. Stoneware with natural ash glaze, 46.5 x 16 x 19 cm. The Minneapolis Institute of Arts, The John R. Van Derlip Fund, Purchased from the Collection of Elizabeth and Willard Clark. 2003.025.CF. In his youth, Tsujimura studied Zen before embarking on a career as a self-taught potter who specializes in wares for the *chanoyu* tea ceremony that capture the essence of the Zen-influenced *wabi-sabi* aesthetic.

3. Emptiness

Mukaiyama Kisho (b. 1968), *Veda Intro no. 1*, 2011. Wax on paper, watercolor, wooden board, 38 × 45.5 × 2.8 cm. Collection of the artist. A devout Shingon Buddhist, Mukaiyama seeks to give visual form to the diffuse colors of light that he envisions in his prayers and describes the light that suffuses in his art as a tranquil presence.

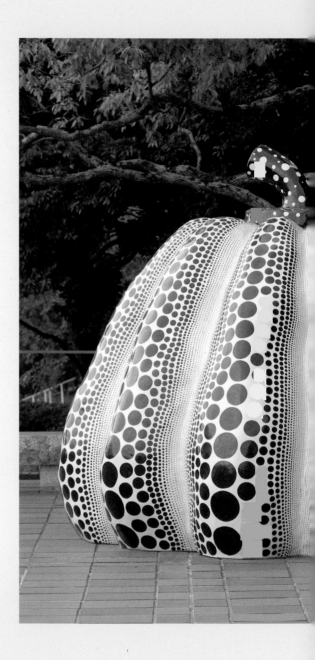

4. Subtlety

Jinzenji Yoshiko (b. 1942), *Coconut Field*, 1993. Engineered Quilt series. Cotton, natural dye soga, and quilting, 250 x 200 cm. Helen Foresman Spencer Museum of Art, University of Kansas. Gift of the artist, 2007.0099. Jinzenji, one of Japan's most well-known quilt makers and commercially successful textile designers until her recent retirement, divided her time between Kyoto and Indonesia. She is best known for her innovative dyeing techniques that create muted, earthy colors from natural dyes. The color in this quilt comes from the bark of the Indonesian soga tree.

5. Flamboyance

Kusama Yayoi (b. 1929), *Pumpkin*, 1994.
Fiber reinforced plastic (FRP), height ca.
120 cm. Fukuoka Municipal Museum of
Art. Kusama is Japan's most famous
avant-garde artist, an influential early
member of the 1960s pop art movement
in New York. Her bold, over-the-top
designs bring to mind the traditional
basara aesthetic.

6. Color Potency

Yamaguchi Yuriko (b. 1948), *Autopoesis*, 2012. Ceiling
installation of hand-cast and dyed resin with stainless steel
wire, overall length 3901.44 x 304.8 cm. Crowell & Moring
LLP, Washington, DC. Yamaguchi explores the inter-
connected nature of a universe comprised of organic
cell-shaped forms drenched with radiant colors,
recollecting the bold pooled application of colors in Rinpa
paintings, the gradation effects in *ukiyoe* prints, and the
resplendent colors associated with the Buddhist paradise.

7. Fluid Brushwork

Takegoshi Jun (b. 1948), *Large rectangular covered box decorated with kingfishers perched on reeds* (exterior and interior), 2005. Porcelain with overglaze enamels, height 16.51 cm, length 49.53 cm, width 12 cm. Private collection, on loan to the Philadelphia Museum of Art. Photo: Richard Goodbody, courtesy of Joan B. Mirviss LTD. Takegoshi, the son of a Kutani ware potter, has pioneered the modernization of the long tradition of Kutani porcelain (see Plate 1-32), updating the traditional Kutani ware aesthetic with his vessels' forms and his lyrical images of plants and birds that he wraps around his vessels.

8. Asymmetry

Hamanishi Katsunori (b. 1949), *Dim No. 8, 2005*. Mezzotint, 19.7 x 24.8 cm. Private collection, USA. Hamanishi uses the painstaking Western mezzotint printing technique, a specialty of many contemporary Japanese print makers, to create striking modern-looking prints whose abstract, asymmetrically balanced proportions recall traditional Japanese aesthetics, such as the balance of stepping stones in a garden or the abstracted forms in Rinpa school paintings.

9. Nature Abstracted

Okada Yoshio (b. 1977), *Moon Spirit Box*, 2009. Lacquer with hemp cloth base, inlaid gold foil, gold flakes, gold powders, and abalone shell, 3.7 x 14.5 x 11.1 cm. Collection of Sue Cassidy Clark, New York. Photo courtesy of Erik Thomsen Asian Art, New York. This artist has created a vision of highly abstracted clouds swirling around a full moon orb, recalling but not imitating the appearance of pre-modern painting and lacquer designs.

10. Spatial Distortion

Kawase Yoshihito (b. 1973), *Tower*, 2000. Painting on panels; mineral pigments, ink, and gold and silver leaf on paper, 182 x 486 cm. Collection of the artist. The artist uses traditional Nihonga painting techniques and compositional devices to create a dark, phantasmagoric vision of contemporary Tokyo, dominated by elevated highways and a monstrous-looking Tokyo Tower.

CHAPTER TWO
THE CULTURAL PARAMETERS OF JAPANESE DESIGN

The design qualities that distinguish the arts of Japan reflect the culture's complexity and plurality and its continually evolving artistic traditions, as befits the hierarchical status, religious beliefs, education, political viewpoints, wealth, personal interests, and place of residence of individual makers and users. Nevertheless, some design aesthetics, such as those associated with the tea ceremony, permeate arts designed for use across a broad spectrum of Japanese society. Others somehow retain an identifiable Japanese aura marked by attitudes towards the production and handling of materials that, above all, stress fine craftsmanship and attunement to nature. This chapter explores these issues by considering the ways Japan's dominant religious traditions of Shinto and Buddhism have influenced the design of Japan's visual arts and through identifying ten key characteristics of Japanese society that have nurtured the creativity of designers, crafts makers, and artists over the centuries. That these design traits have endured despite profound modernizing societal transformations, which began in the late nineteenth century and have continued unabated since, reflects deeply entrenched values that continue to define the cultural identity of the Japanese people.

Plate 2-1 (left) Watanabe Seitei (1851–1918), *Cypress Tree, Moon, and Deer*. Hanging scroll, ink on silk, 110.5 x 26.7 cm. Collection of Gerald and Alice Dietz, Plano, Texas. This painting evokes the mysterious spirit of Shinto in its representation of a deer in the mist alongside a majestic cypress tree, a common sight at Shinto shrines, the trunk of which is here rendered with a single broad stroke of the brush.

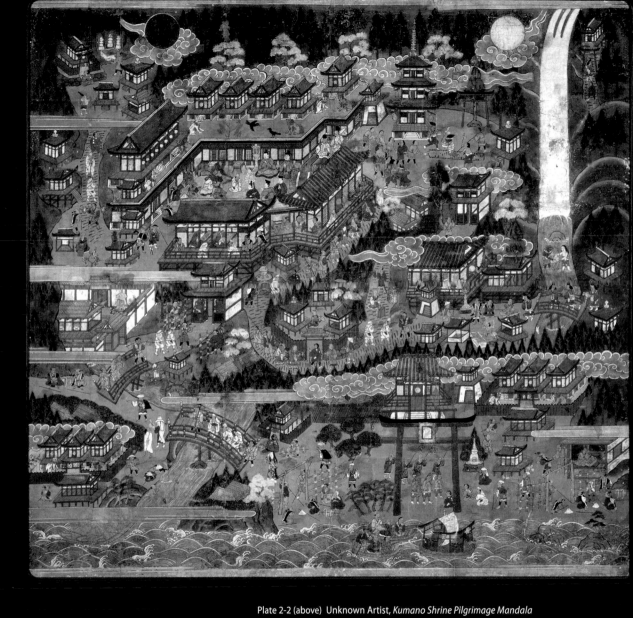

Plate 2-2 (above) Unknown Artist, *Kumano Shrine Pilgrimage Mandala* (*Kumano Nachi Sankei Mandara*), 16th–17th century. Hanging scroll, ink and color on paper, ca. 259 x 165 cm. Collection of Kumano Nachi Grand Shrine. Photo: Inconnu (http://www.ikkojin.net present/ 2011/03/25510.html) {{PD-US}}via Wikimedia Commons. This painting, a cosmic diagram of a sacred space known as a mandala, was once displayed by mendicant monks or nuns to audiences to assist lay persons in visualizing divine powers at sacred locales. Here, below the celestial

RELIGIOUS VALUES AND JAPANESE DESIGN

Although a small minority of the Japanese population embraced Christianity after its introduction in the mid-sixteenth century, people have mainly owed their spiritual world view to the intertwined belief systems of Shinto, ostensibly an indigenous faith, and Buddhism, introduced from continental Asia in the sixth century. Both incorporated aspects of older Chinese philosophical/religious creeds of Daoism and Confucianism, which became known in Japan around the same time as Buddhism.

Japanese religious practice famously blurs the lines between secular and sacred realms. Temples and shrines often serve as centers for entertainment and shopping. Sumo wrestling, for example, got its start as a match to please Shinto gods (*kami*), and later tournaments were held at Buddhist temples. Residences and shops also incorporate household Buddhist altars to honor ancestors and Shinto shrines to protect the dwelling and family members. Small Shinto and Buddhist shrines get erected along roadsides to ensure safe passage to travelers.

Until the modern period, Buddhist temples and Shinto shrines sat side by side in religious complexes that reflected the Japanese pre-modern hybrid belief system known as *honji suijaku*, which coalesced in the Heian period (see Plate 2-2). This ideology promoted joint veneration of Buddhist deities (the *honji*, or original gods) and Shinto *kami,* which were identified as the native manifestations (*suijaku*) of the Buddhist deities, alleviating competition between these two religions.

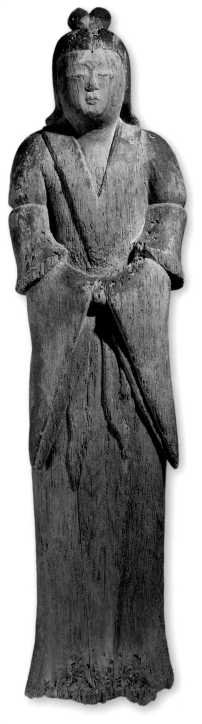

Plate 2-3 (right) *Female Shinto deity*, Heian or Kamakura period, 12th century. Wood with traces of pigment, height 97 cm, width 21.6 cm, diameter 12.1 cm. Asian Art Museum, San Francisco, transfer from the Fine Arts Museums of San Francisco. Gift of Mrs Herbert Fleishacker, B69 S36. Images of Shinto deities (*shinzō*) were first carved during the Heian period. This statue portrays the goddess in a simple approximation of a Heian court dress, largely unpainted and roughly carved to highlight the tool marks of the sculptor.

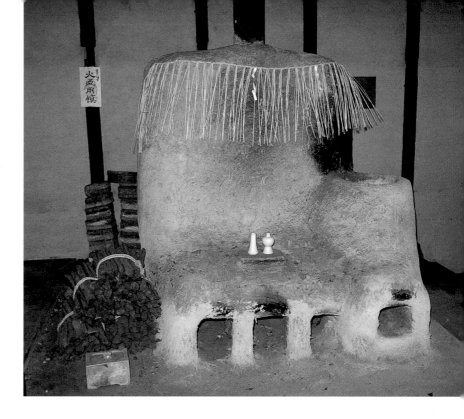

Plate 2-4 (right) *Bisque kiln at the Kawai Kanjirō House, Kyoto.* Photo: Patricia J. Graham, July 1987. The rice straw rope with dangling paper streamers tied around the upper portion of the kiln and the small pure white offering bottles atop the firing chamber designate the kiln as a sacred Shinto space.

The Aesthetic Dimensions of Shinto

The Japanese islands sit atop tectonic fault lines that cause destruction from earthquakes as well as healing properties from the abundance of hot springs they produce. They also lie in a region of the earth with great seasonal variation. These climatic and topographic conditions have contributed to the development of Shinto's emphasis on purification rites and agrarian-based festivals. In its respect for the continual cycle of birth, growth, death and then renewal of life inherent in the changing seasons, Shinto beliefs encompass appreciation of both the old and the new, attitudes that have influenced Japanese artists and designers to the present day.

At the heart of Shinto practice is reverence for its millions of *kami*, the unseen deities who give and protect life, embodiments of life-sustaining forces of nature. *Kami*

Plate 2-5 (left) *Grand Shrine at Ise.* Photo: David M. Dunfield, September 1981. This earliest known shrine building in Japan is the abode of Amaterasu, the sun goddess, and progenitor of the imperial family. The main building, encased in several rows of wooden fences, is accessible only to shrine priests and the imperial family. In a momentous act of purification and renewal, with only a few interruptions during the civil wars in the medieval era, it has been completely rebuilt every twenty years since the year 690, most recently in 2013 for the sixty-second time.

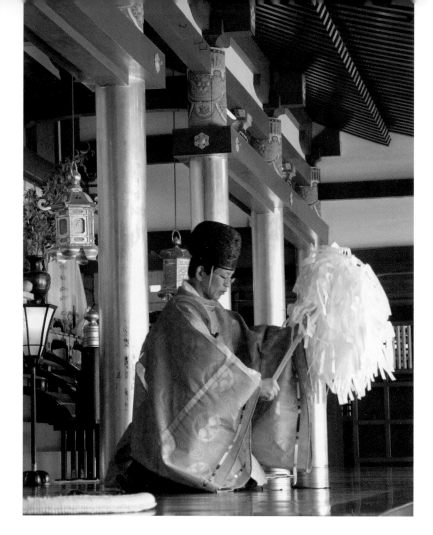

take many forms. They may occupy awe-inspiring places such as oddly shaped rocks, gnarled old trees, towering waterfalls, and majestic mountains, or they may be spirits of living or deceased personages, natural forces (such as thunder and rain), or even useful inanimate objects. Animals such as monkeys and deer are considered messengers of the gods. Some *kami* protect familial clans and others, individual dwellings. So important is protection of the home (or business) that even in Japan today no building is erected without first undergoing a Shinto purification ceremony.

Kami also inhabit raw materials used by crafts makers, who pay homage to them by erecting small shrines or altars to them in their workshops. One of the early writers

Plate 2-6 (above) *Shinto priest performing a ritual purification at the Sumiyoshi Shrine, Fukuoka.* Photo: Patricia J. Graham, May 2012.

Plate 2-7 (right) Shinji Turner-Yamamoto (b. 1965), *Disappearances: An Eternal Journey, SiTE: Lab + University of Michigan School of Art and Design, Grand Rapids, Michigan,* 2011. A large-scale 8000 square foot (750 square meter) site-specific temporary installation created with fossils (coral, limestone, indigenous gypsum fragments/powder), processed gypsum, burnt limestone/concrete floor, and rainwater. The artist, now based in the USA, created this installation in a crumbling former warehouse building using locally sourced ancient rocks. Influences from Shinto infuse his artistic vision: its emphasis on natural materials, its acceptance of the cyclical nature of life, and the appearance of its shrines, surrounded by pristine areas of white sand or gravel.[2]

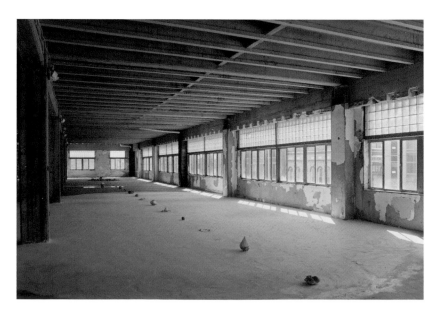

about Japanese arts, Langdon Warner (see page 144), wrote eloquently about this custom:

> *Dealing as this body of beliefs does, with the essence of life and with the spirits inhabiting all natural and many artificial objects, it came about that no tree could be marked for felling, no bush tapped for lacquer juice, no oven built for smelting or for pottery, and no forge fire lit without appeal to the Kami resident in each.*[1]

The abodes of *kami* are known as Shinto shrines. These are bounded by slender, often red, gateways (*torii*) and ropes made of rice straw, and they are frequently erected at beautiful, often remote, locales. The pathway to these places often meanders, rendering their entrances hidden from afar, perhaps influencing the preference for asymmetrical balance in Japanese design. Unlike Buddhist temples that are filled with imagery, representations of the resident *kami* remain hidden from view, enhancing their association with the numinous forces they represent.

Buddhist Influences on Japanese Aesthetics

Buddhism complements Shinto by guiding believers along the correct path through life, assisting in their quest to escape the cycle of death and rebirth and ultimately to achieve perfect enlightenment, an awakened state of consciousness, or emptiness, now often described in English as

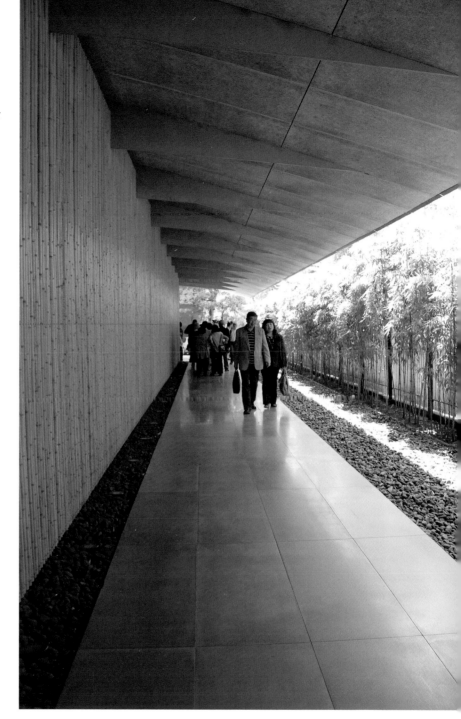

Plate 2-8 (above) Kuma Kengo (b. 1954), *Exterior covered entryway to the Nezu Museum, Tokyo*, 2009. Unlike the rejection of tradition by many modernist architects in the West, Kuma typifies the modern Japanese architects' embracing of their culture's design heritage at its best, evident in the heavy overhanging roof, the use of natural stones and bamboo, and the siting of the entrance out of view, around a corner.

Plate 2-9 (below) *Esoteric Shingon sect Buddhist altar (butsudana) at a private residence, Karuizawa, Japan.* This is a rather large example of a residential altar before which devotees recite daily prayers.

the "Buddha Mind."[3] In Buddhism, depending on sectarian beliefs, enlightenment can be achieved either in this lifetime or after death. Because attaining enlightenment in this life requires intense dedication, many followers opt to seek rebirth after death in a Buddhist paradise, considered a transient state closer to fully realized enlightenment than their present existence on earth. Practitioners employ diverse meditative and devotional acts to achieve salvation, some at public sites of worship and others in the privacy of their own homes.

Pilgrimages to holy sites associated with both Shinto and Buddhism are a defining characteristic of Japanese religious worship and now encompass hundreds of separate pilgrim sites and circuits throughout the country. The act of embarking on a pilgrimage, a spiritual quest to a holy site, is a universal mode of religious worship, associated with Buddhism from its inception and practiced in Japan as early as the seventh century.

Japanese religious practice, both Buddhism and Shinto, also frequently makes use of mandalas (Jp. *mandara*), either two- or three-dimensional, to instruct followers (see Plates 2-2 and 2-11). First introduced from China via Esoteric sects in the ninth century, they feature images of deities and sacred places arranged in a prescribed manner. As they became central to meditative practices of diverse Buddhist sects, their appearances came to vary accordingly. In general,

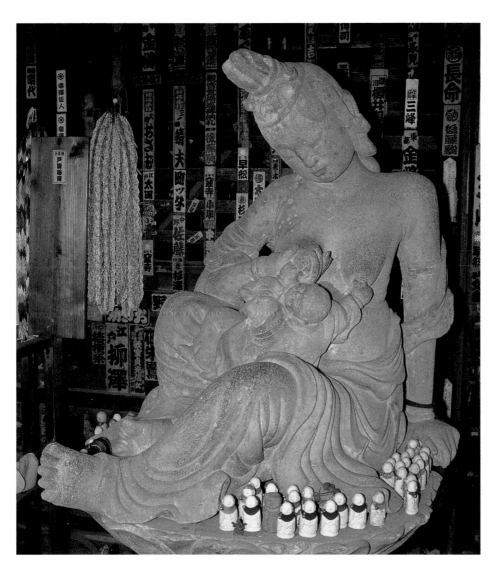

Plate 2-10 (left) *Bodhisattva Kannon surrounded by tiny statues of Bodhisattva Jizō*, 1792, Kinshōji (Chichibu pilgrimage circuit temple #4), Chiba Prefecture. Stone, height ca. 100 cm. Photo: Patricia J. Graham, 2005. The most popular deity venerated at Japanese pilgrimage temples is the compassionate Bodhisattva Kannon, seen here at a temple along a route near Tokyo. Stone statues (*sekibutsu*) such as this are classic examples of religious *mingei*, made by and for the common people's religious devotions. Bodhisattva Kannon here is represented in the guise of a compassionate mother nursing a child (Jibo Kannon). Parents, and especially mothers, offer prayers to her for the health of their living children and for the salvation of the souls of their deceased babies and fetuses, and deposit at her feet little statues of Jizō (a Bodhisattva who protects travelers and children).

they can be described as visual props used in rituals designed to enable devotees to envision sacred realms and deities that aid their understanding of the Buddhist universe and its concepts of enlightenment.

Among the many Buddhist sects in Japan, the Rinzai Zen sect has had perhaps the most powerful influence on the culture's arts. Its stringent emphasis on austerity inspired the development of the *chanoyu* tea ceremony and encouraged appreciation for designs that feature vast areas of emptiness, characteristics pointed out by D. T. Suzuki (see page 137) and many others, including Gian Carlo Calza, who, in turn, ascribes the source for these preferences in Zen to the influence of Daoism on its meditative practices.[4]

Central to Buddhism is belief in the interconnectedness of all creation. Buddhist monuments such as the Indian stupa and its East Asian counterpart, the pagoda, as well as Japan's unique version, the *gorintō* (five element pagoda), embody this concept in tangible form. *Gorintō* are perhaps the best example of how the Japanese visualize abstract Buddhist concepts as pure design (see Plate

2-14). Their beautifully balanced, stacked geometric forms represent the ordering of the universe into five elements, from base to summit: cube (earth), sphere (water), pyramid (fire), semisphere (air), and jewel (space or void), representative of the progression of Buddhist disciples' understanding of Buddhist teachings.

Each form is also associated with one of five directions and corresponding primary colors, borrowed from ancient Chinese cosmological systems that originated with Daoism. Although their three-dimensional form is unique to Japan, they are based on descriptions likening these shapes to the Buddhist cosmological universe in Indian Buddhist sutras of the fifth century. First devised during the Heian period (794–1185), stone funerary monuments in this shape became ubiquitous in temple courtyards, cemeteries, and gardens and were also installed on temple altars as small reliquaries in precious materials, such as gilt bronze or

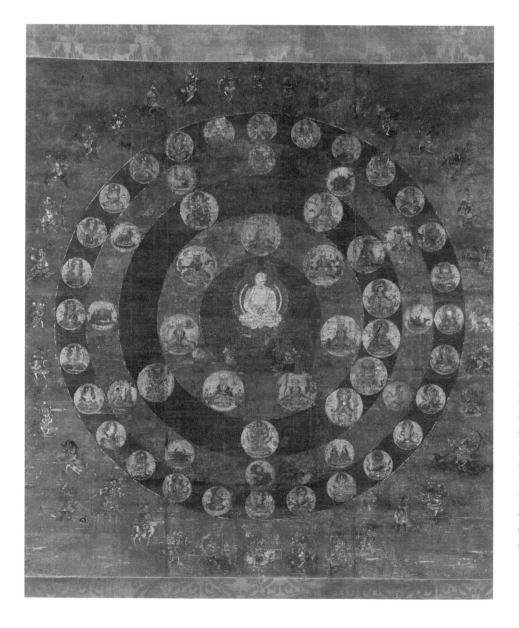

Plate 2-11 (left) *Star Mandala (Hoshi Mandara)*, late 14th–early 15th century. Hanging scroll, ink, colors, and *kirikane* (gold leaf) on silk, 128.3 x 117.5 cm. Metropolitan Museum of Art, Gift of Sue Cassidy Clark, in honor of Bernard Faure, 2020. Photo courtesy of Koichi Yanagi Oriental Fine Arts, New York. Chinese Daoist cosmological beliefs about the supernatural powers of the heavens to prevent disasters and ensure longevity influenced Japanese Esoteric Buddhist concepts visualized in the uniquely Japanese star mandala. In these, the historical Buddha Shakyamuni (Jp. Shaka) presides at the center of the cosmos surrounded by concentric rings of celestial deities and protective animals that personify the stars, five planets, the moon, constellations associated with various phases of the moon, the twelve signs of the zodiac, and thirty-six minor celestial guardians and their associated calendric animals.

Plate 2-12 (left) *Meditation Hall (Zendō), Tōfukuji, Kyoto*, 14 century. Photo: Patricia J. Graham, May 2005. The Zen sect emphasis on meditation has led to their temples having dedicated buildings for this purpose, where monks sit in orderly rows upon *tatami*-matted platforms. This is one of the oldest surviving examples, a serene open space filled with light from high clerestory windows but no distracting outside views.

Plate 2-13 (below) *Partial view of the sand and rock garden, Ryōanji, Kyoto*, late 15 century. Photo: Patricia J. Graham, 2007. This simple, quiet garden of just fifteen rocks on five islands of moss arranged irregularly in a sea of gravel, is widely regarded as the supreme example of the minimalist Zen *karesansui* (dry landscape) style garden. A UNESCO World Heritage Site, it epitomizes the Zen aesthetic.

crystal. Later, they began to be installed in the gardens of private residences, often in the form of lanterns.

Gorintō is one type of Buddhist monument that, in its memorializing of the deceased, reminds followers of another basic Buddhist belief, the transitory and therefore precious nature of life. This awareness has deeply penetrated the aesthetic sensibility of both Japan's visual and literary arts. The oldest of many words to describe these sentiments, *mono no aware*, has already been mentioned on page 20 above as a precursor to *wabi-sabi*, inspired directly by Zen thought. Japanese prose and poetry abound with symbolic imagery expressive of *mono no aware*, most frequently the invocation of specific plants and trees, and even particular colors, used as seasonal allusions for the evanescence of life.[5]

During the medieval period, the word *yūgen*, a borrowed Chinese term expressive of

Plate 2-14 (right) Sugimoto Hiroshi (b. 1948), *Five Elements: Caribbean Sea, Jamaica*, 2011. Optical quality glass, black and white film, height 15.2 cm, width 7.6 cm, diameter 7.6 cm. Negative 301 © Hiroshi Sugimoto, courtesy of Gallery Koyanagi. The artist has reinterpreted the traditional *gorintō* form in a contemporary medium and inserted into its center not a relic of the Buddha or a Buddhist saint but a tiny photograph from a series he completed years earlier of a vast seascape, an apt Buddhist metaphor.

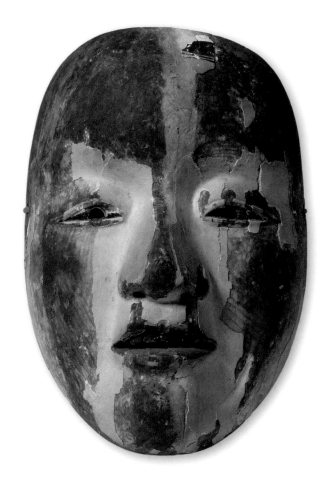

Plate 2-15 (right) *Nō mask of a middle-aged woman (probably Ko-omote),* 15th or early 16th century. Carved and painted wood, 20.32 x 13.7 cm. The Nelson-Atkins Museum of Art, Kansas City, Missouri. Gift of Mrs James F. Terney, 71–35/2. Photo: Tiffany Matson. Subtly expressive, this mask dates to the earliest era when Nō plays were performed. The large areas of missing paint do not detract from its beauty but convey the spirit of *yugen*.

dark mysteriousness came into prominence. *Yūgen*, whose elusive meaning varies with its contexts, as do all Japanese aesthetic expressions, has sometimes been described as "profound grace."[6] This term is most often associated with aesthetics of the Nō theater, which developed then and whose most notable playwright during its formative period, Zeami Motokiyo (1364?–1443?) used it to describe Nō aesthetics. Nō actors attain a spirit of *yūgen* when their highly stylized, dignified movements appear totally natural. Both *yūgen* and *mono no aware* encompass, in slightly different ways, a Buddhist appreciation for the profound and mysterious beauty of nature that characterizes the spirit of early Zen temple gardens (see Plate 3-12).

The celebration of these melancholy emotions encouraged artists to portray imagery of the natural world, especially seasonal themes that capture a fleeting moment in time. For example, the fragile beauty of cherry blossoms heralds spring's arrival, suggestive of the joy of rebirth while simultaneously reminding viewers of life's brevity.

Not only do Japanese writers and artists evoke the passage of time in images of nature, but also in pictures of people, especially beautiful young women, whose beauty vanishes as they age (see Plates 1-22, 1-30, and 1-70). In fact, in the Edo period (1615–1868), the urban red light districts were known as the Floating World (Ukiyo), a place where people could gather to forget their worldly cares. Hence, *ukiyoe* (pictures of the floating [or transitory] world) became the name for the woodblock prints and paintings that depict the people and activities in this world, especially fashionable young women and Kabuki actors (see Plate 1-23), the celebrities of their day.

Buddhism also encouraged artists to envision the sacred beauty (*shōgon*) that all life possesses based on descriptions from Buddhist scriptures of the atmosphere in which the Buddha preached and of the Buddhist paradise itself, often depicted as a magical, timeless universe filled with resplendent, gold-hued deities and myriad jewel-like blossoming trees and flowering plants. In the real world, these bloomed in different seasons, but in the Buddhist paradise, as shown in some Japanese pictorial representations, they all blossomed simultaneously. The fine craftsmanship and luminous gold and polychrome surface designs punctuated with abstract linear patterns found in so many Japanese arts express this notion of sacred beauty.

Plate 2-16 (below) *Writing box (suzuribako) with designs of the seven grasses of autumn (aki no nana kusa),* signed: Shunshō. Black lacquer on wood with gold and silver sprinkled powder (*makie*), colored lacquer, and abalone inlay (*raden*), applied mixed metal water dropper and ink stone, 4.9 x 16.5 x 18.4 cm. The Nelson-Atkins Museum of Art, Kansas City, Missouri. Purchase: William Rockwill Nelson Trust, 33-113/A-G. Photo: Tiffany Matson. The theme of the seven grasses of autumn (bush clover, pampas grass, chrysanthemum, arrowroot, aster, patrina, and gentian) originated in *waka* poetry.

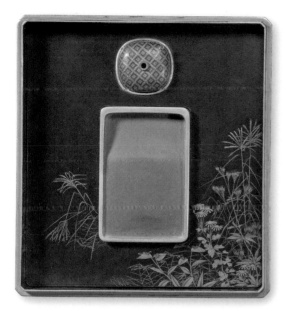
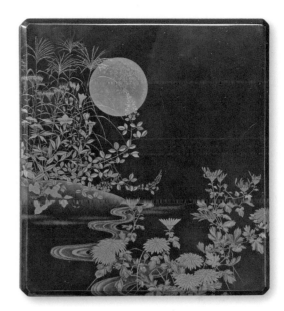

Plate 2-17 (right) Eri Sayoko (1945–2007), *Ornamental Box: Dancing in the Cosmos*, 2006. Wood with polychrome and cut gold, 86 x 16.5 x 16.5 cm. Collection of Eri Kōkei. In 2002, Eri became the first woman designated as a "Living National Treasure" for her achievements in the art of *kirikane* (cut gold leaf decoration). In addition to applying *kirikane* to Buddhist paintings and sculptures, the latter in conjunction with her husband, sculptor Eri Kōkei (b. 1943), she created many beautiful objects, such as this box, whose subtle coloration reflects her training in dyeing. Her designs, inspired by those featured on ancient Buddhist arts, embody the spirit of *shōgon*.

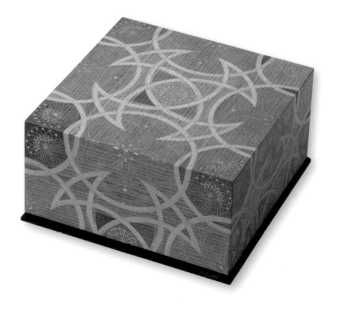

DESIGN IN JAPANESE CULTURE: TEN KEY CHARACTERISTICS

1. Relationship Between Fine Arts and Crafts

Considering how pre-modern Japanese society regarded the production of fine arts and crafts and, concomitantly, the relationship between artists and crafts makers, is fundamental to understanding the overarching and continuing importance of fine design to all types of Japanese arts and crafts industries. Before the late nineteenth century, various words described makers of fine arts and crafts although generally no broad linguistic categories distinguished one from the other. The wide variety of professionals who created handmade things for rituals, commercial trade, and daily life, such as weavers, paper makers, glass blowers, armorers, basket makers, *ukiyoe* print makers, lacquerers, fan and screen makers, potters, and Buddhist image carvers, were all defined as *shokunin* (literally "a person who possesses a skill"). The word *shokunin* excluded only painters

Plate 2-18 (above) *Satsuma-style hexagonal-shaped vase*, late 19th century. Stoneware with overglaze polychrome enamels and gold, signed "Yuzan" (?), height 11.6 cm. Santa Barbara Museum of Art. Gift of George and Kathryn Argabrite, 1978.42.11. Satsuma-style ceramics were among the most popular and widely produced type of craft (*kōgei*) exported abroad and displayed at international expositions during the Meiji period. Westerners particularly admired their finely painted miniature scenes.

and calligraphers in the employ of high status groups in society, such as samurai and people at the court, who were accorded a higher and separate status from other artisans.

The Japanese first invented an all-encompassing word for fine arts (*bijutsu*) in 1873 when preparing for the nation's official participation in the Vienna International Exposition.[7] This word paired *bi*, the abstract notion of beauty, with *jutsu*, the second character in the pre-modern word *geijutsu* ("cultivated skills"), a word borrowed from China where it had been used to describe six skills to be mastered by scholar-intellectuals.[8] Soon, the Japanese coined other words to describe artistic production based on Western nomenclature, including *chōkoku* (sculpture), *kaiga* (painting), and *kōgei* (crafts), the latter describing the many types of handmade Japanese crafts, examples of which were produced in large quantities by artisans in workshop settings. They also created a new word for crafts, *bijutsu kōgei* (art crafts), that reflected their culture's esteem for them and comprised a wide spectrum of crafts in diverse media by artists who strove for creativity and originality.[9] Still, following Western hierarchies, they privileged the "fine arts" of painting and sculpture over all types of crafts.

In the 1920s, definitions for crafts and recognition of their significance to Japanese heritage became more nuanced with their division in juried exhibitions and

Plate 2-19 (right) Mukoyoshi Yuboku (b. 1961) and Nakamura Keiboku, *Shaka Nyorai* (detail), 2003. Wood with polychrome, cut gold leaf (*kirikane*), and crystal eyes, overall height 205 cm. Collection of the artists. Mukoyoshi carves statues to which his wife Nakamura applies painting and cut gold leaf. He is a *busshi* (literally "master of Buddhist arts"), inheritor of a skilled profession that has existed since ancient times. The contemporary art world of Japan does not, however, consider him an artist who creates sculpture (*chōkoku*). Rather, he is defined as a maker of a specialized type of traditional art craft (*dentō kōgei*) because his work is used for devotional purposes and not for display in museums and fine arts galleries.

government-sponsored agencies into three separate categories: *mingei*, which had just then been conceived, *bijutsu kōgei*, and *kōgyō* (industrial design). The latter described well-crafted mass-produced consumer products.

In the late 1940s and early 1950s, the government's reconstruction efforts brought renewed prominence to Japanese crafts with the establishment of the Ministry of Trade and Industry (MITI), which sought to

promote well-known strengths in design-oriented industries. At the same time, existing laws for the protection of cultural properties were strengthened and expanded to highlight craft traditions based on pre-modern art forms, newly described as "traditional crafts" (*dentō kōgei*). As part of this effort, in 1955 the government began to single out outstanding individuals who continued to create traditional crafts through a new designation as

Plate 2-21 (below) Hamada Shōji (1894–1978), *Square Bottle*, 1955. Stoneware with colored glazes and iron decoration, 23.5 x 9.8 x 9.8 cm. Saint Louis Art Museum. Gift of Bernard and Sally Lorber Stein, 20:1999. Hamada Shōji, a professional potter inspired by the rugged and sturdy appearance of pre-modern Japanese folk pottery, assisted Yanagi Sōetsu in establishing the *mingei* movement. Hamada's achievements at melding the folk pottery tradition with the modern, Western-influenced notion of the potter as artist led to his inclusion in the first group of "Living National Treasures" by the Japanese government in 1955.

Plate 2-20 (above) Yamada Hikaru (Japanese, 1923–2001), *Disappearing Vessel (Kieyuku tsubo)*, 1976. Glazed stoneware, 50.1 x 38.1 x 10.8 cm. Metropolitan Museum of Art, Gift of Halsey and Alice North, in celebration of the Museum's 150th Anniversary, 2017.166.20. Photo: Richard Goodbody. Yamada was a founding member of the avant-garde Sōdeisha ceramic artists' association. This deconstructed vase reflects the artist's respect for Japan's long history of producing functional ceramics while simultaneously boldly challenging viewers' perceptions of form and space.

"Living National Treasure" (*Ningen Kokuhō*). This was followed in 1974 by a Law for the Promotion of Traditional Craft Industries that sought to preserve the production of entire craft traditions. So successful have these efforts been that by the 1990s a government survey recorded 184 distinct types of traditional crafts.[10] Today, these laws have evolved into the most complex and sophisticated structure for the preservation of traditional crafts in the world.

Although these modern traditional crafts makers seek to preserve pre-modern techniques, they do not exactly copy past works of art. As perceptively defined by Uchiyama Takeo (b. 1940), director emeritus of the National Museum of Modern Art, Kyoto, "tradition is not simply 'preservation.' It is that element in creative art which does not change at its core but which changes constantly in its expression."[11] This notion of the underlying, unifying force of tradition as a basis for artistic creativity, encompassing not only the necessity of continuity but also changes in taste and creative contributions by individual makers, has always been an important component of artistic production in Japan. It helps account for a sense of Japanese-ness in Japan's arts, regardless of when or in what media they are created.

Separate from these efforts to preserve traditional crafts in the post-war era, diverse groups of designers and crafts makers have created numerous private organizations to promote various types of *bijutsu kōgei*, some taking their cues from pre-modern traditions and others based on Western, modernist, avant-garde artistic values. One of the earliest, most outspoken, and influential of the latter was the Sōdeisha ("crawling through the mud society"), founded in 1948 and disbanded in 1998, which inspired many of Japan's most unorthodox clay artists active today.[12]

2. Emphasis on Craftsmanship and Technological Innovation

Japanese social mores and spiritual beliefs derived first from Buddhism and Shinto, and later from Confucianism, encouraged a patient and perfectionist attitude that has helped fine craftsmanship to thrive in the country. Artists and designers seek to master complex technologies that improve the quality of their arts and building designs to help them meet market demands as well as to better exploit the potentialities of the media

Plate 2-22 (below) *Detail of the bracketing system under the roof of the Tatekakenotō, Kanshinji, Kawachi Nagano, Osaka Prefecture*, 14th century. The complex wooden joinery used in the bracketing system that supports heavy thatch or tile roofs is one of the hallmarks of Japanese architectural design that evolved over many centuries.

in which they work. Many of Japan's well-known design-based arts have long histories of successes due to refinements in native manufacturing processes and/or innovations that incorporate techniques imported from abroad.

Plate 2-23 (above) *Arita ware, Kakiemon-type covered, footed bowl*, ca. 1690. Porcelain with molded and overglaze enamels, diameter 21.3 cm. The Nelson-Atkins Museum of Art, Kansas City, Missouri. Bequest of Mr John S. Thacher, F85–14/A,B. Photo: Jamison Miller. The introduction of high-fired porcelain technology from China to Japan in the early seventeenth century initiated momentous changes in Japan's ceramics industry. Kakiemon ware takes its name from the beautiful reddish-orange persimmon (*kaki*) enamel color perfected by the Arita potter Sakaida Kizaemon (1596–1666), whose descendants have perpetuated his artistic lineage into the present. The finish was enhanced by perfection of a special glaze whose formula was a closely guarded secret for many decades. Until the mid-eighteenth century, this porcelain was made specifically as a fine export product for Europe.

Plate 2-24 (right) Sudō Reiko (b. 1953), *Feather Flurries (Black)*, produced for the Nuno Corporation, 1993. 100 percent translucent silk organdy, with goose, peacock, and guinea hen feathers, width 115 cm. Photo: Sue McNab, courtesy of Sudō Reiko and Nuno Corporation. Sudō is one of the most creative and daring textile designers active in Japan today. Her subtle, multi-dimensional fabric has a frosted moiré (rippled water) appearance, derived from weaving together two transparent layers of plain weave black silk. Where the layers are joined, they form rectangular pockets into which feathers are inserted by hand.

Plate 2-25 (left) Ueno Masao (1949–2019), *Rotation of Ellipse Makes Two Transparent Drums*, 2004. *Madake* bamboo, rattan, lacquer, and gold powder, 50.1 x 50.1 cm. Gift from the Clark Center for Japanese Arts & Culture to the Minneapolis Institute of Arts, 2013.29.686. Although the art of bamboo basketry originated in China, Japanese artists working in this medium have pushed the art form to new heights. This artist, a former architect, uses computer software to design perfectly geometric forms.

Plate 2-26 (below) Kaminuma Hisako (1952–2012), *Incense container with design of cherry blossoms and the sun*. Cloisonné enamel (*shippō yaki*) on metal with copper wires, 6 x 6 x 4 cm. Kaminuma was a gifted artist who revived and improved upon a lost traditional technique for low-fired cloisonné enameling (*doro yaki*) through her perfection of a matt-finished red pigment that infused her designs with a modern spirit. A consummate perfectionist, she discarded a large proportion of her wares because of minute imperfections, some visible only with a magnifying glass. Among her finest works are small, subtly colored boxes like this, used for storing incense.

Plate 2-27 (right) Izumiya Tomotada (active late 18th century), *Netsuke in the form of a dog.* Carved ivory, length 5.3 cm. The Walters Art Museum, 71.1020. These miniature sculptures functioned as toggles to attach medicine pouches to the waist sashes of men's robes. From the eighteenth century, when forbidden from ostentations displays of wealth, men sought instead to commission fine miniature arts they could hide from authorities.

Plate 2-28 (below) *Satsuki azalea bonsai tree.* Exhibited in Ueno Park, Tokyo, May 2012. Height ca. 45 cm. The Satsuki azalea is a native Japanese botanical species, popular for use as *bonsai* (literally "tray plant"). Introduced from China over 1,000 years ago, *bonsai* has since developed into a quintessentially Japanese miniature art form. Its trees are not dwarf varieties but full size plants carefully cultivated to grow in small pots and mimic the appearance of full size species in nature.

3. Beauty in Miniaturization and Detailed Workmanship

Complementing an emphasis on fine craftsmanship and technological innovation, the Japanese have a propensity for appreciating the refined beauty of small spaces, arts of diminutive proportions, and art forms whose beauty derives from painstaking detail. The Korean literary critic O-Young Lee is one of many who have observed these preferences among the Japanese. He ascribes this emphasis to the meaning of the Japanese language word for "craftsmanship" (*saiku*; literally "delicate workmanship").[13] He notes that the Japanese word for beauty has always embodied preferences for "small, delicately wrought things."[14] These word usages support the visual evidence that fine craftsmanship—manifested in attention to details and the creation of small objects—and appreciation of beauty invariable go hand in hand in Japan.

Plate 2-29 (above) Ôta Jinnoei (active ca. 1880–1910), *Box lid with design of palatial residence and garden from the Tale of Genji*. Cloisonné enamel, 16.5 x 11.43 x 6.6 cm. Exhibited at the 1895 Fourth Domestic Industrial Exposition, Kyoto; subsequently in the collections of Emperor Meiji, Empress Meiji, and an imperial prince. Collection of Fredric T. Schneider. The detailed design on this box is a tour de force of technical perfection.

4. Importance of Artistic Lineages and Teamwork

For centuries, Japanese artists and designers have worked in multi-generational workshops headed by a master who oversees apprentices and assistants, facilitating both the learning process of younger team members and efficient production. This system is endemic to many types of social organizations in Japan. Some scholars have attributed this way of working to social structures developed in the distant past when wet rice cultivation and village life demanded communal cooperation for survival. So pervasive had this system of apprenticeship and communal learning become by the Edo period that a special terminology, *iemoto seido* ("headmaster system"), was created to describe it. Many traditional literary and performing art forms, including the tea ceremony, schools of poetry, flower arranging (*ikebana*), and the performing art forms of Nō, Kabuki, and Bunraku theater, still flourish through this *iemoto seido* system.[15] The *iemoto* system reflects Japan's tightly knit social structure, which promotes continuity of family and guild-like lineages that often transmit technical knowledge to members secretly. While this may sometimes lead to conservatism, it would be wrong to think that it stifles innovation. In addition, new traditions are established when ambitious and creative junior members leave to set up workshops of their own.

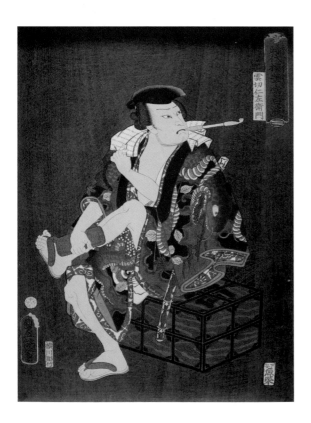

Plate 2-30 (below) Raku Ryōnyū (1756–1834), *Black raku tea bowl, copy of "Shishi" by Raku Do'nyū*. Earthenware with black raku and colorless glazes, width 5.1 cm. Freer Gallery of Art, Smithsonian Institution, Washington, DC. Gift of Charles Lang Freer, F1901.2. Low-fired, lead-glazed raku pottery is one of the most familiar of all types of Japanese ceramics. The Raku family workshop, established in the late sixteenth century, is now headed by a fifteenth generation descendant. Patronage by élite *chanoyu* tea schools contributed to its success. Ryōnyū, "the most prolific and longest-lived member of the Raku house," produced wares that closely imitated his forebears, but also, as here, introduced subtle innovations to the family's familiar style in the glossy black glaze.[17]

Plate 2-31 (above) Utagawa Kunisada (Utagawa Toyokuni III; 1786–1864), *The Actor Kataoka Nizaemon VIII as Kumokiri Nizaemon, from the series Thieves in Designs of the Time (Jidai moyo ataru shiranami)*, 1859. Color woodblock print, 36.8 x 25.1 cm. Collection of Elizabeth Schultz. *Ukiyoe* print production required the collaboration of talented printers and block carvers and entrepreneurial publishers to bring to life the imagery created by the artist who designed the print. Kunisada was one of the most talented and prolific members of the Utagawa School of print makers, from whose ranks many of the most famous nineteenth-century print makers hailed.

5. Linkages Between Literary and Visual Arts

Japanese prose and poetry have long been a source of inspiration for visual artists and written words often appear embedded in visual arts as integral design elements.

During the seventeenth century, a newly imposed Chinese Confucian-based education system that was made compulsory for all citizens, coupled with advances in wood-block printing technology, led to an explosion in the printed book industry that helped facilitate widespread literacy. Books were read for both pleasure and erudition and included titles on diverse subjects. Many of these were *ehon* (illustrated books) whose texts were vital to the meaning and appreciation of the imagery.[16]

The Japanese written language is comprised of native script and Chinese pictographs, which must be written out in a predetermined stroke order and with a proper sense of balance. Thus, diligent practice in writing during childhood instilled an intuitive appreciation for principles of design. In China, Korea, and Japan, calligraphy has long been considered a significant art form, alongside painting, whose tools (brush, ink, and inkstone) and brush techniques it shares. Although styles and lineages of professional calligraphers have proliferated in Japan, the fact that in pre-modern Japan education included writing practice with a brush enabled anyone so inclined to develop some proficiency at painting, however amateur. Indeed, for the upper classes, painting lessons comprised part of their basic education.

In China, Confucian tenets instructed scholars to master four scholarly pursuits: painting, calligraphy, playing *go* (a game of strategy), and playing the *qin* (a stringed instrument like a zither) for self-cultivation, not only for self-betterment but because such efforts imparted ethical values that benefitted society as a whole. In Japan, this mandate resulted in the emergence of informal and formal associations in which individuals studied the Confucian arts and also participated in a wide variety of other artistic pursuits, self-selected according to their own innate talents and inclinations, such as the tea ceremony, poetry writing, flower arranging, martial arts, ceramics making, sutra copying, and the carving of Buddhist sculpture and Nō theater masks. The influence of Chinese Confucian values encouraged the popularity of consciously amateurish styles of painting, in vogue especially during the eighteenth and nineteenth centuries. These originated with ideas developed by Japanese admirers of the Chinese literati, Confucian-trained scholars who, ideally, refused to sully their sage-like nature by painting for profit.

Plate 2-32 (above) *Writing box*, Muromachi period, late 15th–early 16th century. Black lacquer on wood with gold sprinkled powder (*makie*), height 9.4 cm, width 9.5 cm, length 23.5 cm. The Nelson-Atkins Museum of Art, Kansas City, Missouri. Purchase: William Rockhill Nelson Trust, 64–24. Photo: Joshua Ferdinand. Scattered amidst the rocks on the lid are several letters written in the native phonetic script (*hiragana*), indicating the hidden presence of a Japanese *waka* poem, understood when "reading" the text and pictures together.

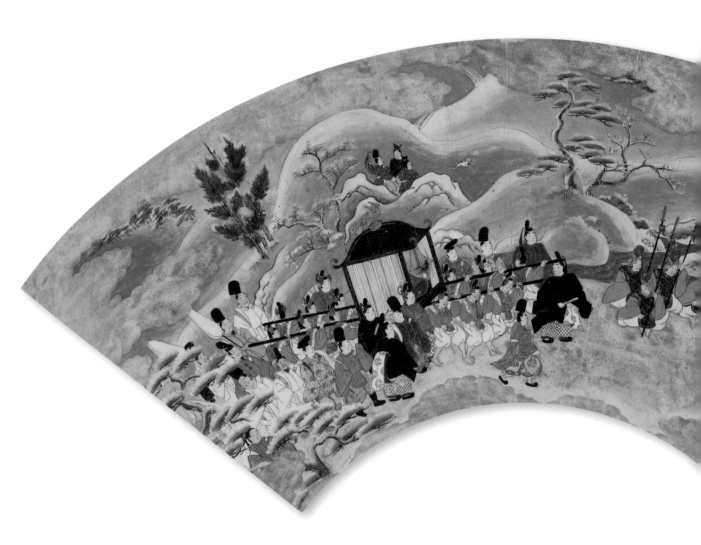

Plate 2-33 (above) Unidentified Artist of the Tosa School, *The Imperial Progress, from The Tale of Genji*, 17th century. Folding fan mounted as a framed painting, ink, color, gold pigment, powdered gold, and gold leaf on paper, 18.7 x 52.7 cm. Collection of John C. Weber. Photo: John Bigelow Taylor. *The Tale of Genji (Genji monogatari)* is a masterpiece of Japanese prose literature. Written around the year 1000 CE by Murasaki Shikibu, a lady-in-waiting to an empress, it depicts the world of a fictional prince, Genji, and by extension the privileged life of courtiers in Kyoto, Japan's imperial capital. Even without the accompanying literary passage, scenes from this novel were so familiar that every educated person could recognize the source.

Plate 2-34 (right) Yamanaka Shinten'ō
(1822–1885), *Landscape*. Hanging scroll,
ink on satin, 150 x 51.2 cm. Collection of
Gerald and Alice Dietz, Plano, Texas.
Shinten'ō was most famous in his lifetime
as a Confucian scholar and imperial
loyalist. He also painted consciously
amateurish landscapes inspired by those of
the Chinese literati, complete with poems
in Chinese, like the one on this painting
that expressed affection for the literati
proclivity of communing with nature.

Plate 2-35 (above) Kaihō Yūshō (1533–1615), *The Four Scholarly Pastimes*, late 16th–early 17th century. Pair of six-panel screens, ink, color, and gold leaf on paper, 162. 6 x 347.3 cm. The Nelson-Atkins Museum of Art, Kansas City, Missouri. Purchase: William Rockhill Nelson Trust, 60–13/1, 2. Photo: Jamison Miller.

Plate 2-36 (left) Kitagawa Utamaro (1753?–1806), *Snake and Lizard, from the picture book Selected Insects (Ehon mushi erabi)*, 1788. Two-page spread from a color woodblock printed album, 21.6 x 31.7 cm. The Minneapolis Institute of Arts. Gift of Louis W. Hill, Jr, P.75.51.130. The young and then relatively unknown Utamarō was hired by the up-and-coming publisher Tsutaya Jūzaburō (1750–1797) to create fifteen illustrations for this early anthology of playful and modern *kyōka* ("crazy verse") that parodied classical *waka* poetry. It was one of the earliest printed books to feature illustrations in color.

Plate 2-37 (below) Ōtagaki Rengetsu (1791–1875), *Summer Tea Bowl (natsu chawan)*, mid-19th century. Earthenware with overglaze slip and underglaze iron, 4.8 x 15.6 cm. Saint Louis Art Museum. Gift of J. Lionberger Davis, by exchange, 121:1988. Rengetsu was one of the few celebrated women artists of pre-modern Japan. As a youth, she studied calligraphy, *waka* poetry, and the game of *go*, which she later briefly taught. After the deaths of her husband and children, she became a Buddhist nun and began to make pottery on which she inscribed her own poems. She supported herself by selling these wares to customers who appreciated their unpolished, amateurish appearance and also enjoyed reading her poetry.

Plate 2-38 (right) Tanabe Chikuunsai I
(1877–1937), *Longevity Mountain*, 1932. Sooted
bamboo, lacquered bamboo, and rattan, 42.5 x
24 x 23.5 cm. Gift of Elizabeth and Willard Clark
to the Clark Center at the Minneapolis Institute
of Arts, 2013.30.21a,b. Chikuunsai, one of the
earliest and best bamboo artists in Japan,
specialized in innovations in basketry tech-
niques adapted from Chinese models. He
founded a school of *ikebana* flower arranging
that specialized in displays for Chinese-style
sencha tea ceremonies, which he also practiced.
Acclaim for his art internationally helped create
a booming market for Japanese bamboo arts
in the West.

Plate 2-39 (below) Genga (active early 16th
century), *Flowers and Birds in a Landscape*, ca.
1520. Pair of six-panel screens, ink, colors, and
gold on paper, 145.5 x 314.4 cm. Freer Gallery of
Art, Smithsonian Institution, Washington, DC.
Purchase, F1971.1–2. This is one of the earliest
known Japanese screen paintings to convey
awareness of the transience of time in its
juxtaposition of natural imagery of springtime,
on the right, with that of autumn, on the left.

6. Appreciation of Changing Seasons

The islands of Japan, now one of
the most industrialized, densely
populated places on earth, are even
today covered with an abundance of
lush forests, mountains, rivers, and
streams, and populated by many
species of indigenous animals, birds,
and insects. Pre-modern Japanese
literature is famous for its poignant
and descriptive allusions to nature.
Visual arts, architecture, and gardens
are equally renowned for their
sensitive use of natural materials,
especially wood, paper, grasses, plant
dyes, clay, bamboo, and lacquer;
and their arts brim with evocative
imagery of the creatures and radiant
features of the land. Many of these
references are seasonally specific,
which has led to generalizations that

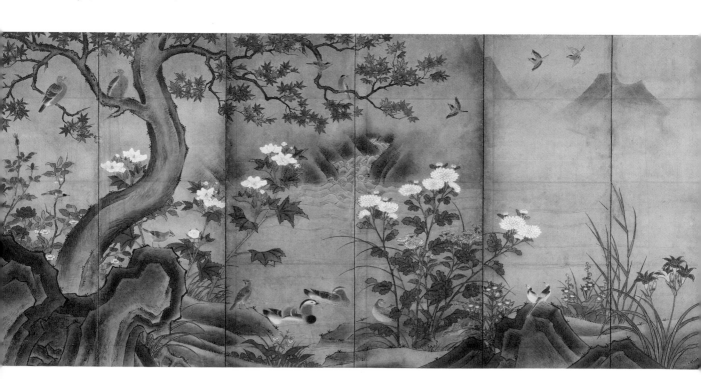

pre-modern Japanese citizens lived a life in tune with nature's cyclical rhythms, reflective of the country's relatively long spring and autumn seasons. This appreciation for nature is generally identified as deriving from attitudes imparted by the culture's religious traditions, both native (Shinto) and imported (Daoist and Buddhist).

Recently, such romanticized notions about the Japanese proclivity for nature have been reassessed.[18] Affection for nature has come to be regarded as a cultural construct, not a love of nature in its untamed form. Because the country's topography has limited the population centers to only about one-third of the land mass, regular encroachment on its wild terrain for resources people need to survive has caused serious ecological problems, such as the widespread deforestation of highly prized *hinoki* (cypress) wood used to construct the finest buildings and Buddhist statuary. The horrific events of the March 11, 2011 Tohoku region earthquake, tsunami, and nuclear power disaster, reveal an escalation of these long-standing conflicts between humans and nature.[19] Yet, it cannot be denied that Japanese crafts makers and designers possess a deep sensitivity in their handling of natural materials and are masters at evoking the beauty of the natural world, especially its seasonal permutations.

Plate 2-40 (below) *Flower vase with springtime ikebana flower arrangement.* Vase: Muromachi period, 15th–16th century, copper metal alloy. Flowers: *baimo* (a type of bulbous lily) and *yamabuki* (Japanese kerria; shrub of rose family). Photo: Kei Kondo, courtesy of Koichi Yanagi Oriental Fine Arts, New York. *Ikebana* is an art form whose roots can be traced to the ancient Buddhist practice of placing offerings of flowers to the Buddha on temple altars. During the fifteenth century, it began to evolve into a secular practice with various schools that taught standardized styles for flower arrangement. *Ikebana* celebrates the beauty of plants in a minimalist display, carefully orchestrated by the hands of its practitioners.

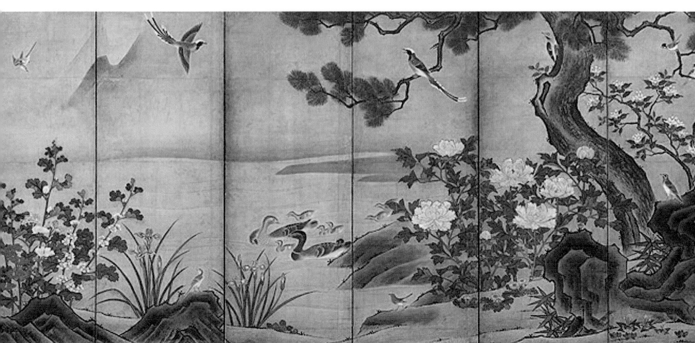

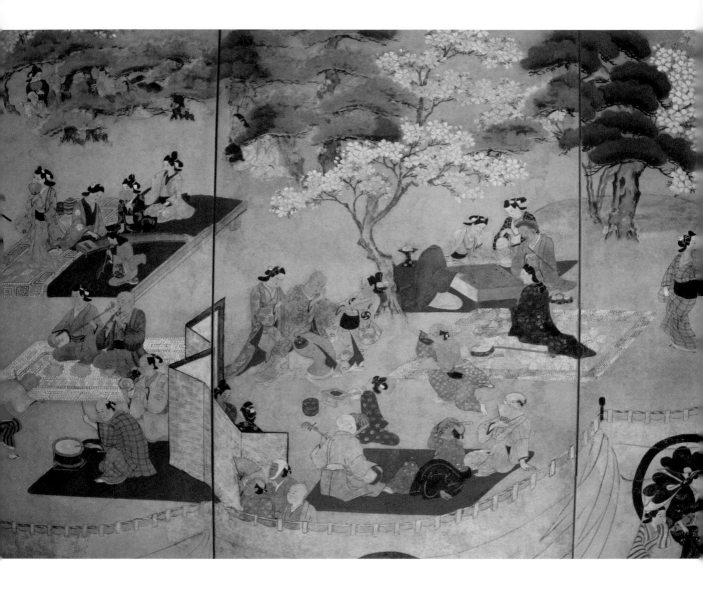

Plate 2-41 (above) Attributed to
Hishikawa Morohira (active 1704–1711),
Hanami (cherry blossom viewing parties).
Detail from one of a pair of six-panel
screens, ink, color, and gold leaf on paper,
93.8 x 242.6 cm. Feinberg Collection. As
evident in this screen, the blossoming
of cherry trees becomes an occasion to
suspend the activities of daily life and
gather under their boughs for gay
parties that include music, dancing and
the drinking of plenty of saké.

Plate 2-42 (opposite below) Taniguchi
Yoshio (b. 1937), *View of distant
mountains from the interior of the
Nagano Prefecture Shinano Art Museum*,
completed 1989. Photo: David M.
Dunfield, 2003. The water garden
alongside this starkly modern building
features a traditional "borrowed
scenery" (*shakkei*) technique that links
the building and its adjacent garden
through the screen of trees to distant
mountains beyond.

Plate 2-43 (below) *Gardeners at work in the gardens of Nijō Castle, Kyoto.* Photo: Patricia J. Graham, May 2005. The careful pruning of trees and grasses and the sweeping away of debris are ongoing tasks of gardeners in Japan. Although intensely mani-cured, Japanese gardens convey an impression of the sweeping grandeur and irregularity of nature.

Plate 2-44 (left) Sakai Dōitsu (1845–1913), *Mt Hōrai, Isle of the Immortals*. Hanging scroll, ink, gold, and color on silk, 99 x 32.4 cm. Collection of Gerald and Alice Dietz, Plano, Texas. Rinpa artist Dōitsu, disciple of Hōitsu (Plate 1-63) has placed a red sun in the center of the picture above a distinctive towering island floating in a sea, a representation of the legendary Daoist isle of the immortals, identified by the presence of cranes, a tortoise, and a cluster of pine, plum, and bamboo (all Daoist symbols of longevity). Mt Hōrai imagery has long appeared in various types of Japanese art, including mirrors, kimono, various objects of daily use, and as a rock feature in Japanese gardens.

7. Rituals Order Daily Life

As mentioned earlier in this chapter, Confucianism and Daoism influenced the development of Shinto and Buddhist ritual practices in Japan. Confucianism, an ethical creed, advocated values of respectfulness, honesty, diligence, and self-cultivation. It also apotheosized ancestors, whose favor was cultivated through acts of piety both in the home and at shrines and temples. Daoism emphasized complementary *yin* (female) and *yang* (male) forces of energy that emanated from the infinite void at the center of the universe, from which all matter appeared, and which governed the five elements (wood, metal, fire, water, and earth). Its practitioners performed complex rituals to assure personal protection, worldly benefits, and even immortality. Daoism, Confucianism, and other Chinese folk beliefs, together with aspects of Esoteric Buddhism and Shugendō (an indigenous Japanese hybrid Buddhist belief system based on shamanistic folk practices drawn from Shinto and Daoism), contributed to the development of a set of native Japanese ritualistic practices known as Onmyōdō, the "Way of yin-yang," that featured rites for personal and national protection, fortune-telling, setting of the calendar, and talismans, for example, *ōtsue* pictures (see Plate 1-52).[20]

Very early in Japanese history, the systematic celebration of festivals throughout the year and

personal religious practices were devised to guarantee purification and protection of individuals, local communities, and the nation. Some seasonal festivals are religious, others only marginally so. Some are celebrated nationally, while others take place at individual temples and shrines in specific geographic regions. In accordance with these cyclical events, people make sure that the decorations in their homes and workplaces and their personal accoutrements and clothing carry appropriate symbolic imagery.

Some symbols derive from nature—birds, trees, flowers, and insects—codified as seasonally specific in *waka* poetry—and others come from objects of the manmade world that are associated with specific festivals. Not all imagery is seasonally specific, however. Some represents deities or auspicious plants that offer protective benefits year round, for example, the Seven Gods of Good Fortune (*Shichi Fukujin*).[21]

The timing of annual observances required an accurate calendar, which the Japanese adopted from China in the early seventh century. Based on Daoist cosmology, the calendar adopted mixed lunar and solar calendars. Twelve months, corresponding to the phases of the moon, comprised each lunar year. According to the solar calendar, years, and individual days, were designated by a complex Chinese system of combining ten "stems" (*jikkan*; the five elements in *yin* and

Plate 2-45 (above) *Nail head cover in the form of the fungus of immortality, private residence Japan*, mid-19ᵗʰ century. Bronze, length ca. 12 cm. The fungus of immortality (*reishi*) is a Daoist symbol, usually represented as seen here by a cluster of wild mushrooms. Daoists believe the ingestion of this plant conferred long life. As such, it is an appropriate emblem to adorn the wall of a Japanese home, where its presence would help protect the residents from disease.

Plate 2-46 (below) Attributed to Kanaya Gorosaburō III (active 1772–1781), *Rabbit-shaped screen holders*,18ᵗʰ century. Bronze, height 11.4 cm, length 12.7 cm. Photo courtesy of Toyobi Far Eastern Art. Rabbits are a popular motif in art because of their auspicious meanings. They are one of the twelve zodiac animals and are popularly thought to inhabit the moon, where they pound rice to make an elixir of immortality.

yang aspects) and twelve "branches" (*jūnishi*; the twelve animals of the zodiac—mouse, ox, tiger, rabbit, dragon, snake, horse, sheep monkey, cock, dog, and boar). Chinese Daoist cosmology influenced beliefs about certain combinations of these elements, and days designated as auspicious or unlucky required the holding of special rites. This cumbersome system was formally

abolished only in 1873 when Japan adopted the Gregorian calendar.

The diversity of Japanese festivals and their transformation over time reveals the complex cultural forces that have shaped Japanese society. Since the Heian period (794–1185), the most important annual festivals are those that owe their origin to Daoist shamanistic rites that marked the five *sekku* (dates marking

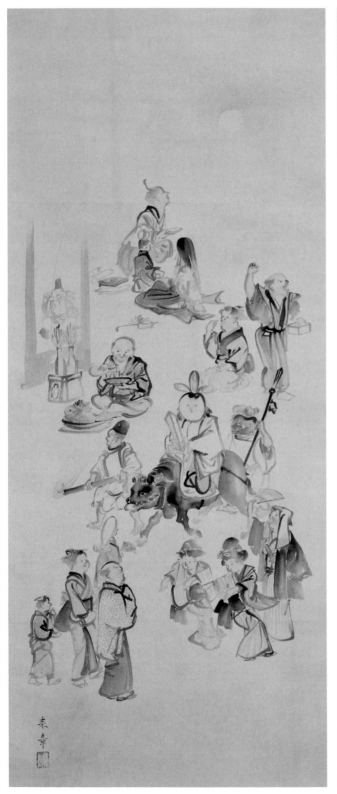

Plate 2-47 (right) *Men hoisting a mikoshi during the Mifune festival in Arashiyama.* Photo: David M. Dunfield, May 1981. During many Shinto festivals, *kami* leave their homes within the shrines to mingle with devotees but remain unseen within the portable shrines (*mikoshi*).

Plate 2-48 (left) Nakajima Raishō (1796–1871), *Annual Festivals of Kyoto.* Pair of hanging scrolls, ink and color on silk, each 99 x 41.8 cm. Collection of Gerald and Alice Dietz, Plano, Texas. Raishō illustrates the five *sekku* festivals on the right. From lower right to upper center these are New Year's dancers by a pine tree display, the third month's doll festival, boys dressed as samurai for boy's day in the fifth month, a man and boy carrying bamboo streamers for the Tanabata festival in the seventh month, and a woman scenting a kimono hung on a rack with chrysanthemums for the chrysanthemum festival in the ninth month. (The festival associated with the woman with flowers in a basket atop her head at upper left remains unidentified although she may represent a dancer in a Tanabata parade.) The left scroll features an assortment of other annual festivals: the autumn moon viewing festival at upper center, dancers participating in the summertime festival to the dead (*obon*) at lower left with a group of spectators gazing skyward to their right to watch the burning of a mountain during the Daimonji festival at the end of the *obon* season (to help ancestral spirits find their way back to the spirit world), the ninth month bull festival at Kōryuji at center, the Setsubun bean throwing festival to ward off evil spirits on the last day of the year at upper right, and the first month's festival dedicated to Ebisu, one of the Seven Gods of Good Fortune, at upper left.

seasonal passages). These dates— 1/1, 3/3, 5/5, 7/7, and 9/9—derived from belief in the power of multiple emanations of certain numerals.[22] At first reserved for the court, by the sixteenth century, as commoner culture blossomed, these rituals had evolved into popular national festivals.

Shinto shrine festivals (*matsuri*) feature purification rites. Central to these are festive components, often exuberant occasions for wild abandon. Some *matsuri* reflect the faith's agrarian origins and celebrate springtime planting and autumn harvests. Others emerged as society became more urbanized, to meet the needs of urban dwellers, for example, those to ward off summertime plagues or to offer prayers for

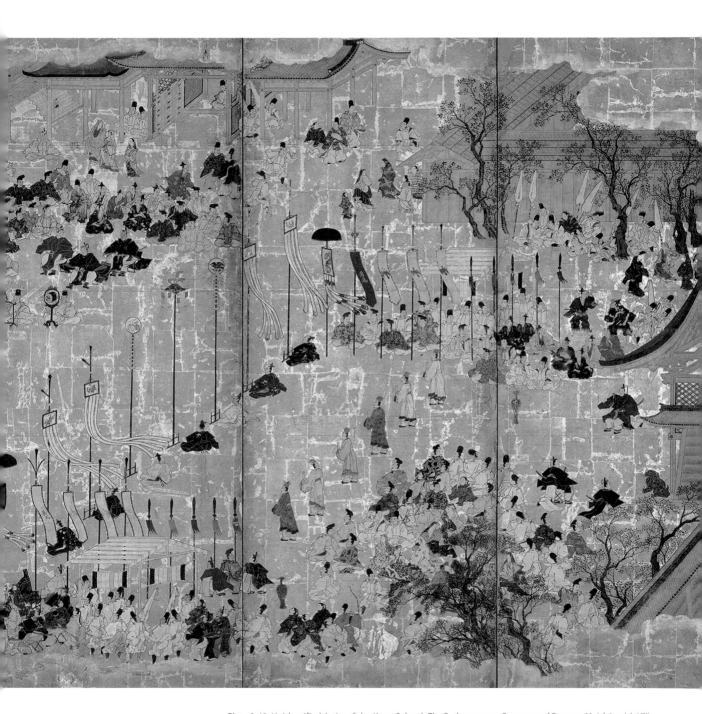

Plate 2-49 Unidentified Artist of the Kano School, *The Enthronement Ceremony of Empress Meishō*, mid-17th century. One of a pair of six-panel screens, ink, color, and gold leaf on paper, 151.1 x 345.4 cm. The Nelson-Atkins Museum of Art, 78-12/1. Photo: Mel McLean. Chinese court rituals, introduced in the sixth century, influenced the development of Japanese Shinto-based imperial rites. The ascension ceremonies for an emperor (or more rarely, an empress), heir to the Shinto sun goddess, were conducted for the benefit of both the Shinto spirits and the people of Japan. This screen gives some indication of the regality of the occasion and epitomizes the opulent aesthetic of *karei*.

Plate 2-50 Kinoshita Yuri, *Shinpu (fresh breeze), woven tea house*, 2011. Bamboo, wood, linen paper and *kozo* paper. Photo: Masaye Nakagawa. The artist, whose Kyoto family has long produced fine kimono fabrics, is now a Seattle-based lighting designer who aims to create what she describes as "woven light." The photograph shows a tea ceremony being performed in her portable tea house on display at the Bellevue Arts Museum, Bellevue, Washington, January 2013.

Plate 2-51 *One course of a formal kaiseki meal, Mankamero Restaurant, Kyoto*, May 2003. Photo: Nicole Hipp. The Japanese ritualize the experience of dining in its *kaiseki* cuisine, which consists of a number of courses served in small dishes on elegant trays. The menu changes with the seasons and the courses comprise a balance of food preparation methods, tastes, and colors.

Plate 2-52 (opposite top) Unknown Artist, *Presentation of the Demon's Head to the Emperor, the final episode of The Demon of Oeyama (Ōeyama Shuten Dōji)*, early 18th century. Handscroll, ink and colors on paper, 30.3 x 506.5 cm. Collection of Gerald and Alice Dietz, Plano, Texas. A popular legend recounts how, in the eleventh century, a giant ogre and his band of marauding cronies wreaked havoc on villages near Kyoto. The emperor dispatched a warrior and his five retainers to quell the beast. In this triumphant scene, after decapitating the creature they carry its head back to Kyoto for presentation to the emperor. Illustrated many times over the centuries, this satirical version features mice as the samurai and a cat as the demon.

Plate 2-53 (opposite bottom) Utagawa Hiroshige (1797–1858), *The Night Attack, Part 3: Achieving the Goal (Youchi san, honmō), from the series The Storehouse of Loyal Retainers (Chūshingura)*, ca. 1840. Horizontal *ōban* colored woodblock print, 25.6 x 36.6 cm. The Art Institute of Chicago, Frederick W. Gookin Collection, 1939.1336. This print portrays the most famous and heroic act of selfless bravery in Japanese history that took place on a snowy night in the year 1703 when a group of forty-seven samurai, whose master had been wrongly forced to commit *seppuku* (ritual suicide), attacked and killed the deed's perpetrator. Afterwards, the *rōnin* (masterless samurai) who participated in this vendetta were sentenced to *seppuku* themselves.

successes in commerce. Buddhist festivals celebrated universally by all sects include the birth, enlightenment, and death dates of the historical Buddha Shaka. In all cases, festivals reinforce communal solidarity.

The importance of ritual in Japanese life has also imprinted itself on the structure of many facets of secular culture, from the tea ceremony to martial arts practices, other etiquette-based aesthetic arts, and even the preparation and service of Japanese cuisine.

8. Penchant for Emotional Extremes

Perhaps because of the decorous and formal nature of much of Japanese religious and secular life, the need for relief from tensions accrued by adherence to demands of a tight-knit social order abound and are manifested in expressions of both violence and humor. Japanese literature overflows with stories of these very human emotions, the earliest of which appear in Shinto's creation myths that envisioned Shinto *kami* as temperamental and prone to emotional outbursts. Described as passionate, hateful, greedy, needy, vulnerable, generous, protective, loving, playful, and boisterous, their characters mirrored those of the Japanese people themselves. Later historical tales of military exploits recounted bloody battles in chilling detail, emphasizing vivid descriptions of treachery and often valorizing the tragic, noble heroes of those on the losing side. As with the popularity of horror movies in today's world, ghost tales that became especially popular in the

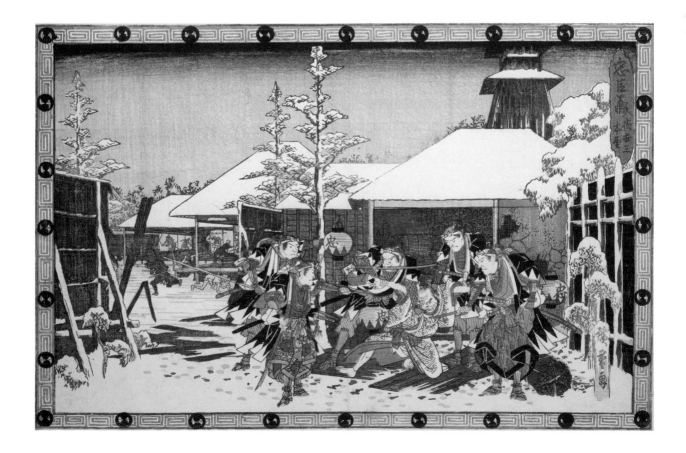

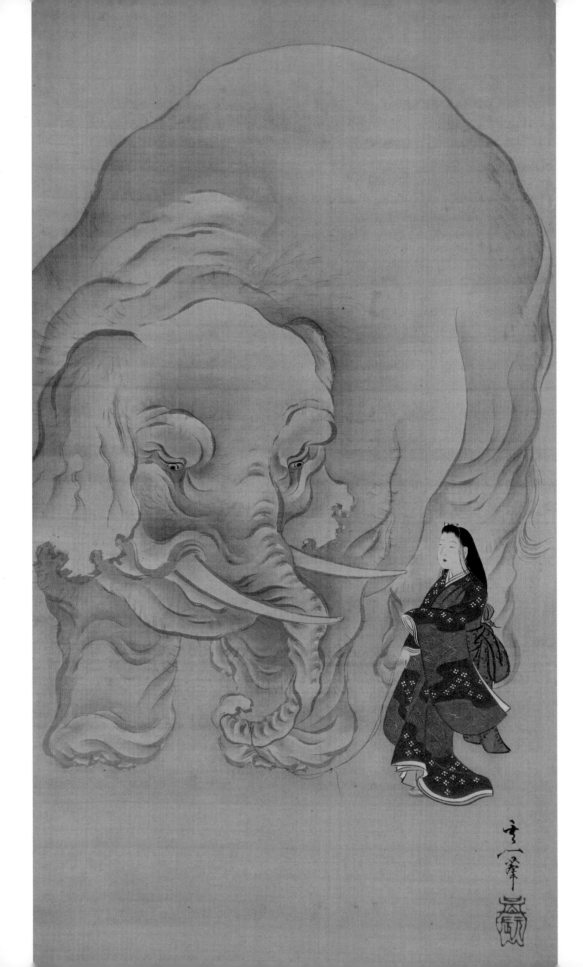

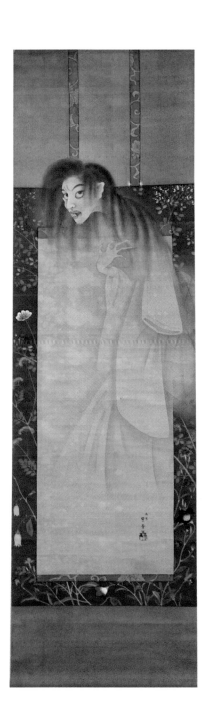

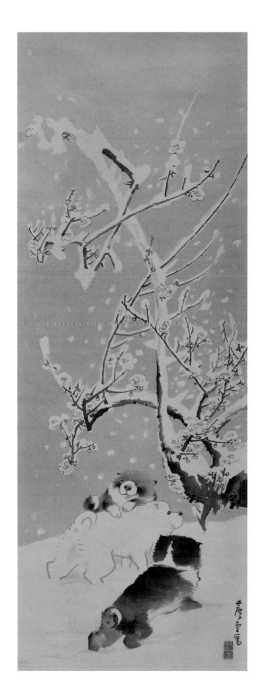

Plate 2-54 (left) Suzuki Kisei (active 1850–1860), *Female Ghost Coming to Life Out of a Painting*. Hanging scroll, ink and light color on silk with a painted mounting, 164.5 x 47.5 cm. Collection of Gerald and Alice Dietz, Plano, Texas. The Japanese believe that when a person dies violently, without reconciling emotional distresses or without having proper funeral rites performed on their behalf, their spirits return to earth as ghosts (*yūrei*) intent upon righting these wrongs. This painting, with its painted mounting, is representative of a genre of ghost paintings created in the nineteenth century that feature the ghost seemingly emerging from the painting.

Plate 2-55 (right) Nagasawa Rōsetsu (1754–1799), *Puppies Playing in the Snow Under a Blossoming Plum Tree*. Hanging scroll, ink and light color on silk, 98.8 x 36 cm. Collection of Gerald and Alice Dietz, Plano, Texas. Puppies playfully frolicking in the snow is a popular subject in Japanese art.

Plate 2-56 (opposite) Suzuki Kiitsu (1796–1858), *The Courtesan Eguchi no Kimi Roping a Giant White Elephant*. Hanging scroll, ink and color on silk, 76.9 x 37 cm. Collection of Gerald and Alice Dietz, Plano, Texas. Eguchi no Kimi was a twelfth-century courtesan who ran a brothel where the poet-priest Saigyō desired to stay the night during his wanderings. The two exchanged a series of erotic and religious-tinged poems when she refused his admission. These later became the basis for a Nō play in which Eguchi no Kimi was portrayed as an incarnation of the Buddhist Bodhisattva Fugen. Humorous adaptations of the subject generally portray the courtesan riding atop an elephant, Fugen's avatar, but in a comic twist she is here shown in diminutive form leading the giant, meek elephant with a slender rope made of strands of her own fine hair.

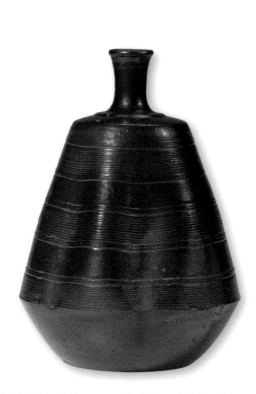

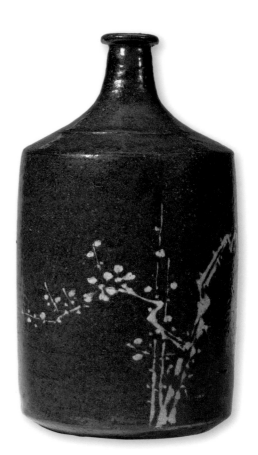

Plate 2-57 (above) *Bizen ware umbrella-shaped saké bottle*, late 17th century. Unglazed stoneware, 23.8 x 17.1 cm. The Nelson-Atkins Museum of Art, Kansas City, Missouri. Purchase: William Rockwill Nelson Trust, 32–58/10. Photo: Tiffany Matson. Bizen ware is most famous for its tea ceremony vessels, but potters there also made objects for everyday use, such as this fancifully shaped bottle.

Plate 2-58 (above) *Yatsushiro ware saké bottle with inlaid slip design of a plum branch*, late 17th–early 18th century. Glazed stoneware with inlaid white slip, 30.5 x 16.5 cm. The Nelson-Atkins Museum of Art, Kansas City, Missouri. Purchase: William Rockwill Nelson Trust, 32–59/7. Photo: Tiffany Matson. The large size and sophisticated design of a plum branch (a Chinese symbol of purity) on this piece suggests that the intended client admired Chinese literati values.

beginning of the seventeenth century appealed to people's visceral fears. In contrast are varied expressions of humor, ranging from ribald to erudite.[23]

9. Distinctions in Local and Regional Culture

Although Japan is a small nation, it has given rise to a multitude of local artistic traditions which depend on the availability of raw materials, reflect local customs, and rely on the special characteristics of each region's topography. Some arts arose as money-making schemes of the local samurai overlords. Others reflect the ingenuity and teamwork of entrepreneurial individuals and groups of villagers. Often whole towns have pooled their collective efforts to create distinctive products marketed regionally, nationally, or even internationally.

One of the most telling examples of regionalism in the arts is the wide variation in the appearance of ceramic bottles (*tokkuri*) for storing and serving saké (rice wine). Since the Edo period, they have been widely produced by local kilns, made to order for local saké brewers in standardized sizes to facilitate measuring the liquid into bottles that would be filled at these brewers' factories. Availability of locally

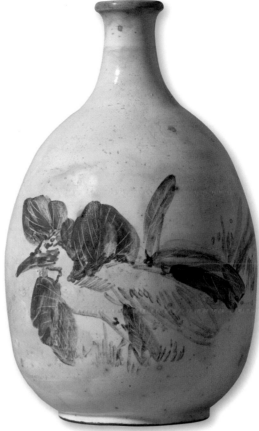

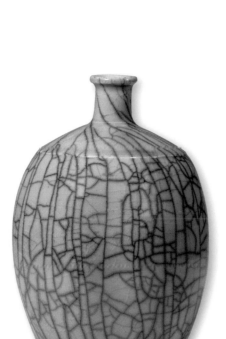

Plate 2-60 (left) *Tanba ware saké bottle with design of a heron, flowering plants, and a poem*, first half 19th century. Stoneware covered with white slip, underglaze blue, and clear glaze, 32.7 x 20.3 cm. The Nelson-Atkins Museum of Art, Kansas City, Missouri. Purchase: William Rockwill Nelson Trust, 32-58/5. Photo: Joshua Ferdinand. This stoneware bottle, designed for use by commoners, was clearly meant to resemble more refined and expensive blue and white porcelains made for more wealthy consumers. Yet, its rugged shape and unpolished painting style marks it as a *mingei*-style vessel.

Plate 2-59 (above) *Arita or related ware saké bottle with slightly pinched sides*, 18th century. Porcelain with crackled celadon glaze, height 22.5 cm. The Nelson-Atkins Museum of Art, Kansas City Missouri. Purchase: William Rockwill Nelson Trust, 32–59/4. Photo: Tiffany Matson. As a result of a booming interest in Chinese culture from the late eighteenth century on, Japanese potters closely emulated Chinese ceramic styles and techniques. One Chinese glaze particularly popular in Japan was celadon, here applied thickly and augmented with large crackles in imitation of Chinese prototypes.

sourced raw materials, the income levels of the consumers for whom they were made, and concomitant differences in taste account for their diverse appearances. The bottles illustrated here come from a large collection of about sixty assembled in 1932 by Langdon Warner (see page 144) together with famed dealer Yamanaka Sadajirō (1865–1936) for the Nelson-Atkins Museum of Art, possibly the largest such collection

Plate 2-61 (right) *Onda ware gourd-shaped saké bottle with wave design*, late 18th–early19th century. Stoneware with freehand slip-trailed design and shiny brown glaze, height 26.67 cm. The Nelson-Atkins Museum of Art, Kansas City, Missouri. Purchase: William Rockhill Nelson Trust, 32–58/14. Photo: Tiffany Matson. Potters in the village of Onda began production in the early eighteenth century and their descendants still create similar wares today. Originally made for local rural residents, under the influence of Yanagi Sōetsu (see page 138), Onda ware later became avidly sought after by collectors of *mingei* ceramics.

in the United States. Warner probably bought the whole collection because of his interest in illustrating the wide variety of design and technical possibilities in a particular art form.

10. Fashion Consciousness Inspires Innovation

Many Japanese artists and designers, both past and present, have not only been highly talented but also great entrepreneurs, who create well-designed products to satisfy

seemingly insatiable consumer desires to be fashionable, captured in the word *iki* (the height of chic, discussed on pages 24–7). This fashion consciousness has long influenced the appearance of many types of arts, especially those associated with the élite members of society and urban commoners, for whom the urgency to appear up to date drives their choices of furnishings for their homes, compels them to construct structures that befit their status, and to wear attire

that confers upon them an air of cosmopolitanism and sophistication. Often, this fashion consciousness is derived from appreciation for exotic foreign products. Due to the limited availability and high costs of many imported goods, and to adapt these to native preferences in taste, Japanese artists and designers have long been adept at modifying imported products for their own uses, whether they be Chinese, Korean, or Western. To do so, they often master complex foreign

Plate 2-62 (below) *Warrior's hat (jingasa) with crest of the Nabeshima warrior clan*, late 18th–early 19th century. Lacquered wood, mother-of-pearl inlay, diameter 42 cm. The Nelson-Atkins Museum of Art, Kansas City, Missouri. Purchase: William Rockwill Nelson Trust, 32–202/23. Photo: Jamison Miller. Although high-ranking warriors went into battle and also attended ceremonial processions wearing elaborate lacquered iron helmets (see Plate 1-38), they and their foot soldiers would wear flatter or peaked caps like this in their camps and during peacetime ceremonies and processions. It is a finely designed work of art, reflective of the fashion consciousness of the samurai class.[24]

Plate 2-63 (above) Attributed to Fujiwara no Nobuzane (1176?–1265?), *Portrait of the Poetess Saigū no Nyōgo Yoshiko, from a set of images of The Thirty-six Immortal Poets*, 13th century. Hanging scroll, ink and color on paper, 27.9 x 51.1 cm. Freer Gallery of Art, Smithsonian Institution, Washington, DC. Purchase, F1950.24. The poetess wears the voluminous and resplendent twelve-layered robe (*jūni hitoe*) fashionable among court ladies of the Heian period that engulfs her in colors emblematic of the seasons, referencing *waka* poetry of the period. Production of the multicolored hues of her garment was a technological feat of dyers working secretly in private households, whose ladies vied with each other to be seen in garments of the most alluring and novel shades.

Plate 2-64 (left) *Kosode (small sleeve robe) with scenes of famous places of Kyoto*, second half 18th century. Blue silk ground with paste-resist dyeing, silk and metallic thread embroidery, 157.5 x 119.4 cm. The Nelson-Atkins Museum of Art, Kansas City, Missouri. Purchase: William Rockwill Nelson Trust, 31-142/14. Photo: Tiffany Matson. During the eighteenth century, Kyoto, the old imperial capital, had become a popular tourist destination, resulting in a fashion for portraying famous sites of the city on women's robes.

Plate 2-65 (below) *Chokuan ware tea set, Kaguyama, Nara Prefecture*, ca. 1940. Unglazed "Haniwa ware" stoneware with rice straw scorch marks. *Kyūsū* (side-handled teapot), height 7 cm, diameter 9.5 cm; five teacups, height 4.5 cm, diameter 7.5 cm; *yusumashi* (water cooler; a spouted dish into which boiling water from the kettle is poured to cool before dispensing it into the teapot) Private Collection, USA. Following the rise in popularity of the Chinese-style *sencha* tea ceremony after the invention of the delicately flavored *gyokurō* ("jade dew") tea in 1835, a new craze for drinking steeped green leaf tea in the nineteenth century ensued and set off a revolution in the world of ceramic production in Japan. Throughout the country, potters began fabricating tea sets in great numbers, many, as here, in unglazed native Japanese styles.

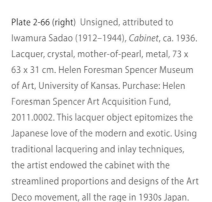

technologies. Sometimes new technology allows for faster production processes, larger and more complicated structures, or simply improves the appearance of the final product, making it more competitive in the marketplace. Japanese consumers today are famous for their love of high fashion and for products that make use of the latest technology. Continual demand by consumers for innovative products helps drive the nation's success in many technically challenging, design-oriented industries in world markets, including electronics, computers, automobiles, architecture, fashion, and graphic and industrial design.

Plate 2-66 (right) Unsigned, attributed to Iwamura Sadao (1912–1944), *Cabinet*, ca. 1936. Lacquer, crystal, mother-of-pearl, metal, 73 x 63 x 31 cm. Helen Foresman Spencer Museum of Art, University of Kansas. Purchase: Helen Foresman Spencer Art Acquisition Fund, 2011.0002. This lacquer object epitomizes the Japanese love of the modern and exotic. Using traditional lacquering and inlay techniques, the artist endowed the cabinet with the streamlined proportions and designs of the Art Deco movement, all the rage in 1930s Japan.

CHAPTER THREE
EARLY PROMOTERS OF "ARTISTIC JAPAN" 1830s–1950s

Japan's arts and crafts first became widely collected in the West during the nineteenth century and simultaneously exerted influence on artists, crafts makers, and designers in diverse fields. This initial wave of interest increased significantly after the Americans forcibly opened the country to international trade in 1854, and continued to impact attitudes towards Japanese design through the early post-World War II years. The striking designs on Japanese arts, with imagery of the natural world or featuring vignettes from everyday life, were widely lauded for their abstract, asymmetrical and dynamic compositions, and bold color palette, as well as their fine craftsmanship and sensitivity to the use of raw materials. These arts inspired the Arts and Crafts and Art Nouveau movements, and facilitated creation of a broad new aesthetic inspired by Japan-derived design, known by the French term Japonisme. Writers, both Western admirers and Japanese nationals, played

a pivotal role in promoting Japan and its arts. Some considered linkages between Asian/Buddhist spirituality and aesthetics as paramount. Others emphasized the novel designs of Japanese arts, which became catalysts for new ideas about principles of modern design that eschewed references to rigid historical styles. At the same time, Japanese writers familiar with Western appreciation of their art forms began to promote their country's arts in the West to help their nation better define its cultural identity in the global arena.

The Western individuals who served as arbiters of taste for Japan's aesthetics and design during this formative period gained their newfound knowledge via various routes. Some had journeyed to Japan to work for the Japanese government as technical experts or professors at newly founded universities, as adventurers or entrepreneurs, or in the service of foreign governments or foreign trading companies. Others simply

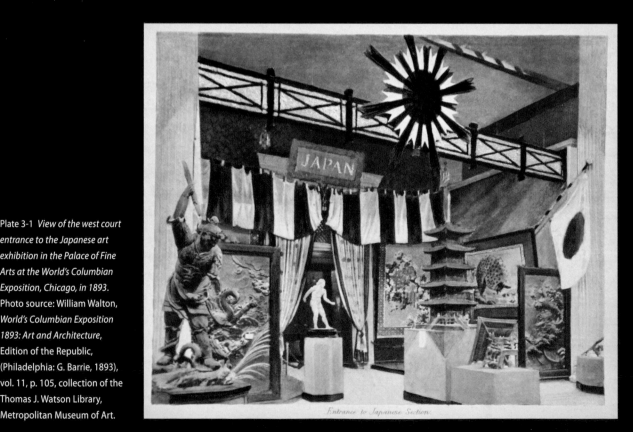

Plate 3-1 *View of the west court entrance to the Japanese art exhibition in the Palace of Fine Arts at the World's Columbian Exposition, Chicago, in 1893.* Photo source: William Walton, *World's Columbian Exposition 1893: Art and Architecture,* Edition of the Republic, (Philadelphia: G. Barrie, 1893), vol. 11, p. 105, collection of the Thomas J. Watson Library, Metropolitan Museum of Art.

went as tourists, for stays often of several months' duration, to see the sites and collect Japanese art at the source. The tales, images, and objects they brought back fueled the interests of those at home, whose own exposure to the culture derived from the widespread availability of Japanese arts at a multitude of venues in their respective countries. Phillip Franz von Siebold (see p. 124 below), in Japan in the 1820s and whose writings on Japan date from the 1830s, was the first influential Western writer and collector.

Several decades after Siebold's return, a public display at the 1862 London International Exposition of the Japanese arts collection amassed in Japan by Sir Rutherford Alcock (1809–1897), greatly stimulated fascination with the country's arts in Europe. Alcock, who served in Japan from 1859 as Britain's first official minister and who later, in 1878, authored a book about Japanese arts, was one of several Englishmen to write on the subject in the 1870s and early 1880s.[1] Two others, Thomas W. Cutler (d. 1909) and George Ashdown Audsley (1838–1925), were both architects who each published deluxe limited edition volumes about Japanese fine and decorative arts aimed at discerning collectors.[2] Cutler's book, *A Grammar of Japanese Ornament and Design* (1880), featured short introductions and many illustrations to Japan's varied arts, arranged by media. He apparently labored over the manuscript for eighteen years. It was intended to update, with emphasis on Japanese design, the influential landmark publication, *A Grammar of Ornament* (1856), by another British architect, Owen Jones (1809–1874), one of the great reformers of the British design movement in the mid-nineteenth century. Audsley's book, *The Ornamental Arts of Japan* (1882), covered much of the same material as Cutler's, with some additional categories of decorative arts (paintings, textiles, embroidery, lacquers, cloisonné enamels, encrusted work, metalwork, carved and terracotta modeled sculpture, and heraldry) featured in gorgeous

Plate 3-2 *Section of a silk brocade*. Described as probably woven in Kyoto in the early 18th century and used as an *obi*. Photo source: George Ashdown Audsley, *The Ornamental Arts of Japan* (London: Sampson Low, Marston, Searle & Rivington, 1882), collection of the Thomas J. Watson Library, Metropolitan Museum of Art, vol. 1, Section Third, plate XI. Textiles were among the most popular of all Japanese arts among early Western collectors, who marveled at their designs and complex production techniques. This example from Audsley's book was one of many owned by the Parisian collector/dealer Siegfred Bing (see p. 122).

full page color plates. Both were highly personal accounts that were based on second-hand sources, not scholarly texts, and both were lavishly illustrated.[3] The detailed factual information included in these and other books of this period was transmitted to the authors from Japanese advisers, chief of whom were Hayashi Tadamasa (1851–1906) and Wakai Kenzaburo (d. 1908), who both came to Paris for the 1878 Exposition Universelle as staff of the Japanese

government's art exporting company, and who stayed on afterwards as private art dealers.

Japanese government-sponsored displays and sales galleries in the halls of the international expositions were among the most popular places where the public could see Japanese arts. These had begun with the Paris Exposition Universelle of 1867, where the samurai lord of the Satsuma domain, not the central government, had sponsored the exhibition of Japanese materials. Among the many fairs in which the Japanese later participated, undoubtedly it was the 1893 World's Columbian Exposition in Chicago that became a watershed moment for the Japanese because, for the first time, the Japanese government had received permission to display art by the country's pre-eminent artists in the Palace of Fine Arts, not in the building designated for displays of industrial arts, an honor accorded to no other non-Western nation.[4]

Concurrent with the expositions, both Japanese and foreign entrepreneurs began to open privately run commercial establishments to sell Japanese arts and crafts in major cities across Europe and the United States. Exhibitions of Japanese arts and crafts at esteemed European and American art museums soon followed, organized by both foreign and Japanese curators. Interest in educating the public about design was, in fact, the early mission of major art museums in the West, including the Victoria and Albert Museum in London, the Metropolitan Museum of Art in New York, and the Museum of Fine Arts Boston. These museums sought to collect art that served as models for artists and designers, and Japanese arts, highly admired for their novel and arresting designs, were collected by museums for this purpose. At first these museums showcased objects, including loans, gifts and bequests from private individuals, as well as from museum purchases, but in the 1930s, as cultural diplomacy before the outbreak of World War II, the Japanese government sponsored three major

exhibitions of Japanese National Treasures abroad, at the Museum of Fine Arts Boston (1936, in celebration of the Tercentenary Celebration of Harvard University), at the Pergamon Museum in Berlin (1939), and at the Golden Gate International Exposition in San Francisco (1939).[5] These landmark exhibitions were all organized by the influential Society for International Cultural Relations (Kokusai Bunka Shinkōkai or KBS), a semi-independent agency that received money from the Japanese Foreign Ministry.[6]

This chapter describes twenty-eight individuals and the influential texts they authored, which introduced the West to Japanese aesthetic and design principles from the 1830s to the 1950s. Writings of the early post-war period are included here because many writers active in the early part of the twentieth century continued to publish until then. The biographies of these individuals are presented within groupings defined by their professions or fields of expertise to provide a sense of how their perceptions about what aspects of Japanese design they considered the most significant were influenced by their professional training. Within these categories, the biographies are presented chronologically according to their year of birth. This admittedly subjective selection represents an attempt to identify those whose writings were broadest and most influential in their own day. Some of the names will be familiar and others may not. My selection omits authors whose impact was limited because of the nature of their publications (such as the early writers discussed above who authored only expensive limited edition publications), who did not hold themselves out as experts and produced only brief articles and reviews in popular magazines or newspapers, who penned mainly narrowly focused studies on particular art forms or individual artists, exhibition, private collection, or museum collection catalogues, and official Japanese government publications (on Japanese arts exhibited at international

VANTINE'S CURIO ROOM—NEW YORK

Plate 3-3 (left) *Vantine's Curio Room, New York*. Postcard, featuring a variety of Japanese wares for sale, ca. 1900. A. A. Vantine & Co., one of the most successful mercantile establishments to sell imported Japanese goods, had its main showroom at 5th Avenue and 39th Street in New York City. The company was founded around 1866 and remained in business through the 1920s. It billed itself as "the most interesting store in the world ... an ever-changing exposition of antique and modern works of art from each nook and corner of Japan, China, Turkey, Persia, India, and the Holy Land."

ARTISTS AND ART PROFESSORS

John La Farge (American, 1835–1910)

Born in New York City to French parents and raised bilingually, La Farge was one of the earliest and most influential American artists to introduce Japanese design and aesthetics to the West through his writings and lectures, and through its influences on his own art, including painting, murals, and stained glass. He probably became aware of Japanese art while living in Paris in 1856 with a cousin, whose friends included Philippe Burty (p. 140) and Theodore Duret (p. 141). There, he made his first purchase of Japanese

art, an illustrated woodblock book by Katsushika Hokusai (1760–1849). La Farge is distinguished for authoring the first published essay on Japanese art by a Western painter, in 1870.[7] In it he interspersed his own observations on the distinctive design qualities of Japanese art with those of earlier writers, emphasizing four important characteristics: a bird's eye perspective for defining depth, love of caricature, compositions emphasizing asymmetrical "occult balance," and harmonious and natural use of colors.[8] Most importantly, he recognized that the genius of Japanese artists as designers lay in their successful blending of two opposite aesthetics of abstraction and realism.[9] La Farge collected and read Western language books about Japan, among them *Japanese Homes and Their Surroundings* by Edward Sylvester Morse (p. 125), in preparation for a trip to Japan in 1886 with his friend, the distinguished writer Henry Adams (1838–1918). Adams and La Farge traveled to Japan "as seekers of nirvana"[10] (Buddhism's escape from reincarnation), though more practically, La Farge sought inspiration for a church mural commission back home. They had as guides the two most famous Bostonian Buddhists, Ernest Fenollosa (p. 134) and collector Dr William Sturgis Bigelow (1850–1926), cousin to Adam's wife. While there, La Farge also met Okakura Kakuzō (p. 136), who tutored him in Chinese spiritual philosophies of Daoism and Confucianism.[11]

Plate 3-4 John La Farge (1835–1910), *Portrait of Our Landlord, the Buddhist Priest Zenshin San, at the Door of the Clergy House, Iyemitsu Temple, Nikko*, 1886. Watercolor and gouache over graphite on off-white woven paper, 22.4 x 25.1 cm. Collection of Bill and Libby Clark. La Farge sketched and painted many watercolors during his stay in Japan.

Plate 3-5 Attributed to Kubota Beisen (1852–1906), *Patrol in China*, 1894–1895. Original drawing, ink and watercolor on paper, sheet 24.1 x 33 cm. Saint Louis Art Museum. Gift of Mr. and Mrs. Charles A. Lowenhaupt, 867:2010. Kubota Beisen, whom Frank Brinkley (p. 132) also admired, was a Kyoto native who moved to Tokyo to work as a journalist-illustrator for a popular newspaper, which sent him to the Sino-Japanese War (1894–1895) front, from which he produced illustrated stories of the battles. His sketches, such as this one, served as models for woodblock prints inserted into the newspaper. Beisen's mastery of sketching from nature is evident in this drawing.

The trip also turned La Farge into an avid collector of many types of Japanese arts, including books of designs for fans, stencils (*katagami*), textile fragments, ceramics, lacquers, woodblock prints, sword guards, and Buddhist paintings. La Farge later reflected on his lifelong attraction to Japanese art in his 1890 book, *An Artist's Letters from Japan*.[12]

Henry Pike Bowie (American, 1847–1920)

Born in Annapolis, Maryland, and raised in San Francisco, Bowie graduated from university there and then embarked on a grand European tour before returning to San Francisco to apprentice as a lawyer. He first visited Japan briefly in 1893 on a world tour, financed by an inheritance from his late wife. Instantly enchanted, he returned the following year for a lengthier stay. Scholarly and modest by nature, he first set out to master the language, spoken and written, then proceeded to study traditional painting himself because he considered the art as key to understanding the culture.[13] Settling first in Kyoto where he met his mentor, painter Kubota Beisen (1852–1906), who specialized in traditional Japanese-style painting (Nihonga), he later

moved to Tokyo. Bowie met with and studied from many of the leading painters of his day, but he held such high admiration for Beisen that on the first page of his seminal book, *On the Laws of Japanese Painting*,[14] he wrote:

> **Dedicated to the memory of Kubota Beisen a great artist and kindly man whose happiness was in helping others and whose triumphant career has shed enduring luster upon the art of Japanese painting.**

Subsequent appreciation of Beisen has been overshadowed, however, by that of other Nihonga artists from Tokyo whom the more celebrated scholars Ernest Fenollosa (p. 134) and Okakura Kakuzō (p. 136) avidly promoted. Bowie did not approve of Fenollosa, who never studied painting himself, and disagreed with the latter's insistence that Japanese painters should adapt their styles to sell works abroad. Bowie's erudite, succinct, and highly personal book reveals his deep affection for Japanese painting. Although it provides a short history of painting, the book emphasized techniques: use of the brush and ink, and names for various types of brush strokes; painting materials; methods of applying color; principles of proportion, shape, and design; the importance of seasonally appropriate allusions; common subjects; aesthetic principles beginning with the importance of capturing the spirit of the subject portrayed; and application of seals and signatures.

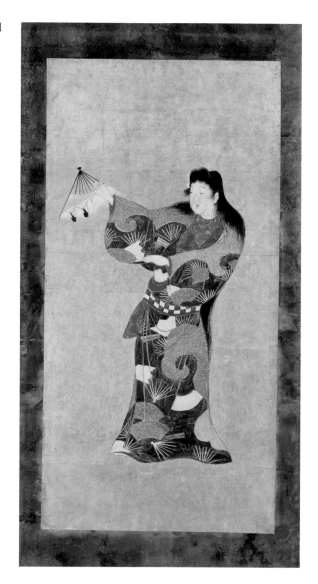

Plate 3-6 Unknown Artist, active Edo period, Kan'ei era (1624–1644) to Keian era (1648-1652), *Dancing Courtesan*. One from a set of eleven panels, ink and color on gold leafed paper, 75.3 x 37.4 cm. Museum of Fine Arts, Boston, Denman Waldo Ross Collection, 17.1091. Photograph © Museum of Fine Arts, Boston, 2013.

Denman Waldo Ross (America, 1853–1935)

A native of Cincinnati, Ohio, Ross moved to Boston at age eight and through family connections mingled with intellectual and élite members of Boston society. He earned an undergraduate degree and then a doctorate in political economy at Harvard in 1875. From a young age he had shown interest in painting to which he only turned after graduation. Around 1889, he began a long career as a professor of design and art theory at Harvard University, in the same department that Langdon Warner (p. 144) joined later. Following a family tradition, Ross served from 1895 as a Museum of Fine Arts Boston trustee and amassed a vast collection of a wide variety of arts from various world cultures,

including Japan, which he donated to the Museum of Fine Arts. His interest in Japan came from diverse sources, including the writings of art historian James Jackson Jarves (p. 139) and several illustrious collectors who were his acquaintances: Charles Lang Freer (1854–1919) and Isabella Stewart Gardner (1840–1924). Unlike Jarves, who never visited Japan, Ross made three trips, in 1908, 1910, and 1912. He developed his ideas about design education and theory in conjunction with two close compatriots, Arthur Wesley Dow (p. 121) and Ernest Fenollosa (p. 134), and presented them in an influential book, *A Theory of Pure Design: Harmony, Balance, Rhythm, With Illustrations and Diagrams* (1907), aimed at aspiring artists.[15] The book offers principles of design rather than design history. In his conclusion, Ross explained that the study of design was important "to induce in ourselves the art-living and art-producing faculties. With these faculties we shall be able to discover Order and Beauty everywhere, and life will be happier and better worth living."[16] Convinced that design concepts inherent in the Japanese arts could serve as models, he wrote about the Japanese emphasis on asymmetrical compositional balance ("occult balance," the same term that La Farge used) and commented on the Japanese propensity for technical perfection.[17] This led him to caution his students to pay attention to how techniques depended on an understanding of the materials they used.

Arthur Wesley Dow (American, 1857–1922)

The foremost art educator of his time, from Ipswich, near Boston, Dow became intrigued with the landscape prints of Utagawa Hiroshige (1797–1858) and Katsushika Hokusai (1760–1849) while studying art in Paris from 1884 to 1889. Inspired by their work, he began experimenting with woodblock printing in the early 1890s, becoming the first American artist to perfect the technique. His prints were first exhibited in 1895 at the Museum of Fine Arts Boston. Their clear, flat patterns and compositions revealed obvious Japanese influences, as noted by art critic Sadakichi Hartmann (p. 142) in his 1902 book on American

Plate 3-7 Attributed to Arthur Wesley Dow (1857–1922), *Bird on a Persimmon Branch*, early 20th century. Stencil (*katagami*), cut mulberry bark paper, 22.86 x 27.3 cm. Helen Foresman Spencer Museum of Art, University of Kansas. Museum purchase: Lucy Shaw Schultz Fund, 2002.0003. The Japanese influence in this stencil is evident in the asymmetrical composition, delicate rendering of a close-up view of the natural world, and the clear, flat, dark–light patterning of the forms. The piece was once in Dow's personal collection, and although it was originally thought to be an actual Japanese stencil, scholars have recently deduced Dow himself created it.

art. Dow also became fascinated with the potential for Japanese stencils to assist in improving the composition and technique of his own and his students' work. In Boston, he had the opportunity to study the largest collection of stencils amassed in the West in the 1880s by William Sturgis Bigelow, whose prints were stored at, and later donated to, the Museum of Fine Arts.[18] Langdon Warner (p. 144) organized an exhibition of Bigelow's stencils in 1910. Later in life, Dow collected stencils himself.[19] Dow's own association with the Museum of Fine Arts began in 1891 when he met Ernest Fenollosa (p. 134), who was then working there as a curator, and for several years, beginning in 1893, Dow served as Fenollosa's assistant. Through Fenollosa, Dow also came to know Denman Ross (p. 120). Dow spent an extended period in Chicago, from 1899 to 1901, where he lectured on his design theories, contributed to art journals, and exhibited his prints at the Art Institute, influencing the young Frank Lloyd Wright (p. 130).[20] In 1895, he moved to New York City where he lived and taught art for the duration of his career. Despite his obvious love for Japanese art, Dow only traveled to Japan once, a three-month stay in 1903 during a round the world voyage. As an educator, Dow encouraged numerous students to adopt Japanese design principles in their art. He first wrote about these in an article in 1893, explaining why he considered Japanese art such an important model for

American artists.[21] His article began with the statement: "Japanese art is the expression of a people's devotion to the beautiful," and concluded by noting that "all Japanese artists are designers." Dow cautioned that "[t]he American artist is in danger of sacrificing composition to realism; he, therefore, needs the stimulus of these matchless works of Eastern genius to draw out his inventive and creative powers."[22] He identified three characteristics of Japanese art that aspiring artists should emulate: line, color ("not limited by scientific laws"), and *nōtan* (literally "dark–light"), that he described as "not light and shadow, but an eternal principle of art, and the Japanese compose in it with matchless daring united to an unerring sense of the beautiful."[23] As already mentioned in connection with the discussion of *nōtan* on pages 44–5, it was Fenollosa, perhaps as early as the mid-1880s, who coined this expression.[24] Dow based his conception of this design principle in large part on his appreciation of Japanese stencils.

ART DEALERS

Siegfred Bing (German, naturalized French, 1838–1905)

Bing was a wealthy Parisian art dealer and seminal figure in the art world of his day who spearheaded efforts to popularize Japonisme. His gallery, La Maison de l'Art Nouveau, established in the mid-1870s, gave its name to the Art Nouveau movement.[25] Bing also had a large private

collection of Japanese *ukiyoe* prints and crafts, including textiles and ceramics, sold off after his death (his textiles were acquired by the Metropolitan Museum in 1896). Above all, he is known for fervently promoting Japanese arts through the magazine he founded and edited, *Le Japon Artistique* (*Artistic Japan*; published in 36 issues between 1888 and 1891 in French, German, and English editions), the first ever popular monthly art magazine. He intended this journal as a forum for educating the European and American art collecting public about Japanese art, aesthetics, and culture, emphasizing its beauty and creativity, and

Plate 3-8 Paper Stencil (*katagami*) with design of scattered hollyhock leaves, 19th century. Mulberry bark paper and silk threads. Saint Louis Art Museum. Gift of V. W. von Hagen, 236:1931.

providing ideas for Western design-ers. Although he routinely included examples of Japanese art from his vast collection in its pages and authored a few of the articles himself, he cast his net widely for authors and topics to address what encom-passed Japan's literary and dramatic arts so as to broaden his readership and place understanding of Japanese arts within a larger cultural con-text. Many European Japanophile luminaries of his day wrote articles for this journal, including British art dealer Marcus Huish (p. 123), Philippe Burty (p. 140), Theodore Duret (p. 141), Louis Gonse (p. 142), and Dr William Anderson (1842–1900), the foremost British collector of Japanese prints and paintings, thereby giving it an air of author-ity. To translate the journal into English, Bing engaged Huish. All the articles stressed the exquisite beauty of Japanese crafts, especially work-manship in small-scale objects in various media, such as wood, metals, engraving, and lacquer. Unrelated to the articles, most featured examples of Japanese cut paper stencil patterns (*katagami*) used for creating designs on textiles, which fostered the wide-spread appreciation and collecting of these materials."[26]

No. 1.--A Master of the Old School. *After Hokusai.*

Plate 3-9 After Hokusai, *Master of the Old School*. Photo source: Marcus Bourne Huish, *Japan and Its Art* (London: B. T. Batsford, third edition, 1912), preface p. v. Although Huish featured many artists and different types of artworks in his *Japan and Its Art*, like Bing's *Artistic Japan*, he interspersed its pages with charming sketches like this one based on those of everyone's favorite Japanese artist, Katsushika Hokusai.

Marcus Huish (British, 1843–1921)

Huish trained as a lawyer at Trinity College, Cambridge, but worked professionally as an art dealer, watercolorist, publisher, and writer. He also served as director of the Fine

Art Society, a well respected art firm that reproduced paintings, orga-nized art exhibitions, and sponsored publications.[27] He also collected Japanese art (and wrote about col-lecting in the journal *Artistic Japan*). Although he never traveled to Japan, Huish amassed considerable knowledge about Japanese art and its culture, and edited and authored a number of significant publications. Editing projects included the *Art Journal*, to which he also contrib-uted essays on Japanese art that he eventually published in book form; the English language edition of the journal *Artistic Japan* published by Siegfred Bing (p. 122); *Transactions of the Japan Society*, an organization which he helped found in 1891 and for which he served as chairman; and the English edition of Count Okuma Shigenobu's *Fifty Years of*

New Japan (*Kaikoku gojūnen shi*, 1909). His book, *Japan and Its Art*, first published in 1889, was aimed "more for the dilettante than the student,"[28] and can be considered a summation of the prevailing attitudes towards Japanese art and culture of his era. In the expanded third edition (published in 1912), he devoted the first 184 pages to discus-sions of various aspects of Japanese culture that facilitated understand-ing of the subjects represented in art and the motivations of artists. In his prologue to that edition, he stated the book's aim was first to give "an idea of the physical aspect of Japan, its history, religion, people, and their mode of living, myths and legends as illustrated in Art. Then, secondly, [to function as] a treatise on its arts, especially those which we term 'industrial'."[29] His observations

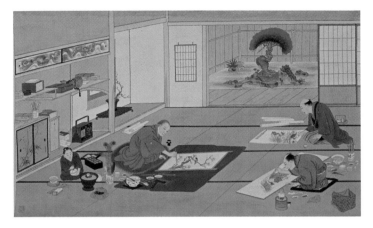

Plate 3-10 Kawahara Keiga (1786–ca. 1860), *Artist's Studio, from the Four Accomplishments series*. Hanging scroll, color on silk, 52.4 x 88.2 cm. National Museum of Ethnology, Leiden, Siebold Collection, No. 1–1039. Keiga served as an official painter to the Dutch residents of Nagasaki and in that capacity painted scenes of daily life and customs in Japan as requested by von Siebold. Here, he has portrayed a painter's studio, a lovely Japanese room adjacent to a garden, with the master at the center putting finishing touches to a painting laid out on a red cloth mat to protect the *tatami*, surrounded by his brushes, ink, and other tools of the trade, while, within his view, his apprentices put finishing touches on additional paintings.

echoed those of other authors of his time, for example, how poetical sentiments of nature permeated all classes. His chapters covered painting, prints, sculpture in wood and ivory, lacquer, metalwork, pottery and porcelain, and embroideries and textiles (including two examples of stencil plates that he owned). This last section, he noted, was one of the chapters new to the third edition, because he especially wanted to feature significant types of manufacturing of arts of his own time.

SCIENTISTS AND PHYSICIANS

Phillip Franz von Siebold (German, 1796–1866)

A physician, Siebold worked in Japan as a medical doctor for the Dutch East India Company from 1823 to 1829, when he was expelled because of alleged espionage with the Russians. A methodical and studious observer, while in Japan Siebold had amassed a collection of botanical specimens and over 5,000 Japanese objects, including a variety of household goods, crafts, tools, *ukiyoe* prints (including many books and single sheet prints by Hokusai), and paintings, with the aim of furthering understanding of the Japanese people.[30] In the early 1830s, Siebold opened his house in Leiden to the public, to make his collections accessible to people. They became the core of a new ethnographic museum in that city, now the Dutch National Museum of Ethnology (Museum Volkenkunde), which was the first such institution in Europe. Siebold was later pardoned and granted permission to return to Japan, which he did in 1859 and 1861, when he served as advisor to the shogun on how to introduce Western science to the country. His collection was legendary; the French art critic Louis Gonse (p. 142) wrote in his book, *L'Art Japonais* (1883), of his visit to see Siebold's vast painting collection,[31] and other prominent early French writers on Japanese art also made pilgrimages to Leiden to see his collection. Siebold tirelessly promoted greater understanding of Japanese people and culture, and for that Europeans consider him the father of Japanese studies in the West. Although he did not comment on aesthetics and design per se, he was obviously a keen admirer of Japanese craftsmanship and its architecture. His legacy includes, in addition to his vast collections, numerous publications, the most important of which is the monumental multi-volume tome, *Nippon*, written in German, published privately and by subscription beginning in 1832, and republished many times over the decades, first in an expanded complete form by his sons in 1897.[32] This book has been described as an insider's account of the land and people of Japan, and featured well ordered assessments of Japanese religious traditions, the arts, history, agriculture, industry, science, and the country's natural environment. Siebold's influence in the English speaking world was limited, however, to an 1841

anonymously edited British volume, *Manners and Customs of the Japanese, in the Nineteenth Century*, that drew heavily on his writings.

Edward Sylvester Morse (American, 1838–1925)

A brilliant Harvard-trained zoologist, Morse had a passion for a type of marine shellfish known as brachiopods. Upon learning they existed in the waters off Japan, he traveled there in 1877, a chance encounter that led to his lifelong fascination with Japanese culture.

Morse conducted the first ever archaeological excavation in Japan at shell mounds near Tokyo, which led to his nearly three-year appointment to teach zoology at the recently established Tokyo Imperial University. From 1880 to 1914 Morse served as director of the Peabody Museum of Archaeology and Ethnology in Salem, during which time he returned to Japan for briefer visits, in 1881 and 1882, when he collected numerous household objects and crafts for the museum. On his last trip, he served as guide for his friend,

collector William Sturgis Bigelow, journeying to Japan for the first time. He also mentored Ernest Fenollosa (p. 134) and Percival Lowell (p. 126). Morse's scientific mind informed his appreciation of Japanese arts. He became an avid and systematic collector of a variety of Japanese crafts and household objects, including ceramics that he sold to the Museum of Fine Arts Boston in 1889, the year before he was appointed Keeper of Pottery at that museum. Morse, in part, owed the acquisition to Denman Waldo Ross

Plate 3-11 *Sumi-tsubo (carpenter's ink pot)*, 19th century. Wood, iron, silk cord, and ivory, length 26 cm, height 10 cm. Private collection, Japan. In his book *Japanese Homes and Their Surroundings*, Morse wrote not only about the appearance of Japanese buildings and their construction methods, but also about the tools used by carpenters, whom he ranked higher than their Western counterparts for their workmanship, patience, and creativity. He pointed out the importance of the *sumi-tsubo* (an inkpot and reel, alongside of which is a cavity filled with ink-soaked cotton fibers) that the carpenters hand-carved themselves, which he illustrated in a fine line drawing, and remarked that they were more precise than Western carpenters' chalk lines.

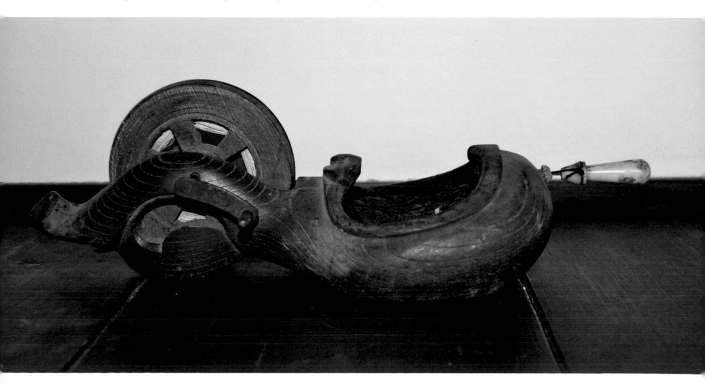

Plate 3-12 *Lower garden at Saihōji (Kokkedera, or Moss Temple), Arashiyama, Kyoto.* Restored in 1339 by Zen priest Musō Soseki (1275–1351). Photograph © sdstockphoto/istockphoto.com. This Zen temple garden is widely acknowledged as the quintessential Japanese moss garden, whose atmosphere is permeated with an air of Buddhist mystery known as *yūgen*. The pond around which the garden is organized is a vestige of an earlier incarnation as a garden that visualized the Western Paradise of the Buddha Amida, central to Pure Land Buddhist beliefs.

(p. 120), who argued for its approval in his role as museum trustee, stating that "the collection [of 5,000 pieces] illustrates, better than any collection of works of art which I have ever seen, the principle which underlies all true artistic activity—the principle that it is not enough to invent new types of things, but each type must be improved and perfected according to the ideal which it suggests to the imagination."[33] Morse's writings include *Japanese Homes and Their Surroundings* (1885), which he dedicated to William Sturgis Bigelow; *Catalogue of the Morse Collection of Japanese Pottery* (1900),[34] and *Japan Day by Day* (1917),[35] the latter a compilation of the meticulous journals he kept

while in Japan. Although a scientist, his books reveal his belief that the Japanese people's lifestyle and work ethic contributed to the culture's aesthetic sensibility. For example, in describing the displays at an industrial exhibition Morse attended in Ueno Park in Tokyo, he wrote of his awe of Japanese designs and use of material, stating that "no words can describe the grace, finish, and purity of design; these and other exquisite productions of the Japanese show their great love of nature and their power to embody these simple *motifs* in decorative art, and after seeing these it seems as if the Japanese were the greatest lovers of nature and the greatest artists in the world."[36]

Percival Lowell (American, 1855–1916)

Born into a prominent Boston family, Lowell is best remembered as the astronomer and mathematician who founded the Lowell Observatory in Flagstaff, Arizona. Prior to embarking on that profession, however, he had such deep passion for Japan that he traveled there for prolonged visits between 1883 and 1893, often in the company of his cousin William Sturgis Bigelow. He also was mentored by Edward Sylvester Morse (p. 125). Lowell, an intrepid adventurer and gifted linguist who quickly attained some competency in Japanese, is considered the first American to sympathetically attempt to understand and explain the

Japanese people and their culture. Among his books are *Occult Japan, or, The Way of the Gods* (1895)[37] and *The Soul of the Far East,* (1888),[38] a modest-sized but perceptive reflection on how Asian and Japanese religious traditions fostered a spiritual world view that encouraged imagination and intuitive appreciation of art. Therein he commented:

Artistic perception is with him an instinct to which he intuitively conforms, and for which he inherits the skill of countless generations. From the tips of his fingers to the tips of his toes, in whose use he is surprisingly proficient, he is the artist all over. Admirable, however, as is his manual dexterity, his mental altitude is still more to be admired; for it is artistic to perfection. His perception of beauty is as keen as his comprehension of the cosmos is crude; for while with science he has not even a speaking acquaintance, with art he is on terms of the most affectionate intimacy.[39]

Elsewhere in the book he observed the Japanese passion for nature, stating that

This love of nature is quite irrespective of social condition. All classes feel its force, and freely indulge the feeling. Poor as well as rich, low as well as high, contrive to gratify their poetic instincts for natural scenery. As for flowers, especially tree flowers, or those of the larger plants, like the lotus or the iris, the

Japanese appreciation of their beauty is as phenomenal as is that beauty itself.[40]

He also commented on the poetic qualities of Japanese painting and perceptively noted that nature, not man, is the artist's ideal source of inspiration. These ideas gained wide currency later among writers about Japanese aesthetics and design, including Lafcadio Hearn (p. 133), and also Imagist poets inspired by Asian spirituality, including Lowell's sister Amy Lowell (1874–1925) and Ezra Pound (1885–1972).

INDUSTRIAL DESIGNERS AND ARCHITECTS

Christopher Dresser (Scottish, 1834–1904)

Dresser pioneered the field of industrial design with well-designed, functional, machine-made products for wide distribution. He was also a botanist, prolific writer, lecturer, and inveterate collector of Japanese crafts and household goods. Dresser trained as a designer at London's new Government School of Design, established to spearhead reform in the field of design through joint study of art and science. There, Dresser concurrently researched and published on botany. His education included the study of Japanese design through examples of artifacts collected by the school's affiliate arts institution, the South Kensington

Museum (now the Victoria and Albert Museum).[41] One of his mentors at the school was the previously mentioned architect Owen Jones, to whose book, *The Grammar of Ornament*, he contributed a botanical drawing. Upon graduation, Dresser lectured and wrote about botanical subjects as appropriate ornamentation for the "Arts-and-Manufacture" industries, with particular reference to Japanese arts.[42] Dresser, who visited and published articles about the major European and American international expositions, developed an even keener interest in Japan when he attended the 1862 International Exposition in London and saw Sir Rutherford Alcock's collection. Following a visit to the Centennial Exposition in Philadelphia in 1876, he visited Japan for over three months to present examples of British industrial arts as gifts to the Tokyo Imperial Museum, to counsel the Japanese on ways to improve the international marketability of their crafts industries, and to acquire Japanese art for his own collection and for the Tiffany Co., whose collection was known by, and perhaps influenced, John La Farge (p. 118), Edward Sylvester Morse (p. 125), and Ernest Fenollosa (p. 134). Because of connections he had made with Japanese officials who had previously visited London, he was permitted to travel widely and allowed access to imperial art collections off limits to ordinary visitors. His book that followed this trip, *Japan: Its Architecture, Art,*

Plate 3-13 *Kyoto ware saké ewer with design of chrysanthemums in imitation of Dutch faience, 1840–1860.* Earthenware with overglaze blue enamel over a white ground, height 7.6 cm, diameter 10.5 cm. Victoria and Albert Museum, London, 603&LID-1877. This ewer was purchased in 1877 from Londos & Co., who probably acquired it from Christopher Dresser, who had been in Japan earlier that year.

and Art Manufactures (1882), was a travelogue in which he analytically presented his impressions of Japan's architecture and craft industries in detail.[43] He expressed great admiration for the work ethic of Japan's crafts makers and noted in his preface the Japanese "national style of conventional ornament" and that his book attempted "to explain how architecture resulted from climactic and religious influences, and how the ornaments with which domestic objects are figured, and the very finish of the objects themselves, are traceable to religious teachings."[44] In his sophisticated understanding of the relationship of architecture and aesthetics to the culture's religious values, he stands alone among his contemporaries. Dresser marveled not only at large monuments but also at minutiae, such as the metalwork of nail head covers and door hinges, that he declared "would supply the art student with material for study, and examples to copy, for weeks."[45] Subsequent to this trip, Dresser promoted Japanese arts more

intensely in exhibitions, lectures and publications, marveling that it had affected him more profoundly than his formal education.[46] Throughout his career, Dresser created designs, often as advisor to small, specialized manufacturing firms, for ceramics, furniture, textiles, wallpaper, carpets, glass, iron, and silver. Influenced by the approaches and design sensibilities of Japanese crafts makers, his own work emphasized designs suitable to the materials from which they were fashioned, introduced the use of standardized components, and featured abstracted, simplified natural motifs or fine geometrical patterns. Both prior to his trip and after his return, he was also involved with companies that imported Japanese artifacts to London.

Josiah Conder (British, 1852–1920)

Conder trained as an architect at the University of London. In 1877, at the remarkably young age of twenty-four, he somehow managed to secure a position as the first

architecture professor of the new Imperial College of Engineering in Tokyo (now part of Tokyo University) without ever having designed a building himself.[47] There, he taught the first Western-trained Japanese architects. He also designed a number of notable public and private buildings in Japan, both before and after leaving his teaching post in 1884, many of which remain standing today. In Japan, Conder was befriended by Frank Brinkley (p. 132), who also had come to Japan to work for a Japanese institution. Like Brinkley, he spent the duration of his life in the country, married a Japanese woman, and sought to transmit his knowledge of the culture to the Western public in numerous lectures in Japan and in publications widely read abroad.[48] Also like Brinkley, Conder studied Japanese painting with famed artist Kawanabe Kyōsai (1831–1889), about whom he authored a book and whose paintings he collected. More significant to the history of appreciation for Japanese design, however,

were the books he wrote on flower arranging and gardens. His book, *The Flowers of Japan and the Art of Floral Arrangement*, on ikebana, was published in 1891 by a Japanese publisher.[49] In its first part, he described the Japanese love of flowers throughout the seasons, opening with the following remark:

The flower charm which exists in Japan is not, however, mainly one of pastoral associations, but is closely connected with the national customs and the national art. The artistic character of the Japanese people is most strikingly displayed in their methods of interpreting the simpler of natural beauties.[50]

Subsequent sections of the book explored flower arranging as an art form, beginning with a month-by-month chart of flowers, then moving on to the history and theory of ikebana and a discourse on the philosophical basis for the classifications and nomenclature for floral designs before delving into the particulars of the art, which he described with great specificity. Condor stressed that practicing ikebana was a form of self-cultivation, commenting that a "religious spirit, self denial, gentleness, and forgetfulness of cares, are some of the virtues said to follow from a habitual practice of the art of arrangement flowers."[51] His two volume set of books on garden design,

Plate 3-14 *Rikugien garden, Tokyo.* Photo: Patricia J. Graham, May 2006. A nearly identical view of this garden was illustrated in a black and white collotype photograph by K. Ogawa in Conder's supplement to his book *Landscape Gardening in Japan*, there titled "Garden at Komagome." He described this lake view as "remarkable for its serene and unassuming grandeur." He noted that the rocks in the center of the lake were "arranged to form an open archway, in imitation of hollowed sea-rocks which are seen at various places near the Japanese coast."[52] This beautiful stroll garden was originally constructed in the late seventeenth century as part of an estate of a powerful samurai warrior. Today, it is a public park.

Landscape Gardening in Japan and *Supplement to Landscape Gardening in Japan* (1893), featured lithograph drawings in the first volume and collotype photographs by pioneering photographer Ogawa Kazumasa (1860–1929) in the second. This was the first definitive publication on this subject in English. On the first page of his preface, Conder indicated that he strove to reveal "that beneath the quaint and unfamiliar aspects of these Eastern compositions, there lie universally accepted Art truths." Thus, although he presented a short section on historical gardens and their variety, his book emphasized formalist "rules and theories" of the art, which could be understood and adapted by his Western audience, such as descriptions of rules for garden proportion, scale, rhythm, relationships between elements, and so forth.[53] In his seeking of universal art truths and linkage of art appreciation to morality, his ideas resonated with those of other art reformers of his age, such as Denman Waldo Ross (p. 120) and Ernest Fenollosa (p. 134), among others.

Frank Lloyd Wright (American, 1867–1959)

America's most notable twentieth-century architect, Wright is famous for his interest in Japanese art and architecture. When Wright came to Chicago to work as an apprentice architect after graduation from engineering school at the University of Wisconsin in 1887, he was immediately exposed to Japanese art and design aesthetics through his mentor, Louis Sullivan, who owned many books on the subject and collected Japanese art. One of those books must have been *Japanese Homes and Their Surroundings* by Edward Sylvester Morse (p. 125). The 1893 World's Columbian Exposition, with its displays of Japanese arts of all sorts and actual Japanese buildings, must have further whetted his interest in Japanese design. His appreciation for Japanese prints began in the 1890s as well, through lectures at the Chicago fair by Ernest Fenollosa (p. 134) and exposure to the art of Arthur Wesley Dow (p. 121), who lectured in Chicago, wrote for Chicago art journals, and who had an exhibition at the Art Institute of Chicago of his Japanese-influenced prints in that decade.[54] Wright first traveled to Japan in 1905, during which time he bought his first Japanese prints, and the next year he curated the first exhibition of the prints of Utagawa Hiroshige at the Art Institute.[55] So enamored was he of Japanese prints that he authored a book on the subject in 1912.[56] Although he declined to admit to direct influences from Japan, and insisted that nature was his source of influence, in his autobiography he wrote of his attraction to Japanese spiritual traditions, in part from his own observations during visits to Japan and in part influenced by the writings of Okakura Kakuzō (p. 136), passages from whose books he would occasionally quote.[57] By 1915 Wright was considered one of the most important American collectors and dealers of Japanese woodblock prints—he had thousands. Many he sold to his architectural clients for decoration in their homes, and he is said to have made more money from their sales than he did on the design of their houses. His role as a dealer, however, had been somewhat overlooked (his autobiography only mentions his selling of prints) until 1980 when Julia Meech, then working as a curator at the Metropolitan Museum, decided to investigate the sources of acquisition of the museum's vast Japanese print collection. Wright's name was prominent among those from whom the prints were acquired. Wright also amassed a sizeable number of other types of Asian arts, including Japanese screens, Buddhist paintings, textiles, and Asian ceramics, carpets, and sculptures (mainly Chinese), but it was the prints that most seriously piqued his interest. Their attraction to him lay in their abstract design qualities as well as their vague (to him) spirituality, and he described his prints in terms of the values he professed for himself: "democracy, spirituality, purity, and harmony with nature."[58]

Bruno Taut (German, 1880–1938)

Taut was a modernist architect who had fled to Japan in 1933 to escape Nazi Germany. There, he developed a deep appreciation for traditional Japanese architecture,

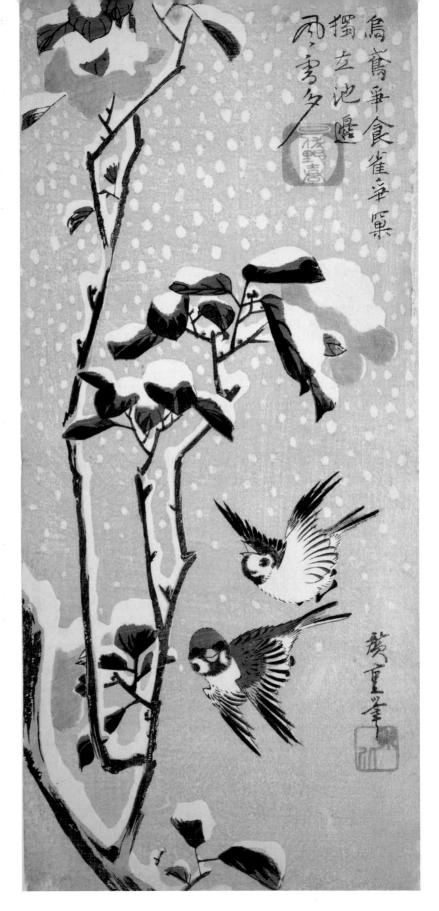

Plate 3-15 Utagawa Hiroshige (1797–1858), *Camellias and Sparrows in Falling* Snow, ca. 1837. Woodblock print with colors and embossing, 38.7 x 17 cm. Art Institute of Chicago, Clarence Buckingham Collection, 1925.3637. Hiroshige was Wright's favorite Japanese artist, and although he is best known today for his landscapes, Wright especially admired his bird and flower prints, which he recommended his architectural clients to use as decoration in their homes. This was one of many Japanese prints purchased by Clarence Buckingham from Frank Lloyd Wright in 1911.

which resonated with his favoring of modernist-style architecture emphasizing functional buildings that exposed their underlying materials and lacked extraneous decoration. While lecturing on the subject at Tokyo Imperial University, he must have come to the attention of the Japanese government's cultural authorities, because his two highly influential books on the subject, published in 1936 and 1937, were produced by a Japanese commercial publisher in conjunction with the Society for International Cultural Relations (KBS).[59] In his lectures and books, Taut praised Japanese native architecture generally as a superb contribution to world heritage, and heaped the highest praise on two buildings since then hailed as masterpieces of simplicity in accordance with modernist architectural values: the Katsura Imperial Villa (see pages 12–15) and the Imperial Shinto shrine at Ise (see Plate 2-5). Ise was the pre-eminent imperial Shinto shrine, closely associated with the emperor, so the KBS must have approved Taut's admiration of it. Japanese modernist architects had before him already begun to appreciate Katsura in their efforts to find native sources for modern architecture, and they introduced him to it. Because he was the first to write in English about these buildings, until recently he was regarded as the first person to recognize their greatness.[60] He declared Katsura the epitome of Japanese architecture and a triumph of modernism, in contrast to the shogunal mausoleum shrines at Nikko which he reviled.

Plate 3-16 *View of the main shoin building at the Katsura Imperial Villa*, completed ca. 1663. Photograph © peko-photo/photolibrary.jp. The building's unpretentious appearance, clarity of forms, and elegantly balanced proportions of the structural elements, in contrast with the irregular shapes and placement of the stones that line the path, have earned this building the highest praise among admirers of traditional Japanese architecture.

JOURNALISTS

Frank (Captain Francis) Brinkley (Irish, 1841–1912)

Brinkley studied mathematics and classics at Trinity College, Dublin, then entered the Royal Military Academy from which he was dispatched to the Far East. He arrived in Japan in 1867, ostensibly for a brief tour but that, in fact, lasted for the duration of his life.[61] Brinkley's keen interest in Japanese arts led him to befriend fellow expatriate, designer Josiah Conder (p. 128). Linguistically gifted, he soon resigned his military post and after serving as advisor and instructor to the Japanese government, married a Japanese woman of samurai birth, then became owner and editor of the authoritative *Japan Mail* newspaper (forerunner to the *Japan Times*) in 1881. Brinkley's prolific and wide-ranging writings about Japan included an authoritative Japanese language dictionary, war reports for *The Times* of London on the Sino-Japanese and Russo-Japanese Wars, and several sets of books for the Boston publisher Josiah Millet, beginning with his editing *Japan: Described and Illustrated by the Japanese* (1897–1898; in 10–12 volumes, produced in standard, deluxe and imperial editions). Okakura Kakuzō (p. 136) was one of many Japanese authorities who contributed the essays for the publication that Brinkley himself translated into English. This set is famous for its inclusion of over 200

Plate 3-17 Okazaki Sessei (1854–1921), *Pair of cast bronze door panels*, 1890. Bronze with wood, each 218.5 x 137 x 3.5 cm. © 2013 University of Alberta Museums, University of Alberta, Edmonton, Canada, Mactaggart Art Collection, 2010.21.11. These panels were first publicly and prominently displayed at the west court entrance to the Japanese art exhibition in the Palace of Fine Arts at the World's Columbian Exposition, Chicago in 1893 (see Plate 3-1). Brinkley wrote about them at length in volume 7 of his book, *Japan: Its History, Arts, and Literature*, where he marveled at the technical tour de force of their production.

hand-tinted albumen photographs and one-color collotypes of flowers inserted into each volume by Ogawa Kazumasa, whose photos were also featured in Josiah Conder's book on landscape design. Millet also published Brinkley's eight-volume set, *Japan: Its History, Arts, and Literature* (1901). Its eighth volume focused on Japanese ceramics, a subject about which Brinkley, a keen collector, was considered one of the world's experts. It included pages of detailed illustrations of marks and seals. His many writings on art over the course of his career reveal his astute understanding and great appreciation of the technical virtuosity of Japanese handicrafts, especially lacquers and metalwork. Curiously, his name has faded from history, unlike that of his contemporaries Edward Morse (p. 125), also a ceramics collector, and Ernest Fenollosa (p. 134).

Lafcadio Hearn (Greek, naturalized Japanese, 1850–1904)

Hearn was born in Greece to an Irish army surgeon father and Greek-born mother. He moved to Ireland with his mother to live with his father's relatives when his father was posted to the West Indies, but she soon abandoned him, as did his father soon afterwards. His father's family paid for his education in France and Great Britain, until money ran out, whereupon at age nineteen he was sent to live with distant relatives in Cincinnati, Ohio. There, while living in poverty, he began a career as a newspaper reporter, which eventually took him to New Orleans, the West Indies, and then to Japan at age forty. He fell in love with the country and settled there permanently, marrying a Japanese woman from the Koizumi samurai clan, and changing his surname to hers when he became a Japanese citizen in 1896. While teaching at Tokyo Imperial and Waseda Universities, he wrote prolifically for Western readers about Japanese daily life and customs in books and a series of essays, in magazines such as *Atlantic Monthly*. Among his most popular books were *Glimpses of Unfamiliar Japan* (1894), *In Ghostly Japan* (1899), *Japan: An Attempt at Interpretation* (1904), and *Kwaidan* (1904). Although neither a collector of art nor an art critic, his writings nevertheless enthralled his foreign readers and both furthered their understanding of the psyche of the Japanese people and encouraged them to collect Japanese arts and crafts for their homes. Recent interest in this perceptive, eloquent, but nearly forgotten writer has been stimulated by Jonathan Cott's moving biography, *Wandering Ghost* (1991).

Plate 3-18 Toyohara Kunichika (1835–1900), *The Ghost of Okiku, a Scene from the Kabuki Play Banchō Sarayashiki*,1892, 10th month. Color woodblock print triptych, 107.9 x 24.4 cm. Helen Foresman Spencer Museum of Art, University of Kansas. Gift of H. Lee Turner, 1968.0001.266.a,b,c . At the time Hearn lived in Japan, ghoulish and spine-chilling ghostly tales, of which there are hundreds, were all the rage and his books and magazine essays introduced many of them to Western readers. These were popu-larized in paintings and prints such as this triptych, comprised of three single sheet prints aligned vertically to resemble a scroll painting (see Plate 2-54). It portrays a scene from a famous Kabuki play about the ghost Okiku, about whom Hearn wrote in his essay "In a Japanese Garden" published in the *Atlantic Monthly* magazine.[62] Okiku, a servant, was blackmailed by her master into becoming his mistress. To avoid that fate, she threw herself into a well and drowned. Thereafter, as seen here, she emerged nightly to haunt him.

PHILOSOPHERS

Ernest Fenollosa (American, 1853–1908)

A native of Salem, Massachusetts, Fenollosa is legendary for inspiring appreciation of Japanese art and design both in Japan and the West. He studied philosophy and divinity at Harvard and Cambridge Universities and first went to Japan in 1878 to teach political economy and philosophy at Tokyo Imperial University, through introductions from Edward Sylvester Morse (p. 125). While there, he visited numer-ous ancient religious sites, collected art, and together with his protégé Okakura Kakuzō (p. 136) was among those who worked to found Japan's

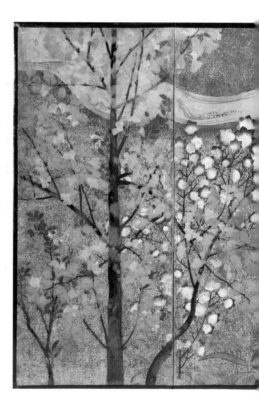

first art training school, the Tokyo School of Fine Arts (Tokyo Bijutsu Gakkō), encouraging Tokyo-based artists to create new styles of traditional painting (Nihonga). In Boston, Fenollosa became the first curator of Oriental art at the Museum of Fine Arts (1890–1895), but was dismissed because of a scandal surrounding his divorce and immediate remarriage. He was an advisor to Boston area Japanese art collector Charles Goddard Weld (1857–1911), to whom he sold his personal collection, which was later donated to the Museum of Fine Arts, and he also associated with other fans of Japan, particularly John La Farge (p. 118), Denman Waldo Ross (p. 120), Arthur Wesley Dow (p. 121), Percival Lowell (p. 126), and

collector William Sturgis Bigelow. Like them, Fenollosa was greatly attracted to Asian spiritual traditions through his study of Japanese art and he also converted to Buddhism. In 1893, Fenollosa, together with Morse, served as judge for the pottery competition at the World's Columbian Exposition in Chicago, where he also lectured on art education, based on his experiences in Japan. Later, he advised Detroit collector Charles Lang Freer, whose collection became the core of the Smithsonian Institution's Freer and Sackler Museums. In his survey book, *Epochs of Chinese and Japanese Art: An Outline History of East Asiatic Design*, whose text he completed in 1906 and which was published posthumously by his wife

Plate 3-19 Anonymous Rinpa School Artist, *Autumn Trees and Grasses by a Stream*, second half 17th century. Left half of a six panel folding screen, ink, color, gold, and silver on paper, 121.9 x 312.4 cm. Metropolitan Museum of Art, Rogers Fund, 15.127. Fenollosa sometimes misattributed fine un-signed Rinpa paintings such as this one to the school's founder, Hon'ami Kōetsu (1558–1637). He included a reproduction of a section of this screen in his *Epochs of Chinese and Japanese Art*, and noted that its "aesthetic purity and loftiness of both line and color come out in perfect combination."[63]

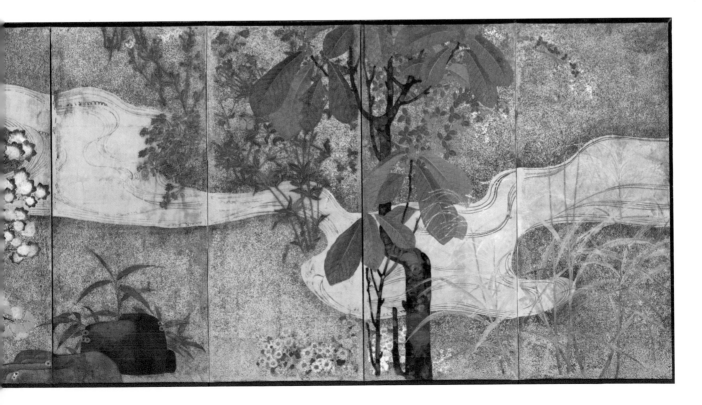

in 1912,[64] he outlined his ideas on the spiritual qualities and design principles of Japanese art. There, he mentioned the term *nōtan*, the dark–light principle about which his disciple Dow had previously written. He also praised Japanese painters of the Rinpa School above all others, calling them "the greatest painters of tree and flower forms the world has ever seen."[65] Rinpa artists, he noted, were also highly esteemed among élite Japanese collectors, who, like him, appreciated their abstracted, simplified design sensibility and bold application of color, celebrated as being devoid of foreign influences. His commentary echoed and expanded upon writings on Rinpa artists by Louis Gonse (p. 142), whose book he reviewed at length, with specific critique of Gonse's discussion of Rinpa.[66] Although erroneous and outdated even at the time of its publication, Fenollosa's *Epochs* has often been reprinted. Other unpublished notes by Fenollosa on translations of Japanese Nō plays and Chinese poetry were published posthumously, edited by modernist writer Ezra Pound, for

whom the metaphysical concepts expounded upon by Fenollosa served as important catalysts for his own writings throughout his career.

Okakura Kakuzō (also called Tenshin), Japanese, 1863–1913)

Arguably the most widely influential and contentious Japanese intellectual of his day, Okakura was, in the words of John Clark,

> *interested both in art and theories of the state. He served as government bureaucrat, but was also a poet and writer in both Japanese and English. He worked as an art educationalist, an art-world administrator, and an art movement ideologist. He was engaged as a curator for the Imperial Household Museum and wrote major, pioneering works as a member of the first generation of modern Japanese art historians. In his views of the outside world he was both an ultranationalist and an internationalist.[67]*

Okakura was born and raised in Yokohama, with its large foreign population, where he received both a Western missionary and traditional Japanese temple-schooled education. He later studied philosophy under Ernest Fenollosa (p. 134) at Tokyo Imperial University. Through Fenollosa, Okakura met the "Boston Orientalists" William Sturgis

Plate 3-20 Takamura Kōun (1852–1934), *One of a pair of ranma (transom) panels from the Phoenix Hall (Hōōden) at the World's Columbian Exposition, Chicago*, 1893. Wood with polychrome, 95 x 280 x 20 cm. Art Institute of Chicago. Gift of the University of Illinois at Chicago. Conservation made possible by an anonymous donor, Roger L. Weston, Richard and Heather Black, Patricia Welch Bro, Mary S. Lawton, John K. Notz, Jr, Richard and Janet Horwood, Charles Haffner III, Mrs Marilynn B. Alsdorf, and Walter and Karen Alexander, 2009.631. Okakura Kakuzō served as a member of Japan's committee that selected objects for the World's Columbian Exposition in Chicago in 1893, in his role as director of the art section at the Tokyo Imperial Museum. This enabled him to arrange for art by Takamura Kōun and other members of his school's faculty to be well represented there and for them to create the interior room decorations for the Hōōden, the Japanese national building that was erected at the fair. This recently restored transom panel is one of the few treasures from this building to have survived.

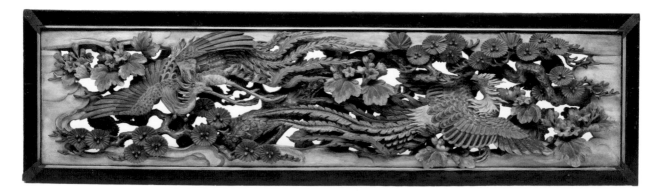

Bigelow, Henry Adams, and John La Farge (p. 118), with whom he developed a close friendship and obtained entry into the world of New York and Bostonian high society when he visited for the first time in 1886. Okakura worked on projects with Fenollosa in conjunction with the political élite of Japan who sought to modernize their nation through the infusion of Western-influenced institutional structures. These included surveys of historic temples and shrines and the co-founding of the Tokyo School of Fine Arts, that he directed from 1890 until his ouster in 1896 (when he established an alternative school with funding from Bigelow). In 1901, Okakura made his first trip to India, where he lodged in Calcutta with the family of famed Indian writer Rabindranath Tagore (1861–1941), who became his good friend. There, Okakura wrote his first English language book, *The Ideals of the East* (1903), in which he praised Japanese cultural heritage as a culmination of and naturalization of Indian spirituality (as transmitted to Japan through Buddhism), and Chinese humanism, which he saw as a synthesis of the Chinese philosophies of Confucianism and Daoism. Japan's role on the global scene, he believed, was to transmit these Oriental ideals to the West, an idea he expressed with the phrase "Asia is one," the opening line of this book. His writings here and elsewhere indicated that he believed not only in a binary opposition between Asia and the West but also in Japan's

superiority over the West.[68] In 1904, he returned to the United States and became curator of Oriental Art at the Museum of Fine Arts Boston. At this time, he became close to collector Isabella Stewart Gardner and began holding tea ceremonies as a way of introducing Westerners to the essence of Japanese culture. His subsequent, and most successful publication, *The Book of Tea* (1906), was dedicated to his friend La Farge. It presented a more positive and overarching assessment of Japanese aesthetics that presented participation in the tea ceremony as a means to impart beauty and profound meaning to one's life. Right at its beginning, he described "teaism"

as a cult founded on the adoration of the beautiful among the sordid facts of everyday existence. It inculcates purity and harmony, the mystery of mutual charity, the romanticism of the social order. It is essentially a worship of the Imperfect, as it is a tender attempt to accomplish something possible in this impossible thing we know as life.[69]

He described tea as "the cup of humanity" and its tea room as "the Abode of Vacancy or the Abode of the Unsymmetrical," a mere cottage constructed of wood and bamboo. Obviously this was not a guide to the formal preparation of tea but rumination on how to make sense of its aesthetic world. Because of the great response to his book, the *chanoyu* tea ceremony gained currency as the quintessential Japanese aesthetic.

Plate 3-21 *Garden path stepping stones at the Sumiya, Kyoto*, late 17th–18th century. In his book *Zen and Japanese Culture*, D. T. Suzuki endeavored to credit Zen for inspiring the well-known Japanese penchant for asymmetrical balance, which he illustrated with an example of stepping stones similar to those in this photograph. He likened the preference for imperfection and asymmetry to "the Zen way of looking at individual things as perfect in themselves and at the same time embodying the nature of totality which belongs to the One."[70]

D. T. (Daisetsu Teitaro) Suzuki (Japanese, 1870–1966)

A seminal and controversial figure, Suzuki has profoundly influenced perceptions of Zen and its influence on Japanese arts and culture in the West. He possessed a broad intellectual curiosity, impeccable academic training, and stellar linguistic competency in several Asian and European languages, including English. He first studied at Tokyo Imperial University, and there began training under the esteemed and cosmopolitan Zen master Sōen Shaku (1860–1919) of Engakuji in

Kamakura. Through him, Suzuki met Paul Carus (1852–1919), philosopher of comparative religions, while attending the World's Parliament of Religions in Chicago in 1893, and subsequently lived with Carus in Illinois for several years from 1905, working on translations of Asia religious texts. In 1911, he married Beatrice Lane, an American follower of Theosophy, who encouraged his investigations into the nature of divinity and spiritual wisdom. He became a professor of Buddhist philosophy, first at Gakushūin in Tokyo and from 1919 in Kyoto at Ōtani University. During the 1930s, influenced by prevailing discourses that sought to promote the uniqueness of the Japanese people, his lectures and essays for both foreign and native audiences described Zen as the underlying basis for Japan's love of nature, its aesthetics and art forms, including *haiku* poetry, architecture and gardens, the tea ceremony of *chanoyu*, and swordsmanship. The first of his writings in this vein was published by the Society for Intercultural Relations (KBS) that also published works by Bruno Taut (p. 130), Harada Jirō (p. 147), and Tsuda Noritake (p. 148) around the same time. In 1938, his talks and writing were compiled into a book, *Zen Buddhism and Its Influence on Japanese Culture*. Suzuki returned to the USA in 1949 and remained there for ten years, guest lecturing at various universities and teaching in the philosophy department at Columbia University from 1952 to 1957, where

Plate 3-22 *Karatsu ware (Yumino kiln) large kneading bowl,* 18th century. Glazed stoneware, height 18.5 cm, diameter of mouth 55.9 cm. The Nelson-Atkins Museum of Art, Kansas City, Missouri. Purchase: William Rockhill Nelson Trust, 33-1587. Photo: Joshua Ferdinand. This type of bowl, with its naive, rustic beauty and rough and vigorous painting of a simple pine tree over a clay surface covered with white slip, was one of the types of folk ceramics much admired by Yanagi Sōetsu. Yanagi personally selected this piece for the Nelson-Atkins Museum's collection at the request of his friend Langdon Warner (p. 144), the museum's first advisor for Asian art.

his students included many leading intellectuals. He also authored numerous popular and scholarly volumes in English about the Zen school, Buddhism and Asian spirituality during this time. His best known work of this period, *Zen and Japanese Culture* (1959), revised and expanded his 1938 volume on the subject.[71] Although his viewpoint elevates certain aesthetics at the expense of other, equally characteristic ones, for example overemphasizing the importance of the *chanoyu* tea ceremony aesthetics of *wabi* and *sabi*, it remains a classic.[72] Through these lectures and writings Suzuki initiated a boom in

interest in Zen in America that has continued unabated ever since.[73]

Yanagi Sōetsu (Japanese, 1889–1961)

An upper-class Tokyo-born philosopher of religions, Yanagi was the person who first identified and described arts and crafts created by and for the common people as *mingei* (page 46). He was much inspired by the Socialist-influenced philosophy of the British Arts and Crafts Movement, whose followers deplored industrialized mass-produced crafts and believed that the aesthetic expression of a culture

lay not in products created for élites by famous artists but in the anonymous products of the common people. British potter Bernard Leach (1887–1979), a leader of the British movement, was a close friend. Leach was responsible for introducing Western readers to Yanagi's writings.[74] Yanagi believed that *mingei* was a defining element of Japanese civilization that distinguished Japan's modern cultural identity from that of the Asian mainland and of the West, an idea which fit the fervent nationalistic sentiment of his era.[75] In 1931, Yanagi first promoted his ideas in the magazine *Kōgei* ("Crafts") and in 1934, he founded the Japanese Folk Craft Association which published the *Mingei Monthly* journal from 1939 up to World War Two. In 1954, the association began publishing a new official journal, *Mingei*. In 1935, he began organizing exhibitions of folk crafts in a museum he founded in Tokyo, the Japan Folk Crafts Museum (Tokyo Mingeikan). For this museum, he collected not only crafts made in Japan but also those made in Korea, which Japan then occupied. The art dealer Yamanaka Sadajirō (1865–1936) helped spread appreciation for *mingei* among collectors in the West by selling examples of these arts in his galleries. Langdon Warner (p. 144), a great admirer, quoted a favorite saying of Yanagi in several of his publications: "If the repetition of a machine is the death of all art, the manual repetition by a craftsman is the very mother of skill and skill is the mother of beauty."[76]

ART HISTORIANS AND ART CRITICS

James Jackson Jarves (American, 1818–1888)

A cultured and prolific art critic, Jarves published one of the earliest books about Japanese art, *A Glimpse at the Art of Japan* (1876), despite having never visited the country. It was such an influential volume that as late as 1933 a reviewer for the *New England Quarterly* gave it a glowing assessment.[77] A native of Boston,

Plate 3-23 *Dangling hairpin* (*Bira kanzashi*), Edo period (1615–1868). The hairpin has a gold flower with a coral center and other silver and coral flowers, long dangling blossoms and small coral pale balls, and a plum-shaped pendant. Helen Foresman Spencer Museum of Art, University of Kansas, William Bridges Thayer Memorial, 1928.0321. James Jackson Jarves admired finely wrought functional objects such as this.

Jarves was an inveterate traveler who lived for a time in Hawaii and the South Seas, where he dabbled in newspaper publishing before traveling to Europe in 1851 and settling permanently in Florence, Italy, soon afterwards. There, as a self-taught amateur, he began a career as a writer about art for the American public. By the time he penned his book on Japanese art, he was a respected authority as well as a serious collector of Old Master drawings and Italian paintings, which inspired Jarves to punctuate his book with comparisons between the Japanese and Europeans. He included mainly prints and book illustrations by the *ukiyoe* artist Katsushika Hokusai, then all the rage in Europe. But in many respects, he demonstrated a high level of perceptiveness about Japanese culture and its arts, commenting on the importance of nature and its dominance in poetic imagery, stating "no people more thoroughly understand the respective offices of Art and Nature, and where to draw the boundary between them."[78] He also lavishly praised Japanese craftsmen, noting that "the workman was a thorough *worker* and master of his particular art, content with nothing short of absolute technical perfection, aesthetic and material, in every object he undertook, whether it was cheap or valuable."[79] Not surprisingly, he especially admired detail-oriented and technically challenging arts such as Satsuma ceramics, bronzes, lacquers, and ivories, all popular export products readily available in Europe.

Plate 3-24 Félix Hilaire Buhot, artist (French, 1847–1898); Henri Charles Guérard, etcher (French, 1846–1897), *Masque en Bois, from the series Japonisme: Dix Eaux-Fortes* (*Japonisme: Ten Etchings*), 1883. Etching on yellow handmade Chinese paper with silver and gold leaf, sheet/paper 32.8 x 27.7 cm. Helen Foresman Spencer Museum of Art, University of Kansas, 1989.0015.02. Between 1874 and 1885 Burty hired print maker Félix Hilaire Buhot to create a portfolio of ten prints, later published commercially, featuring examples from the various categories of Japanese arts he collected. This sheet depicts a Japanese demon mask (*ko-besihimi* type) for the Nō theater. The inscription in black ink to the left of the mask records the name of the mask maker (Deme Yūkan, d. 1652), probably copied from the artist's inscription carved into the back of the mask. Burty intended the series to be distributed to a broad audience so as to help popularize Japanese arts.[81] The rare printing of this particular set was done on cheap, imported, and previously used Chinese paper. The red characters, printed in China, and appearing upside down in this composition, impart an exotic Oriental aura to the image.

Plate 3-25 *Amida Buddha*, originally from Banryūji, Meguro District, Tokyo, mid-18th century. Cast bronze, height 440 cm. Musée Cernuschi, Paris. Photo © Philippe Ladet/ Musée Cernuschi/Roger-Viollet/The Image Works. This statue was one of the most famous objects Henri Cernuschi brought back to Paris from Japan. The public first saw it when he lent his collection to an exhibition at the Palais de L'Industrie in 1873–4. Afterwards, it held a prominent place in his Parisian mansion that, upon his death in 1896, was turned into a public museum. Theodore Duret (p. 141) made it even more famous with inclusion of it in his book, *Voyage en Asie* (1874), and his evocative comments that "his features convey absolute calm, the absence of passion and of desire, and the stamp of this type of ecstasy particular to Buddha, who, detached from everything and freed from life, has achieved the dissolution of his own feelings, even of his personality; that is to say, all that Buddhist metaphysicians and theologians could conceive or dream, the artist has here realized in bronze."[82]

Elsewhere he commented on the propensity of the Japanese to create wonderfully wrought *useful* objects, declaring "the mechanical perfection of Japanese carpentry, metal work, papers, leather, in short whatever they manufacture, from a mammoth bell down to a box-hinge or hairpin (Plate 3-23), is quite as conspicuous to the eye of a mechanic as are the aesthetic features of objects of art to an artist's senses."[80]

Philippe Burty (French, 1830–1890)

Burty was an early art critic who advocated appreciation of Impressionist artists and other new art trends, as well as a writer and collector of Japanese arts. His enormous and diverse collection of Japanese art (sold after his death) included woodblock prints, sword guards, bronze sculptures, ceramics, lacquers, theatrical masks (Plate 3-24), *inrō*, and textiles. His friends and associates in the art world included the art dealer Siegfred Bing (p. 122), from whom he acquired some of his art and for whose journal he contributed essays on ceramics and pottery, and artists Edouard Manet (1832–1883), John La Farge (p. 118), and James McNeill Whistler, the latter also patronized by Marcus Huish (p. 123). So enthralled was he with all things Japanese that he helped found the secret Jing-Lar Society in Sèvres, France (home of the Sèvres Porcelain Manufactory), in 1866–7. This small group of like-minded artists and writers

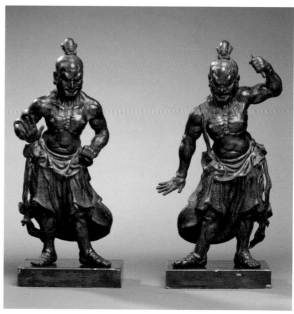

Plate 3-26 (left) Unidentified Artist of the Chōshū School, *Sword guard (tsuba) with openwork design of insects and autumn grasses*, 18ᵗʰ century. Iron, diameter 7.1 cm. The Walters Art Museum, 51.403. Sword guards were among the most popular Japanese decorative arts collected in France in the late nineteenth century and Louis Gonse (p. 142) featured a number of them in his book. This one, with its abstracted, asymmetrical design of imagery from the natural world exemplifies the type that was most in vogue in Gonse's day.

Plate 3-27 (right) Ogawa Ritsuō (Haritsu; 1663–1747), *Pair of Niō Guardians*. Carved and stained softwood with paint-lacquer decoration to the skirts, height of Misshaku (right) 24.7 cm, height of Naraen (left) 24.6 cm. Collection of Sydney L. Moss, Ltd. In his book *Japanese Art*, Sadakichi Hartmann (p. 142) praised Ritsuō's sculpture and described him as "the most skillful lacquerer the world has ever known."[83] His comments relied on an article, "Ritsuō and His School," by British collector Ernest Hart, that had appeared in *Artistic Japan*. There, Hart illustrated these Niō and commended them for preserving the grandeur and strength of the celebrated originals they copied."[84]

gathered to celebrate Japanese culture by dressing in kimono and eating Japanese food with chopsticks. Burty's interest in Japanese arts related to his desire to see them used as models for the decorative artists of his country, whose works he considered lackluster. He admired Japanese artists' technical virtuosity and incorporation of themes from nature, which he linked to Western aesthetics associated with romanticism. His writings in various journals highlighted not only

Japanese aesthetics and design characteristics (asymmetry, color sensibility, facility in drawing) but also the manners and customs of the Japanese people, which he, like many others of his time, considered inseparable from understanding the culture's art forms. He is perhaps best known for coining the widely used French term *Japonisme*, in an article for the journal *La Renaissance Littéraire et Artistique* in 1872, which he defined as "a new field of study—artistic, historic, and ethnographic."[85]

Théodore Duret (French, 1838–1927)

Duret was a political journalist and an important art critic, the first to promote Impressionism, and who later in life coined the term *avant garde*. His interest in Japan was aroused during a three-month stay in 1871, part of a grand tour of Asia that he undertook together with his friend, the collector Henri (Enrico) Cernuschi (1821–1896), an Italian émigré banker who resided in Paris. Duret became especially smitten

with Japanese prints, which he collected and gave to the Bibliothèque Nationale in Paris in 1900. His 1882 book on Katushika Hokusai helped propel that artist's fame in Europe.[86] He was also acquainted with Siegfred Bing (p. 122), for whose journal, *Artistic Japan*, he contributed articles about engraving on Japanese prints and the decorative artistry of Japanese combs, noting that the Japanese were the first to transform the comb into an ornamental object. Duret also helped to stimulate Western interest in Buddhism, its material culture, and in Cernuschi's vast collection of Buddhist art in his 1874 book, *Voyage en Asie*[87] (see Plate 3-25).

Louis Gonse (French, 1846–1921)

Gonse was a well respected art critic whose friends included Siegfred Bing (p. 122), collector Henri Cernuschi, Philippe Burty (p. 140), Theodore Duret (p. 141), and other Japanese art enthusiasts. Gonse holds the distinction of being the first foreigner to author a major historical survey in a Western language on the art of Japan, *L'Art Japonais*, which was originally published in French in 1883 and translated into English in 1891.[88] It featured many works from Cernuschi's collection, including the Buddha statue that Duret had praised in his book *Voyage en Asie* (Plate 3-25), and objects from Bing's and Burty's collections, as well as from his own, which included

netsuke carvings (judging from the examples he included in his book, he appears to have been partial to animals), sword guards (see Plate 3-26), masks, and ceramics. In *L'Art Japonais*, he extolled highest praise upon lacquers, which he described as "the glory of Japan." Gonse also contributed to his friend Bing's journal, *Artistic Japan*, where, for the first issue (1888), he famously described the Japanese as "the foremost decorators in the world" in his essay "Génie des Japonais dans le Décor" (The genius of the Japanese in décor). For number 23 of that journal (1890), he excerpted passages from his book in an article about the design genius of the Rinpa School painter Ogata Kōrin (1658–1716), the first in the West to do so.[89] The Rinpa School and Kōrin, in particular, were later highly praised by Ernest Fenollosa (p. 134), as noted above.[90]

Sadakichi Hartmann (Japanese/German/American, 1867–1944)

Hartmann was an art critic who wrote about a wide range of visual, literary, and dramatic art forms, including American and Japanese art, photography, and the aesthetics of Japanese-style poetry and Nō drama. He is best known today as a pioneer of photography criticism.[91] Poet Kenneth Rexroth (1905–1982) credited him as the first to write in English using the Japanese short three-line poetic form of *haiku* (*haikai*) and the longer verse form

of *tanka*.[92] Hartmann was born in Nagasaki, Japan, to a Japanese mother and a German businessman father, but after his mother died in childbirth he was sent him to live with relatives in Hamburg, Germany. Upon remarriage, his father enrolled him in military school, but he rebelled, was disinherited, and at age fourteen was sent to America to live with relatives in Philadelphia. There he worked in menial jobs by day and voraciously studied art at night. Hartmann furthered his studies through self-financed summer trips to Europe. Ambitious, inquisitive, brazen, and passionate, he befriended the elderly poet Walt Whitman (1819–1892), for whom he occasionally translated German correspondence, and who inspired

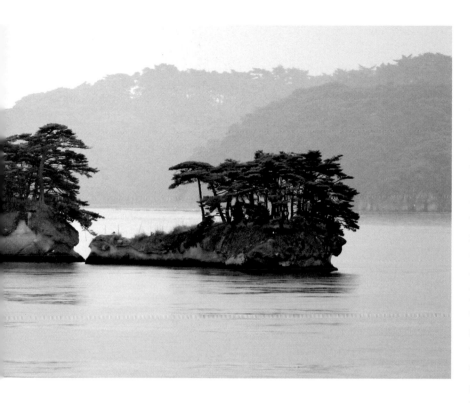

Plate 3-28 *View of Matsushima*. Photograph © Greir11/Dreamstime.com. As a poet, Laurence Binyon is most famous for his war poem, "For the Fallen," written in 1914. But his poems about some of Japan's most sacred historic sites—Mt Kōya, Matsushima, Hakone, and Miyajima—written following his 1929 trip to Japan are admired for the contemplative imagery that reveals his deep love and knowledge of Japanese culture. Scholarly in tone, they have been described as "early examples of a sober receptiveness to Japanese culture."[96] The first stanza of Binyon's poem "Matsushima" is quoted below.[97]

O paradise of waters and of isles that gleam,
Dark pines on scarps that flame white in a mirrored sky,
A hundred isles that change like a dissolving dream
From shape to shape for them that with the wind glide by!

him to pursue a career in the arts. Because of his Japanese heritage and its popularity in the art world of his day, Hartmann was drawn to all things Japanese. His Asian appearance gave him an air of authority about what was then called Oriental art, despite his upbringing entirely in the West. In an article in the *Paris Herald* (September 1906), writer Vance Thompson described him as

"[o]ne of the strangest and most original men of letters of the day…. He was born in the land of wistarias and chrysanthemums, and he sees life with that Japanese anarchy of perspective. His gifts are abundant and multiform, and his genius for writing has many modes and moods. He is lyric, naive and mystic, brutally realistic, dramatic at turns and for all that eminently oriental."[93]

Hartmann's writings on Japanese art bear consideration because he was the first writer to address the influence of Japanese art and design on American artists in his two-volume survey book (1902),[94] where he commented on Japanese influence on artists such as Arthur Wesley Dow (p. 121). Hartmann only wrote one book specifically on Japanese art (1903),[95] that he described as a publication for the layman, with a bibliography that indicated his familiarity with all the major Western writers on both Japanese art and culture, whom he often paraphrased (see Plate 3-27), and with chapters that surveyed the usual types of arts, arranged loosely within an overly simplified historical framework emphasizing the art of his own time.

Laurence Binyon (British, 1869–1943)

Binyon was a prolific poet, playwright, and art historian with expertise in British, Persian, and Japanese pictorial arts. He worked at the British Museum for the duration of his career, from 1893 to 1933, first as an assistant in the Departments of Printed Books, and Prints and Drawings, and from 1913 as the first Keeper of the new Department of Oriental Prints and Drawings. That appointment followed publication, in 1908, of a broad survey book on the history of East Asian painting which helped elevate his status to the foremost authority in the West on Japanese pictorial arts.[98] In the book, he echoed the

praises of Ernest Fenollosa (p. 134) and others that the paintings of the Rinpa School should be considered as the "supreme achievements of pictorial design."[99] Binyon's dual vocations, as both a talented poet and respected art historian, enabled him to influence individuals with varied interests in Japan, including Arthur Waley (1889–1966), the eminent scholar and translator of Chinese and Japanese literature who was his assistant at the museum, and the poet Ezra Pound. Fairly early in his career, in 1911, he contributed a volume to publisher John Murray's extensive *Wisdom of the East Series*, where in language both poetic and erudite he endeavored to explain to Westerners motivations of Chinese and Japanese painters, with special focus on the significance of nature.[100] His text explored both the spiritual basis for Far Eastern painting as well as its formalist design characteristics, describing the painters' emphasis on light and shade with Fenollosa and Dow's term *nōtan*, which he equated on page 86 of his book with the Western term "chiaroscuro." Binyon made only one trip to Japan, in 1929 (see Plate 3-28), to present a series of lectures at Tokyo Imperial University in which he compared Western and Japanese art and cultural traditions. In 1933–4, he delivered a series of six lectures at Harvard University in its Charles Eliot Norton Lecture series that were subsequently published in a volume he dedicated to Langdon Warner (p. 144).[101] In it, he addressed some of the major themes and topics

that had engaged his interest over the course of his career, including the influence of Zen on East Asian arts and *ukiyoe*. He made references to the writings of Okakura Kakuzō (p. 136) about the shared heritage of Asian art, and Arthur Waley's recent and now classic translation of *The Tale of Genji*.

Langdon Warner (American, 1881–1955)

An art historian and curator, Warner learned to appreciate Japanese art and design from an impressive group of mentors, all members of the first generation of scholars, collectors, and curators of Japanese art at the Museum of Fine Arts Boston: Denman Wald Ross (p. 120), Okakura Kakuzō (p. 136), and Yanagi Sōetsu (p. 138). From Okakura, Warner learned about the *chanoyu* tea ceremony and its aesthetics. From Ross and, through him indirectly, from Ernest Fenollosa (p. 134), he acquired a fondness for Japanese design and craftsmanship. From Yanagi, Warner developed an interest in *mingei*. Although his temperament prevented him from pursuing an advanced degree, Warner eventually became one of the most influential Asian art historians in the United States. After graduating from Harvard in 1903, he came under the tutelage of Okakura, who sent him off to Japan for training before allowing him to work as his assistant at the Museum of Fine Arts Boston. Before he parted from the museum in 1913 for a more glamorous

position as head of archaeological expeditions in China and Inner Asia, he organized, in 1910, an exhibition on Japanese stencils from the collection of William Sturgis Bigelow, noting in the catalogue introduction, published in the museum's *Bulletin*, that typically "the processes have interested this Museum much less than results, and we have seldom gone into the technique of the arts of which we possess examples."[102] This fascination with the process of art creation in relation to stencils was probably derived from acquaintance with the highly influential art educator Arthur Wesley Dow (p. 121), an outspoken advocate of their usefulness as teaching tools. For much of his later career, he worked at Harvard as curator and lecturer, in the same department as Denman Ross, where he taught the first ever course on Oriental art at any American university. In addition, he served as director of the Philadelphia Museum of Art and advised the Cleveland Museum of Art and the Nelson-Atkins Museum of Art on Asian acquisitions. He also coordinated several major loan exhibitions of treasures from Japan, both before and after World War II, in cooperation with Japanese officials, including Tsuda Noritake (p. 148), for the Arts of the Pacific Basin exhibition in San Francisco in 1939. His greatest love was for Japanese Buddhist sculpture, about which he published several volumes in the pre-war period, but he is best remembered for his small but thoughtful late

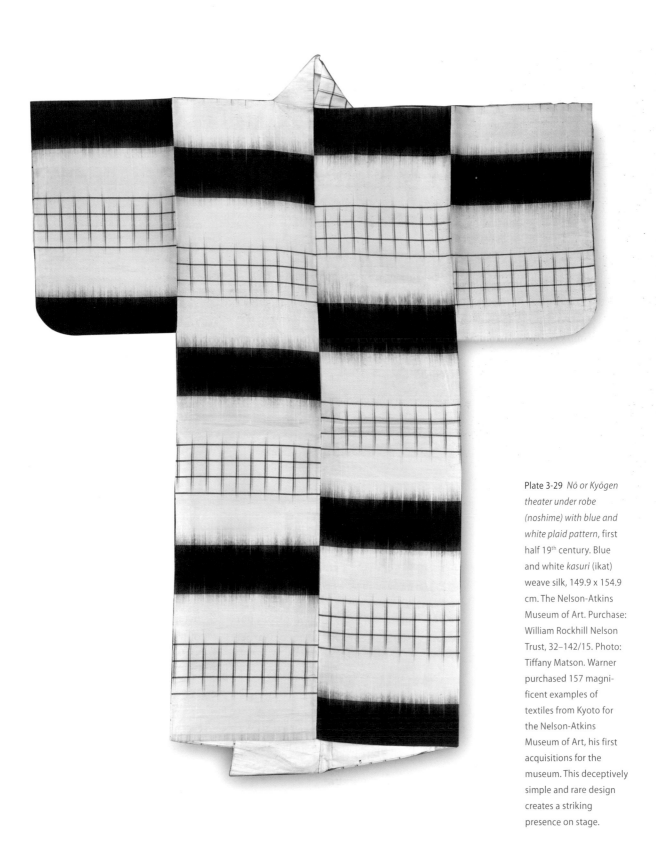

Plate 3-29 *Nō or Kyōgen theater under robe (noshime) with blue and white plaid pattern*, first half 19th century. Blue and white *kasuri* (ikat) weave silk, 149.9 x 154.9 cm. The Nelson-Atkins Museum of Art. Purchase: William Rockhill Nelson Trust, 32–142/15. Photo: Tiffany Matson. Warner purchased 157 magnificent examples of textiles from Kyoto for the Nelson-Atkins Museum of Art, his first acquisitions for the museum. This deceptively simple and rare design creates a striking presence on stage.

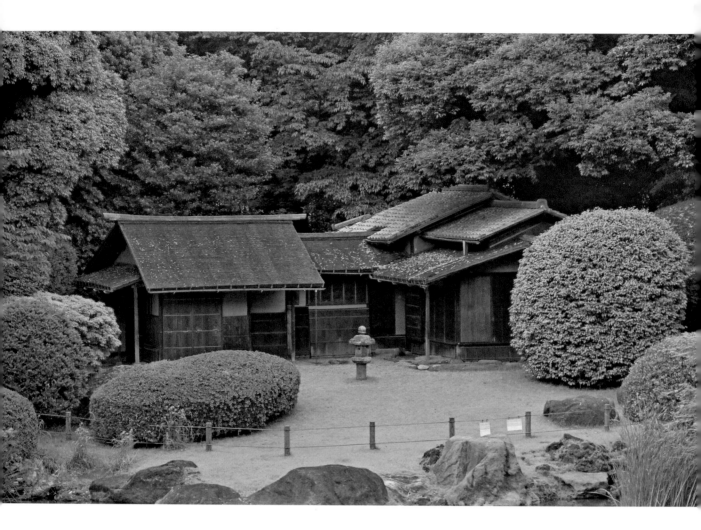

Plate 3-30 *Chanoyu tea house in the garden of the Tokyo National Museum.* Photo: Patricia J. Graham, May 2012. This tea house was designed by tea master Kobori Enshū (1579–1647) for his private residence in Kyoto. After being relocated several times, it came into the collection of the Tokyo National Museum in 1963. The rustic appearance of the structure, with its plain wood surfaces and thatch roof, epitomizes the understated and humble aesthetics of *chanoyu* praised by Harada Jirō.

work, *The Enduring Art of Japan* (1952), in which he expressed the aesthetic and cultural values that he so admired in the Japanese people.[103] There, he wrote of the many ways attentiveness to nature nurtured the artist. In a chapter on Buddhism, he wrote "nature suggests the materials used by the artist and the limitations that cramp him,"[104] and in a chapter on Japan's native religion of Shinto as "nurse of the arts," he mused that "possession of the mysteries of a craft means nothing less than a power over nature gods and it creates a priest out of the man who controls it."[105] Influenced by Yanagi in his comments about folk art, he remarked that "an individual genius, however his accomplishment may astonish and delight us, will always express himself and will therefore necessarily be of less significance than an artist who expresses us all."[106] These sorts of impassioned remarks endeared him to his students, and his many friends in Japan, where he remains a much beloved figure for whom four memorials were erected posthumously in recognition of his efforts to save historic monuments and arts from bombings during World War II.[107]

Harada Jirō (Japanese, 1878–1963)

Harada worked for many years at the Imperial Household Agency, the administrative body to the Tokyo Imperial Museum (now the Tokyo National Museum). He authored numerous books about traditional Japanese art and aesthetics in English between 1928 and 1954, on topics as varied as Japanese landscape gardening (which he tied to Japanese concepts of spirituality), architecture, including the Shugakuin and Katsura Imperial Villas, and the eighth century Shōsōin Imperial Treasure House at Tōdaiji, Nara, as well as masks, textiles, woodblock printing, and incense boxes.[108] Although many details of his life remain unknown, he obviously had a great command of English, probably having learned it as a child, as did D. T. Suzuki (p. 137), who was his contemporary and whose views on the uniqueness of Japanese aesthetics seem similar to those Harada expressed in his books, especially his *A Glimpse of Japanese Ideals* (1937).[109] That book compiled some of the lectures he presented at various universities in the United States over the course of thirteen months beginning in the autumn of 1935. His trip and the book that resulted were sponsored by the Society for Intercultural Relations, which arranged for him to have a visiting lectureship at the University of Oregon for fall and winter terms and to lecture at other universities on the Pacific West Coast and in Boston in the spring, to help promote the exhibition of Japanese art treasures that took place at the Museum of Fine Arts Boston in 1936. The tone of his writing is learned and engaging but also off-putting because of its digression into imperialist and nationalist rhetoric, for example, describing the number one character of the Japanese people as their spirit of loyalty and patriotism[110] and that their "taste for art and refinement [was] side by side with their admiration for military prowess."[111] Harada's lectures and his writings all focused on sophisticated pre-modern Japanese arts associated with the élites of society, most of which had been designated as National Treasures or Important Cultural Properties by the Japanese government. These arts had never before been displayed in the West and he made a point of emphasizing to his audiences that there was so much more to appreciate about Japanese art than the *ukiyoe* prints that were then widely collected in the West.

Plate 3-31 *Kinkakuji (Golden Pavilion) and garden, Rokuonji, Kyoto National Treasure.* Photograph © Denimjuls/Dreamstime.com. Originally built in the 1390s as the private retreat of a wealthy and powerful warrior ruler, it was turned into a Buddhist memorial temple to him after his death. It was destroyed by arson in 1950 and meticulously reconstructed in 1964. The Kinkakuji pavilion and its garden, still a top tourist destination in Kyoto today, were among the famous temple sites featured in Tsuda Noritake's *Handbook of Japanese Art*.

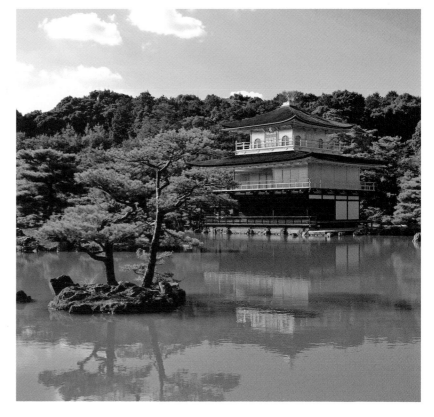

He stressed the aesthetics of *shibumi* (otherwise known as *shibui*), *sabi*, and *wabi*, which had emerged in tandem with the *chanoyu* tea ceremony, expanding upon the writings of Okakura (p. 136). Harada described *chanoyu* as "an institution founded on the adoration of the beautiful in the midst of the sordid facts of everyday life"[112] and implied, rather simplistically, that its five guiding principles—sincerity, harmony, respect, cleanliness, and tranquility[113]—had impacted various facets of Japanese culture and art, including its architecture, landscape gardening, calligraphy, painting, applied arts, interior decoration, and etiquette[114] and represented the driving force of Japanese aesthetics.

Tsuda Noritake (Japanese, 1883–ca. 1961)

Tsuda was an enigmatic and prolific pre-war scholar who did graduate studies at Tokyo Imperial University in religion and Asian art. He was employed in succession from the 1910s through the 1930s by the Tokyo Imperial Museum, the Metropolitan Museum of Art in New York, the Imperial Japanese Railways, and the Society for Intercultural Relations. His many publications reveal an enthusiasm for cultural and ethnic nationalism, evident in varied degrees in the art writings of other Japanese at that time: Okakura (p. 136), Yanagi (p. 138), and Harada (p. 147). While in the employ of the Society for International Cultural Relations in

the 1930s, in addition to writing *Handbook of Japanese Art*, an authoritative survey book on Japanese art that remains in print to this day,[115] Tsuda coordinated two US exhibitions of treasures from Japan for the Society, one in Boston in 1936 and the other in San Francisco in 1939, the latter together with organizer Langdon Warner (p. 144), whom he had met in Japan in 1918. His abovementioned book, first published in 1935, has the distinction of being the first survey of Japanese art, gardens and architecture in English by a Japanese author. It presents an official Japanese perspective, having been published in Japan by a commercial Japanese publisher working in close cooperation with the Society for International Cultural Relations for whom Tsuda was then employed. Its publication was timed to prepare the public for the 1936 Boston exhibition of Japanese treasures that Tsuda helped to coordinate. The book situated within historic, religious, and cultural contexts the buildings, gardens, and arts created by the historical élites of society and artists of prestigious lineages that the government was promoting to the world as its cultural patrimony, many having been recently designated as National Treasures (see Plate 3-31). These were described in the book's second part, a guide to major temples and museums. Collections highlighted included those of the Imperial Household (the emperor's personal collection), the three great "Imperial" national museums in

Kyoto, Nara, and Tokyo, and the most esteemed ancient temples and shrines of those cities and elsewhere. Despite its aim, Tsuda's tone throughout was never imperious but was passionate and engaging, even when describing the fine craftsmanship of the arts, which he must have included to showcase the creative genius of Japanese artists' technical skills. The book also featured a section on *ukiyoe* prints, no doubt because of their popularity with foreign audiences. The book, alas, included some obvious factual errors known as such even in his own time, errors derived from writings by Ernest Fenollosa (p. 134), whom Tsuda greatly admired.

THE LEGACY OF THE EARLY WRITERS

Despite much new scholarship on Japanese design in recent decades, older writings have not been entirely forgotten. The pre-eminence of modern and contemporary Japanese designers, and the expansion of scholarly studies of Japanese art history and visual culture, Japonisme, Japanese architectural history, and global design history, have all contributed to a wider appreciation for Japanese design. Understanding has been considerably facilitated by increased availability of many pre-war volumes on Japanese arts and design that publishers have been reprinting since the 1960s.

Plate 3-32 *Cover of "The Grammar of Japanese Ornament,"* by George Ashdown Audsley, T. W. Cutler, and Charles Newton (New York: Arch Cape Press, 1989). This reprint excerpted and compiled into a single volume the sumptuously illustrated texts by George Ashdown Audsley (*The Ornamental Arts of Japan*, 1882) and Thomas W. Cutler (*A Grammar of Japanese Ornament and Design*, 1880). Also included in the reprint are sections of a French pattern book, *Estoffes de Soie du Japan* (originally published ca.1900 by Henri Ernst).

Reprints in modest or deluxe facsimile editions include books by most, but not all, of the early writers discussed in this chapter: Alcock, Binyon, Brinkley, Conder, Dow, Dresser, Duret, Fenollosa, Harada, Hearn, Huish, Jarves, Lowell, Morse, Okakura, Ross, Siebold, Suzuki, Tsuda, Warner, and Yanagi. These reprints cater mainly to two markets—readers interested in the history of Japanese studies in the West and art and design educators/practitioners. Tuttle Publications has reprinted many books that fit the former category and Dover Publications the latter. Reprints of old books aimed at designers include some rare early volumes on narrow subjects, including *The Book of Delightful and Strange Designs: Being One Hundred Fac-Simile Illustrations of the Art of the Japanese Stencil-Cutter*, originally published in London in 1892.[116] It illustrated Japanese stencils from the collection of the book's author, British publisher Andrew Tuer (1838–1900). That book had helped spread interest in stencils as an art form, and was produced simultaneously in English, French, and German editions.

GLOSSARY

basara—outlandish elegance

bijutsu—fine arts

bijutsu kōgei—art craft

bonsai—"tray plants," the art of pruning plants for display in small pots or trays

busshi—sculptors who carved wooden Buddhist icons

chanoyu—the tea ceremony for powdered tea

chōkoku—the modern Japanese word for sculpture

chōzubachi—a stone water basin, originally found outside temples and shrines, now ubiquitous in Japanese gardens, used for cleansing (purifying) hands and mouths

Confucianism—an ancient Chinese philosophy that stresses ethical values of respect for authority but also asserted that rulers needed to govern with wisdom and compassion

Daoism (Taoism)—("the way" or "the path"), an indigenous, ancient Chinese philosophy that later developed into a complex ritual-based religion. Daoism conceives reality as emerging from a vast void at the center of the universe that generated a mysterious and omnipresent energy (*qi*), comprised of complimentary *yin* (female) and *yang* (male) forces. Its ritual practices and deities assist followers in their quest to live in harmony with these forces.

dentō kōgei—the modern Japanese language word for traditional crafts

doro yaki—low-fired, matt-finish cloisonné enameling

ehon—illustrated books

fūryū—stylish elegance

ga—elegance

gei—artistic skill

go—a Chinese board game of strategy, introduced to Japan along with Confucian values

gorintō—five element pagoda

hade—bright and exuberant beauty

haikai—short form, linked-verse poetry of three lines, each consisting of 5, 7, and 5 syllables (sometimes referred to as *haiku*)

hanami—"flower-viewing," almost always a reference to gatherings for viewing cherry blossoms

hinoki—cypress tree

hiragana—native Japanese script

honji suijaku—the joint worship of Buddhist deities (*honji*, or original gods) and Shinto *kami,* the native manifestations (*suijaku*) of the Buddhist deities

iemoto seidō—headmaster system

ikebana—the art of flower arranging

iki—stylish, sophisticated elegance

jimi—somber and proper beauty

jingasa—a flattened style samurai helmet originally worn by foot soldiers

jūni hitoe—a twelve-layer robe worn by ladies of the Heian period

kabuki—popular theater that originated in the Edo period

kabuku—outlandish elegance

kaiga—the modern Japanese language word for painting

kami—Shinto deities

karei—sumptuous elegance

karesansui—a dry landscape garden, featuring sand or gravel in place of actual water

katagami—cut paper stencils used for dyeing on cloth

kazari—modes of decoration and display

kōgei—the modern Japanese language word for crafts

kōgyō—industrial design

kosode—a small-sleeved robe, precursor of the kimono

kuwashii—superb craftsmanship

kyōka—"crazy verse;" playful poetry of the Edo period that parodied classical *waka* verse

ma—an interval in time and space

machiai—a waiting shelter for guests to tea ceremonies

makie—lacquer decorated with sprinkled metallic powders

matsuri—annual festivals held at Shinto shrines

mingei—folk crafts

mitate—literally "viewed as," an old literary term that by the 18th century came to be used in titles of *ukiyoe* prints of subjects that were humorous visual puns or allusions to classical literary themes

miyabi—opulent elegance

mono no aware—wistful melancholia for beauty lost to the passage of time

mushin—emptiness

netsuke—a small carved toggle attached to silk cords draped over sashes of men's Japanese robes, the opposite end of which was fastened to small containers (*inrō*) for daily necessities, such as tobacco or medicines.

Nihonga—modern Japanese-style painting

nijiri guchi—a crawl door for guests to enter tea rooms

ningen kokuhō—Living National Treasure

Nō (Noh)—classical theatrical drama featuring masked actors, music, and chanting

nōtan—"dark–light," a Japanese design term invented by Westerners

Onmyōdō—literally "the Way of yin-yang," a set of syncretic Japanese ritualistic practices that encompass divination, setting of the calendar, and performance of protective rites, based on Chinese Confucian and Daoist cosmological beliefs in conjunction with aspects of esoteric Buddhism and Shugendō (an indigenous Japanese hybrid Buddhist belief system based on shamanistic folk practices drawn from Shinto and Daoism).

qin—a Chinese zither-like stringed instrument, favored by Confucian scholars

ranma—transom in a Japanese room

Rinpa (Rimpa)—"art of the Korin School", a decorative style of Japanese painting first created in the 17th century

roji—gardens that lead to tea rooms

rōnin—masterless samurai warriors

sabi—appreciation for beauty in old and withered things

sekibutsu—stone Buddhist statues, usually carved by and for commoners

sekku—dates of annual purification festivals marking seasonal passages (1/1, 3/3, 5/5, 7/7, 9/9)

sencha—steeped leaf tea; also the name of the tea ceremony featuring steeped tea

seppuku—ritual, often forced, suicide

shakkei—"borrowed scenery," a style of traditional Japanese garden design incorporating natural features beyond the boundaries of the garden proper

shibui (adjective form of the noun: *shibusa* or *shibumi*)—subtle and unpretentious elegance

Shinto—Japan's indigenous faith, centered on *kami* worship

Shinzō—sculpture of Shinto deities

shippō yaki—cloisonné enameling

shoga—calligraphy and painting

shōgon—a Buddhist term for the sacred beauty of life

shoin—a formal style of Japanese residential architecture

shōji—paper-covered sliding doors

shokunin—a professional artisan (literally "a person who possesses a skill")

soboku—artless simplicity

suikinkutsu—a musical bamboo pipe (literally "water *qin* [zither] cave"), through which water splashes into the stone water basin (*chōzubachi*) in a Japanese garden

suki—informal, subtle elegance

sukiya—an informal form of Japanese residential architecture

sumi tsubo—an ink pot; a carpenter's tool for marking lines

tatami—rice straw mats used in traditional Japanese rooms

Tōkaidō—the major highway that linked the old imperial capital of Kyoto to Edo (Tokyo)

tokkuri—bottles designed for storing and serving saké (rice wine)

tokonoma—an essential feature of traditional Japanese rooms; an alcove for display of a hanging scroll, flower arrangement, incense burner, and other small decorative objects

torii—gateways, often red, that mark the boundary of sacred Shinto shrines

tsuba—a sword guard

tsubo niwa—a courtyard garden

tsukubai—a small, usually stone, basin or boulder, set low to the ground and filled with water for the purification of the hands and mouths of visitors to shrines, temples, and tea ceremonies

tsutsugaki—freehand paste-resist dyeing

Ukiyo—the Floating World (euphemism for licensed entertainment quarters)

wabi—rustic elegance

wabi-cha—a rustic-style tea ceremony for *chanoyu*

waka—classical Japanese poetry form of thirty-one syllables

yūgen—the medieval Japanese word for a deep and mysterious beauty

yūrei—ghost

ENDNOTES

Preface

1 From Lafcadio Hearn, *Glimpses of Unfamiliar Japan*, Boston: Houghton, Mifflin & Company, 1894, pp. 8–9. For a moving and sensitive biography of Hearn, see Jonathan Cott, *Wandering Ghost: The Odyssey of Lafcadio Hearn*, New York: Alfred A. Knopf, 1991.

2 "Craftsmanship in Japanese Arts," in Paul Kocot Nietupski, Joan O'Mara, and Karil J. Kucera (ed.), *Reading Asian Art and Artifacts: Windows to Asia on American College Campuses*, Bethlehem, Pennsylvania: Lehigh University Press, 2011, pp. 123–48.

Chapter One

1 See Kathyrn B. Hiesinger and Felice Fischer, *Japanese Design: A Survey Since 1950*, Philadelphia: Philadelphia Museum of Art, 1994; and Chiaki Ajioka, "Aspects of Twentieth-Century Crafts: The New Craft and Mingei Movements," in J. Thomas Rimer (ed.), *Since Meiji: Perspectives on the Japanese Visual Arts, 1868–2000*, Honolulu: University of Hawaii Press, 2012, pp. 408–44.

2 Information from the International House of Japan website http://www.i-house.or.jp/en/index.html <accessed December 12, 2012>

3 Mori Masahiro, Kenji Kaneko, Masanori Moroyama, and Hitomi Kitamura, *Mori Masahiro: tōjiki dezain no kakushin (Masahiro Mori, a reformer of ceramic design)*, Tokyo: Kokuritsu Kindai Bijutsukan, 2002.

4 Tange Kenzo et al., *Katsura: Tradition and Creation in Japanese Architecture*, New Haven: Yale University Press, 1960. Prior to this publication, Japanese modernist architect Sutemi Horiguchi had authored a monograph on Katsura, released only in a Japanese language edition, so it had more limited impact. See *Katsura rikyū*, Tōkyō: Mainichi Shinbunsha, 1952.

5 See Yasufumi Nakamori, *Katsura: Picturing Modernism in Japanese Architecture*, Houston: Museum of Fine Arts, 2010.

6 Isozaki Arata and Ishimoto Yasuhiro, *Katsura Villa: Space and Form*, New York: Rizzoli, 1987; translation of their Japanese language edition, 1983.

7 Isozaki Arata and Virginia Ponciroli, *Katsura Imperial Villa*, Milan: Electa Architecture, 2004.

8 Ibid, pp. 17–18.

9 Ibid, p. 30.

10 *House Beautiful*, 102/8, 1960, p. 4, quotation from caption to the cover image of Katsura, written by Gordon.

11 See Monica Michelle Penick, "The Pace Setter Houses: Livable Modernism in Postwar America," Ph.D. Dissertation, University of Texas at Austin, 2007.

12 John Kenneth Galbraith, *The Affluent Society*, Boston, Houghton Mifflin, 1958. For a discussion of Gordon's and others' responses to this book, see Robert Hobbs, "Affluence, Taste, and the Brokering of Knowledge: Notes on the Social Context of Early Conceptual Art," in Michael Corris (ed.), *Conceptual Art: Theory Myth, and Practice*, Cambridge: Cambridge University Press, 2004, pp. 200–2.

13 As quoted in Hobbs, "Affluence, Taste, and the Brokering of Knowledge," p. 205.

14 Ibid, p. 207.

15 Gordon's papers relating to these issues are now part of the repository of the Archives of the Freer Gallery of Art and Arthur M. Sackler Gallery of the Smithsonian Institution.

16 Elizabeth Gordon, "The Profits of a Long Experience with Beauty," *House Beautiful*, 102/8, p. 87.

17 Elizabeth Gordon, "The Four Kinds of Japanese Beauty," *House Beautiful*, 102/8, p. 120.

18 Elizabeth Gordon, from a caption to an illustration for the article "What Japan Can Contribute to Your Way of Life, *House Beautiful*, 102/8, p. 55.

19 Anthony West, "What Japan Has That We May Profitably Borrow," *House Beautiful*, 102/8, 1960, p. 75.

20 Seizō Hayashiya, *Chanoyu: Japanese Tea Ceremony*, New York: Japan Society, 1979. See also H. Paul Varley and Isao Kumakura, *Tea in Japan: Essays on the History of Chanoyu*, Honolulu: University of Hawaii Press, 1989, especially pp. 238–41.

21 See Teiji Itō, Ikkō Tanaka, and Tsune Sesoko, *Wabi, Sabi, Suki: The Essence of Japanese Beauty*, Hiroshima: Mazda Motor Co., 1993.

22 D. T. Suzuki, *Zen and Japanese Culture*, New York: Pantheon, and London: Routledge and Kegan Paul, 1959, pp. 23–4.

23 Yanagi Sōetsu and Bernard Leach, *The Unknown Craftsman: A Japanese Insight into Beauty*, Tokyo: Kodansha International, 1972, p. 123.

24 Elizabeth Gordon, "The Bloom of Time Called Wabi and Sabi," *House Beautiful*, 102/8, 1960, pp. 96–7.

25 Ibid, p. 97.

26 Leonard Koren, *Wabi-Sabi for Artists, Designers, Poets and Philosophers*, Berkeley, California: Stone Bridge Press, 1994.

27 Penelope Green, "At Home With Leonard Koren: An Idiosyncratic Designer, a Serene New Home," *The New York Times*, September 23, 2010.

28 See, for example, Robyn Griggs Lawrence, *The Wabi-Sabi House: The Japanese Art of Imperfect Beauty*, New York: Clarkson Potter, 2004; Mark Reibstein and Ed Young, *Wabi Sabi*, New York: Little, Brown, 2008, a children's book featuring a cat living in Kyoto named Wabi Sabi who embarks on a quest to discover the meaning of its name; and Arielle Ford, *Wabi Sabi Love: The Ancient Art of Finding Perfect Love in Imperfect Relationships*, New York: HarperOne, 2012.

29 As quoted in Gordon, "The Bloom of Time Called *Wabi* and *Sabi*," p. 123.

30 Ibid, p. 94.

31 Hiroshi Nara, *The Structure of Detachment: The Aesthetic Vision of Kuki Shūzō*, with a translation of *Iki no kōzō*, Honolulu: University of Hawaii Press, 2004, p. 1.

32 Ibid, pp. 30–2.

33 Quotation from Doris Croissant, "Icons of Feminity: Japanese National Painting and the Paradox of Modernity," in Joshua S. Mostow, Norman Bryson, and Maribeth Graybill (ed.), *Gender and Power in the Japanese Visual Field*, Honolulu: University of Hawai'i Press, 2003, p. 135.

34 Nara, *The Structure of Detachment*, p. 41.

35 Ibid, p. 50.

36 See the discussion of *fūryū* in Nobuo Tsuji, "Ornament (*Kazari*): An Approach to Japanese Culture," *Archives of Asian Art*, 47, 1994, pp. 36–9.

37 See Patricia J. Graham, *Tea of the Sages: The Art of Sencha*, Honolulu: University of Hawai'i Press, 1998.

38 As defined by John T. Carpenter in "'Twisted' Poses: The *Kabuku* Aesthetic in Early Edo Genre Painting," in Nicole Coolidge Rousmaniere (ed.), *Kazari: Decoration and Display in Japan 15th–19th Centuries*, London: The British Museum, 2002, pp. 42–4, and Carpenter's introduction to section two of this volume, "Swagger of the New Military Elite: First Half of the 17th Century," pp. 114–15.

39 Ibid, p. 43.

40 Professor Tsuji's extensive publications on this subject include *Kisō no keifu: Matabe–Kuniyoshi*, originally published in Japanese in 1970 and translated into English as *Lineage of Eccentrics: Matabei to Kuniyoshi*, Tokyo: Kaikai Kiki Co., 2012; and *Playfulness in Japanese Art*, The Franklin Murphy Lectures VII, Lawrence, Kansas: Spencer Museum of Art, University of Kansas, 1986.

41 Tenmyouya Hisashi, *Basara: Japanese Art Theory Crossing Borders, From Jomon Pottery to Decorated Trunks*, Tokyo: Bijutsu Shuppan-sha, 2010, p. 11.

42 Kumakura Isao, "Keys to the Japanese Mind: The Culture of MA," *Japan Echo*, 34/1, 2007.

43 Isozaki Arata et al., *Ma: Space-Time in Japan*, New York: Cooper-Hewitt Museum, 1979. The exhibition also traveled to Paris.

44 See Isozaki's more recent writing on *ma* in Isozaki Arata, *Japan-ness in Architecture*, Cambridge, Masachusetts: MIT Press, 2006, especially "*Ma* (Interstice) and Rubble," pp. 81–100.

45 Ibid, p. 12.

46 Gian Carlo Calza, *Japan Style*, London: Phaidon Press, 2007, p. 110.

47 Ibid.

48 Koike Kazuo (ed.) (trans. Ken Frankel and Yumiko Ide), *Issey Miyake: East Meets West*

(*Miyake Issei no hasso to tankan*), Tokyo: Heibonsha, 1978.

49 Arthur C. Danto, "Dialogues with Clay and Color," in Susan Peterson, *Jun Kaneko*, London: Laurence King Publishing, 2001, p. 11.

50 Tanizaki Jun'ichirō (trans. Thomas J. Harper and Edward G. Seidensticker), *In Praise of Shadows*, New Haven: Leete's Island Books, 1977, p. 14.

51 Ibid, p. 19.

52 Dorr Bothwell and Marlys Mayfield, *Notan: The Dark–Light Principle of Design*, New York: Reinhold Book Corp., 1968; reprinted New York: Dover, 1991.

53 Ibid, Dover reprint, pp. 6–7.

54 Ibid, p. 78.

55 As correctly explained by Joseph Masheck in his essay, "Dow's 'Way' to Modernity for Everybody," in Arthur W. Dow and Joseph Masheck, *Composition: A Series of Exercises in Art Structure for the Use of Students and Teachers*, Berkeley: University of California Press, 1997, p. 21. This book is a reprint of Dow's original book on the subject, with a slightly different title, *Composition: A Series of Exercises Selected from a New System of Art Education, Part I*, Boston: J. M. Bowles, 1899.

56 Sharon Himes, "Notan: Design in Light and Dark," *ArtCafe*, March 9, 2011 http://artcafe.net/?p=117 <accessed December 12, 2012>

57 See Yūzō Yamane, "The Formation and Development of Rimpa Art," in Yūzō Yamane, Masato Naitō, and Timothy Clark, *Rimpa Art From the Idemitsu Collection, Tokyo*, London: British Museum Press, 1998, pp. 13–14.

58 John T. Carpenter, *Designing Nature: The Rinpa Aesthetic in Japanese Art*, New York: Metropolitan Museum of Art, 2012, p. 11.

59 Sherman E. Lee, *Japanese Decorative Style*, Cleveland: Cleveland Museum of Art, 1961, p. 7.

60 Ibid, p. 8.

61 Sherman E. Lee, *The Genius of Japanese Design*, Tokyo: Kodansha International, 1981.

62 Michael Dunn et al., *Traditional Japanese Design: Five Tastes*, New York: Harry N. Abrams, 2001.

63 Michael Dunn, *Inspired Design: Japan's Traditional Arts*, Milan: 5 Continents Editions, 2005.

64 Nicole Coolidge Rousmaniere, "Arts of *Kazari*: Japan on Display," in Nicole Coolidge Rousmaniere (ed.), *Kazari: Decoration and Display in Japan 15th–19th Centuries*, London: The British Museum, 2002, pp. 20–1.

65 Calza, *Japan Style*, p. 9.

66 Ibid, p. 109.

Chapter Two

1 Langdon Warner, *The Enduring Art of Japan*, Cambridge: Harvard University Press, 1952; reprint New York: Grove Press, 1978, pp. 18–19.

2 See Shinji Turner-Yamamoto, Patricia Graham, and Justine Ludwig, *Shinji Turner-Yamamoto Global Tree Project*, Bologna: Damiani Editore, 2012.

3 See Jacquelynn Baas and Mary Jane Jacob (eds.), *Buddha Mind in Contemporary Art*, Berkeley: University of California Press, 2004, p. 265.

4 Gian Carlo Calza, *Japan Style*, London: Phaidon Press, 2007, p. 33.

5 On *mono no aware*, see Shuji Takashina, "The Japanese Sense of Beauty," in Alexandra Munroe (ed.), *From the Suntory Museum of Art, Autumn Grasses and Water: Motifs in Japanese Art*, New York: Japan Society, 1983, pp. 10–11. See also Haruo Shirane, *Japan and the Culture of the Four Seasons: Nature, Literature, and the Arts*, New York: Columbia University Press, 2012.

6 On *yūgen*, see Richard B. Pilgrim, *Buddhism and the Arts of Japan*, New York: Columbia University Press, 1993, second revised edition, pp. 35–8; Stephen Addiss, Gerald Groemer, and J. Thomas Rimer, *Traditional Japanese Arts and Culture: An Illustrated Sourcebook*, Honolulu: University of Hawai'i Press, 2006, pp. 93–5; and Graham Parkes, "Japanese Aesthetics," *The Stanford Encyclopedia of Philosophy* (ed. Edward N. Zalta) 2011 edition, <http://plato.stanford.edu/archives/win2011/entries/japanese-aesthetics/ <accessed December 15, 2012>

7 Dōshin Satō, *Modern Japanese Art and The Meiji State: The Politics of Beauty*, Los Angeles: Getty Research Institute, 2011, pp. 70–8; originally published as *Meiji kokka to kindai bijutsu: bi no seijigaku*, Tokyo: Yoshikawa Kōbunkan, 1999.

8 Ibid, p. 78.

9 Rupert Faulkner, *Japanese Studio Crafts: Tradition and the Avant-Garde*, London: The Victoria and Albert Museum, 1995, p. 12.

10 On crafts makers designated as Living National Treasures and others, see Nicole Rousmaniere (ed.), *Crafting Beauty in Modern Japan: Celebrating Fifty Years of the Japan Traditional Art Crafts Exhibition*, Seattle: University of Washington Press, 2007. See also Masataka Ogawa et al., *The Enduring Crafts of Japan: 33 Living National Treasures*, New York: Walker/Weatherhill, 1968. For a survey of traditional crafts made in Japan today, see Diane Durston, *Japan Crafts Sourcebook: A Guide to Today's Traditional Handmade Objects*, Tokyo: Kodansha International, 1996.

11 Uchiyama Takao, "The Japan Traditional Art Crafts Exhibition: Its History and Spirit," in Nicole Rousmaniere (ed.), *Crafting Beauty in Modern Japan: Celebrating Fifty Years of the Japan Traditional Art Crafts Exhibition*, Seattle: University of Washington Press, 2007, p. 32.

12 Rupert Faulkner, "Sōdeisha: Engine Room of the Japanese Avant-garde," in Joan B. Mirviss Ltd (ed.), *Birds of Dawn: Pioneers of Japan's Sōdeisha Ceramic Movement*, New York: Joan B. Mirviss Ltd, 2011, pp. 11–17.

13 O-Young Lee, *The Compact Culture: The Japanese Tradition of Smaller Is Better*, Tokyo: Kodansha International, 1984, p. 19. Lee (b. 1934) is a well respected cultural critic who has spent time as a researcher and professor in Japan and served as Korea's first Minister of Culture.

14 Ibid, p. 22. This point is also made by Shuji Takashina in "The Japanese Sense of Beauty," in Alexandra Munroe (ed.), *From the Suntory Museum of Art, Autumn Grasses and Water*, New York: Japan Society, 1983, p. 10.

15 See Isabella Stewart Gardner Museum (ed.), "Competition and Collaboration: Hereditary Schools in Japanese Culture," *Fenway Court*, Boston: Isabella Stewart Gardner Museum, 1992; and P. G. O'Neill, "Organization and Authority in the Traditional Arts," *Modern Asian Studies*, 8/4, 1984, pp. 631–45.

16 See Roger S. Keyes, *Ehon: The Artist of the Book in Japan*, New York: The New York Public Library, 2006.

17 Morgan Pitelka, *Handmade Culture: Raku Potters, Patrons, and Tea Practitioners in Japan*, Honolulu: University of Hawai'i Press, 2005, p. 141.

18 See Haruo Shirani, *Japan and the Culture of the Four Seasons*.

19 See, for example, Conrad Totman, *The Green Archipelago: Forestry in Preindustrial Japan*, Berkeley: University of California Press, 1989; and Ian Jared Miller, Julia Adeney Thomas, and Brett L. Walker, *Japan at Nature's Edge: The Environmental Context of a Global Power*, Honolulu: University of Hawai'i Press, 2013. For a scathing critique of land abuse in contemporary Japan, see Alex Kerr, *Dogs and Demons: Tales from the Dark Side of Japan*, New York: Hill and Wang, 2001.

20 On Ōnmyōdō, see "Onmyōdō in Japanese History," *Japanese Journal of Religious Studies*, 40/1, 2013.

21 Merrily Baird, *Symbols of Japan: Thematic Motifs in Art and Design*, New York: Rizolli International, 2001, pp. 9–25.

22 On *sekku*, see U. A. Casal, *The Five Sacred Festivals of Ancient Japan: Their Symbolism and Historical Development*, Tokyo: Sophia University and Charles E. Tuttle, Co., 1967.

23 See Nobuo Tsuji, *Playfulness in Japanese Art*, Lawrence, Kansas: Spencer Museum of Art, University of Kansas, 1986; and Christine Guth, *Asobi: Play in the Arts of Japan*, Katonah, New York: Katonah Museum of Art, 1992.

24 On samurai taste, see Andreas Marks, Rhiannon Paget, and Sabine Schenk, *Lethal Beauty: Samurai Weapons and Armor*, Washington, DC: International Arts and Artists, 2012.

Chapter Three

1 Rutherford Alcock, *Art and Art Industries in Japan*, London: Virtue and Co., 1878.

2 Thomas J. Cutler, *A Grammar of Japanese Ornament and Design*, London: B. T. Batsford, 1880; and George Ashdown Audsley, *The Ornamental Arts of Japan*, London: Sampson Low, Marston, Searle & Rivington, 1882.

3 See Olive Checkland, *Japan and Britain after 1859: Creating Cultural Bridges*, London: RoutledgeCurzon, 2003, pp. 87–8.

4 For examples of what arts Japan displayed at the fairs, see Los Angeles County Museum of Art, Tokyo Kokuritsu Hakubutsukan, Nihon Hōsō Kyōkai, NHK Puromōshon, Ōsaka Shiritsu Bijutsukan, and Nagoya-shi Hakubutsukan, *Japan Goes to the World's Fairs: Japanese Art at the Great Expositions in Europe and the United States, 1867–1904*, Los Angeles, California: LACMA, Tokyo National Museum, NHK, and NHK Promotions Co., 2005. See also Ellen P. Conant, "Refractions of the Rising Sun: Japan's Participation at International Exhibitions 1862–1910," in Tomoko Sato and Toshio Watanabe (eds.), *Japan and Britain: An Aesthetic Dialogue 1850–1930*, London: Lund Humphries in association with the Barbican Art Gallery and the Setagaya Art Museum, 1991, pp. 79–92.

5 On the Boston exhibition, see Museum of Fine Arts, Boston (ed.), *Illustrated Catalogue of a Special Loan Exhibition of Art Treasures from Japan, Held in Conjunction with the Tercentenary Celebration of Harvard University, September–October, 1936*, Boston: Museum of Fine Arts, 1936. On the San Francisco exhibition, see Kokusai Bunka Shinkokai (ed.), *Catalogue of Japanese Art in the Palace of Fine and Decorative Arts at the Golden Gate International Exposition on Treasure Island, San Francisco, California, 1939*, Tokyo: Kokusai Bunka Shinkokai, 1939; Langdon Warner, "Arts of the Pacific Basin: Golden Gate International Exposition," *Magazine of Art*, 32/3, 1939; and *Pacific Cultures, Department of Fine Arts, Division of Pacific Cultures*, San Francisco: Golden Gate International Exposition, 1939.

6 The Society for International Cultural Relations (KBS) was created soon after Japan withdrew from the League of Nations in 1933 as a way to independently continue the aims of that organization through furthering international understanding about Japanese art, history, and culture. It produced numerous English language publications by both Japanese and foreign authors and sponsored lecture series and art exhibitions abroad. It was succeeded by the Japan Foundation in 1972.

7 John La Farge, "Japanese Art," in Raphael Pumpelly, John La Farge, W. J. Linton, and Julius Bien, *Across America and Asia: Notes of a Five Years' Journey Around the World, and of Residence in Arizona, Japan, and China*, New York: Leypoldt & Holt, 1870, pp. 195–202.

8 For a discussion of this point, see Henry Adams, "John La Farge's Discovery of Japanese Art: New Perspectives on the Origins of *Japonisme*," *Art Bulletin*, 67, 1985, pp. 475–6.

9 Ibid, p. 478.

10 On La Farge and Buddhism, see Christine M. E. Guth, "The Cult of Kannon Among Nineteenth Century American Japanophiles," *Orientations*, 26/11. (December 1995): pp. 28–34.

11 See Christopher Benfey, *The Great Wave: Gilded Age Misfits, Japanese Eccentrics, and the Opening of Old Japan*, New York: Random House, 2003, pp. 141–68.

12 John La Farge, *An Artist's Letters from Japan*, New York: The Century Co., 1897.

13 Biographical information based on Theodore Bowie, "Portrait of a Japanologist," in Jack Ronald Hillier and Matthi Forrer (ed.), *Essays on Japanese Art Presented to Jack Hillier*, London: R. G. Sawers Publishing, 1982, pp. 27–31.

14 Henry P. Bowie, *On the Laws of Japanese Painting: An Introduction to the Study of the Art of Japan*, San Francisco: P. Elder and Company, 1911.

15 Denman Waldo Ross, *A Theory of Pure Design: Harmony, Balance, Rhythm, With Illustrations and Diagrams*, Boston: Houghton Mifflin, 1907.

16 Ibid, p. 194.

17 For a discussion of this issue, see Marie Frank, *Denman Ross and American Design Theory*, Lebanon, New Hampshire: University Press of New England, 2011, pp. 68–72.

18 Thomas S. Michie, "Western Collecting of Japanese Stencils and Their Impact in America," in Susanna Kuo, Richard L. Wilson, and Thomas S. Michie, *Carved Paper: The Art of the Japanese Stencil*, Santa Barbara, California: Santa Barbara Museum of Art, 1998, p. 163.

19 Ibid, p. 158.

20 Kevin Nute, *Frank Lloyd Wright and Japan: The Role of Traditional Japanese Art and Architecture in the Work of Frank Lloyd Wright*, New York: Van Nostrand Reinhold, 1993, p. 86.

21 Arthur Wesley Dow, "A Note on Japanese Art and on What the American Artist May Learn There-From," *The Knight Errant*, 1/4, 1893, pp. 114–17. This article preceded his influential book on the subject, *Composition: A Series of Exercises Selected from a New System of Art Education, Part I*, Boston: J. M. Bowles, 1899.

22 Dow, "A Note on Japanese Art," p. 113.

23 Ibid, p. 115.

24 Joseph Masheck, "Dow's 'Way' to Modernity for Everybody," in Arthur W. Dow and Joseph Masheck, *Composition: A Series of Exercises in Art Structure for the Use of Students and Teachers*, Berkeley: University of California Press, 1997, p. 21.

25 Gabriel P. Weisberg, Edwin Becker, and Evelyne Possémé, *The Origins of L'art Nouveau: The Bing Empire*, Amsterdam: Van Gogh Museum, 2004.

26 See Michie, "Western Collecting of Japanese Stencils," p. 156; and Mabuchi Akiko, Takagi Yoko, Nagasaki Iwao, and Ikeda

Yuko, *Katagami Style*, exhibition catalogue (in Japanese with a separate English text supplement), Mitsubishi Ichigokan Museum, Tokyo: Nikkei, 2012.

27 Basic biographical information from Anne Helmreich, "Marcus Huish (1843–1921)," *Victorian Review*, 37/1, 2011, pp. 26–30.

28 Marcus Bourne Huish, *Japan and Its Art*, London: B. T. Batsford, third edition, 1912, p. 342.

29 Ibid, p. 5.

30 Ken Vos, "The Composition of the Siebold Collection in the National Museum of Ethnology in Leiden," *Senri Ethnological Studies*, 54, 2001, pp. 39–48.

31 Siebold never published the 700–800 paintings he collected, but his handwritten notes described them as "scientific objects" and he categorized them according to thematic topics. See W. R. van Gulik, "Scroll Paintings in the Von Siebold Collection," in Matthi Forrer, Willem R. van Gulik, Jack Ronald Hillier, and H. M. Kaempfer (eds.), *A Sheaf of Japanese Papers*, The Hague: Society for Japanese Arts and Crafts, 1979, p. 59.

32 Philipp Franz von Siebold, *Nippon. Archiv zur beschreibung von Japan und dessen neben- und schutzl ndern Jezo mit den südlichen Kurilen, Sachalin, Korea und den Liukiu-inseln*. Originally published beginning in 1832; a complete posthumous enlarged edition was published by Würzburg: L. Woerl, 1897.

33 Frank, *Denman Ross and American Design Theory*, p. 239.

34 Museum of Fine Arts Boston and Edward Sylvester Morse, *Catalogue of the Morse Collection of Japanese Pottery*, Cambridge: Riverside Press, 1900.

35 Edward Sylvester Morse, *Japan Day by Day, 1877, 1878–79, 1882–83*, two volumes, Boston: Houghton Mifflin Company, 1917.

36 Ibid, vol. 1, pp. 252–3.

37 Percival Lowell, *Occult Japan, or, The Way of the Gods: An Esoteric Study of Japanese Personality and Possession*, Boston: Houghton Mifflin and Co., 1894.

38 Percival Lowell, *The Soul of the Far East*, Boston: Houghton, Mifflin and Co., 1888.

39 Ibid, pp. 110–11.

40 Ibid, pp. 131–2.

41 Information on Dresser and Japan comes from Widar Halén, "Dresser and Japan," in Michael Whiteway (ed.), *Shock of the Old: Christopher Dresser's Design Revolution*, London: Victoria and Albert Museum Publications, 2004, pp. 127–39.

42 He first wrote about Japanese art in his book, *The Art of Decorative Design*, London: Day and Son, 1862.

43 Christopher Dresser, *Japan: Its Architecture, Art and Art Manufactures*, London: Longmans, Green, and Co., 1882; reprinted London: Kegan Paul International, 2001; reprinted New York: Dover as *Traditional Arts and Crafts of Japan*, 1994.

44 Ibid (Kegan Paul edition), p. vi.

45 Ibid, p. 114.

46 Halén, "Dresser and Japan," p. 134.

47 Biographical information comes from Fujimori
Terunobu, "Afterword: Josiah Conder and
Japan," in J. Conder, *Landscape Gardening in
Japan: With the Author's 1912 Supplement to
Landscape Gardening in Japan*, Foreword by
Azby Brown, Tokyo: Kodansha International,
2002, pp. 230–40. Terunobu's essay was
originally published in the exhibition catalogue:
Kawanabe Kusumi et al. (eds.), *Josaia Kondoru
ten: Rokumeikan no kenchikuka/Josiah Conder:
A Victorian Architect in Japan*, Tokyo: Higashi
Nihon Tetsudo Bunka Zaidan, 1997, and
also included in the enlarged reprint of that
catalogue, Suzuki Hiroyuki et al., *Josiah Conder*,
Tokyo: Kenchiku Gahōsha, 2009.

48 See Yamaguchi Seiichi, "Josiah Conder on
Japanese Studies," in Hiroyuki Suzuki et al.,
Josiah Conder, pp. 49–52.

49 Josiah Conder, *The Flowers of Japan and the Art
of Floral Arrangement*, Tokyo: Hakubunsha,
Ginza, 1891.

50 Ibid, p. 2.

51 Ibid, p. 41.

52 J. Conder and K. Ogawa, *Supplement to
Landscape Gardening in Japan,* vol. 2, Tokyo:
Kelly and Walsh, 1893, description to plate
XXII.

53 Josiah Conder, *Landscape Gardening in Japan*,
Tokyo: Kelly and Walsh, 1893; and Conder and
Ogawa, *Supplement to Landscape Gardening in
Japan*. In 1912, Conder published an expanded
and revised version of the supplement that was
reprinted by Kodansha in 2002 (see fn. 47).

54 Nute, *Frank Lloyd Wright and Japan*, p. 86.

55 Frank Lloyd Wright, *Hiroshige: An Exhibition of
Colour Prints from the Collection of Frank Lloyd
Wright*, Chicago: Art Institute of Chicago, 1906.

56 Frank Lloyd Wright, *The Japanese Print,
An Interpretation*, Chicago: Ralph Fletcher
Seymour Co., 1912.

57 Julia Meech, *Frank Lloyd Wright and the Art of
Japan: The Architect's Other Passion*, New York:
Harry N. Abrams, 2000, p. 267.

58 Ibid, p. 270.

59 *Fundamentals of Japanese Architecture*, Tokyo:
Kokusai Bunka Shinkōkai, 1936; and *Houses
and Peoples of Japan*, Tokyo: Sanseidō, 1937.

60 See Jonathan M. Reynolds, "Ise Shrine and a
Modernist Construction of Japanese Tradition,"
The Art Bulletin, 83/2, 2001, pp. 316–41.

61 For a critical biography, see Ellen P. Conant,
"Captain Frank Brinkley Resurrected," in Oliver
R. Impey and Malcolm Fairley (eds.), *The
Nasser D. Khalili Collection of Japanese Art, Umi
o watatta Nihon no bijutsu. Dai 1-kan, Ronbun
hen* (Decorative arts of the Meiji period from
the Nasser D. Khalili Collection, vol .1, Essays),
London: Kibo Foundation, 1995, pp. 124–50.

62 *Atlantic Monthly*, 70/417 (July 1892): pp. 14–33.

63 As discussed in John T. Carpenter, *Designing
Nature: The Rinpa Aesthetic in Japanese Art*,
New York: Metropolitan Museum of Art, 2012,

pp. 20–21. The painting is reproduced in Ernest
Fenollosa, *Epochs of Chinese and Japanese
Art: An Outline History of East Asiatic Design*,
London: William Heineman, 1912, vol. 2,
opposite p. 132 and discussed on p. 134.

64 Fenollosa, *Epochs of Chinese and Japanese Art*,
vol. 2, p. 129.

65 Ibid.

66 See Timothy Clark, "'The Intuition and the
Genius of Decoration:' Critical Reactions to
Rinpa Art in Europe and the USA During
the Late Nineteenth and Early Twentieth
Centuries," in Yūzō Yamane, Masato Naitō, and
Timothy Clark, *Rinpa Art: From the Idemitsu
Collection, Tokyo*, London: British Museum
Press, 1998, pp. 72–3.

67 John Clark, "Okakura Tenshin and Aesthetic
Nationalism," in J. Thomas Rimer (ed.), *Since
Meiji: Perspectives on the Japanese Visual Arts,
1868–2000*, Honolulu: University of Hawaii
Press, 2012, p. 212.

68 Ibid, pp. 236–8. For perceptive reassessments
of Okakura by numerous scholars, see also
"Beyond Tenshin: Okakura Kakuzo's Multiple
Legacies," *Review of Japanese Culture and
Society*, Josai University Journal, vol. 24, 2012.

69 Kakuzō Okakura, *The Book of Tea*, New York:
Putnam's Sons, 1906, p. 1.

70 D. T. Suzuki, *Zen and Japanese Culture*, 2010
reprint, Princeton: Princeton University Press,
p. 27.

71 Daisetz Teitaro Suzuki, *Zen Buddhism and Its
Influence on Japanese Culture*, Kyoto: Eastern
Buddhist Society, 1938.

72 See Richard Jaffe's introduction to the 2010
edition.

73 See Jane Naomi Iwamura, "Zen's Personality:
D. T. Suzuki," *Virtual Orientalism: Asian
Religions and American Popular Culture*,
New York: Oxford University Press, 2011,
pp. 23–62.

74 Muneyoshi Yanagi and Bernard Leach, *The

Unknown Craftsman: A Japanese Insight into
Beauty*, Tokyo: Kodansha International, 1972.

75 For critiques of Yanagi, see Yuko Kikuchi,
*Japanese Modernisation and Mingei Theory:
Cultural Nationalism and Oriental Orientalism*,
London: RoutledgeCurzon, 2004; and Kim
Brandt, *Kingdom of Beauty: Mingei and the
Politics of Folk Art in Imperial Japan*, Durham:
Duke University Press, 2007. See also Chiaki
Ajioka, "Aspects of Twentieth-Century Crafts:
The New Craft and Mingei Movements," in J.
Thomas Rimer (ed.), *Since Meiji: Perspectives on
the Japanese Visual Arts, 1868–2000*, Honolulu:
University of Hawaii Press, 2012, pp. 424–31.

76 Langdon Warner, *The Enduring Art of Japan*,
Cambridge: Harvard University Press, 1952,
p. 83.

77 Theodore Sizer, "James Jackson Jarves: A
Forgotten New Englander," *New England
Quarterly*, 6/2 (June 1933), p. 328.

78 James Jackson Jarves, *A Glimpse at the Art of
Japan*, New York: Hurd & Houghton, 1876;
reprinted Rutland, Vermont: Tuttle Publishing,
1984, p. 155 (Tuttle edition).

79 Ibid, p. 136.

80 Ibid, p. 139.

81 Gabriel P. Weisberg, "Buhot's Japonisme
Portfolio Revisited," *Cantor Arts Center Journal*,
6, 2008/9, pp. 35–45.

82 Théodore Duret, *Voyage En Asie*, Paris: Michel
Lévy, 1874, p. 23. English translation from
Jacquelynn Baas, *Smile of the Buddha: Eastern
Philosophy and Western Art from Monet to
Today*, Berkeley: University of California Press,
2005, p. 22.

83 Sadakichi Hartmann, *Japanese Art*, Boston:
L. C. Page, 1903, pp. 248–9.

84 Ernest Hart, "Ritsuō and His School," *Artistic
Japan*, 2/12, pp. 142–3. For further discussion
and additional photos of these statues, see
Paul Moss, *One Hundred Years of Beatitude:
A Centenary Exhibition of Japanese Art*,

London: Sydney L. Moss, 2011, pp. 192–8.

85 Gabriel P. Weisberg, *The Independent Critic: Philippe Burty and the Visual Arts of Mid-Nineteenth Century France*, New York: P. Lang, 1993.

86 Théodore Duret, *L'art Japonais: Les Livres Illustrés, Les Albums Imprimés: Hokousai*, Paris: Quantin, 1882.

87 Théodore Duret, *Voyage En Asie*, Paris: Michel Lévy, 1874.

88 Louis Gonse, *L'art Japonais*, Paris: Librairies-imprimeries réunies, 1886. English edition, *Japanese Art*, Chicago: Morrill, Higgins and Co., 1891.

89 Timothy Clark, "The Intuition and the Genius of Decoration," in Yūzō Yamane, Masato Naitō, and Timothy Clark, *Rimpa Art From the Idemitsu Collection, Tokyo*, London: British Museum Press, 1998, pp. 68–9.

90 Ibid, pp. 72–3, for a discussion of Gonse's assessment of Rinpa in relation to Fenollosa.

91 As discussed in Cary Nelson, "Contemporary Portraits of Sadakichi Hartmann," *Modern American Poetry*. http://www.english.illinois.edu/maps/poets/g_l/hartmann/portraits.htm <accessed September 5, 2012>

92 David Ewick, "Hartmann, Sadakichi. Works 1898?–1915?" *Japonisme, Orientalism, Modernism: A Critical Bibliography of Japan in English-language Verse of the Early 20th Century*, 2003. http://themargins.net/bib/B/BC/bc24.html#bc24a <accessed September 4, 2012>

93 Biographical information is drawn from George Knox, "Introduction," *The Life and Times of Sadakichi Hartmann, 1867–1944*, catalogue of an exhibition at the University Library and the Riverside Press-Enterprise Co.,University of California, Riverside, May 1–May 31, 1970; University of California, Riverside, John Batchelor, Clifford Wurfel, and Harry W. Lawton, *The Sadakichi Hartmann Papers: A Descriptive Inventory of the Collection in the University of California, Riverside, Library*, Riverside, California: The Library, 1980. See also Jane Calhoun Weaver, *Sadakichi Hartmann: Critical Modernist: Collected Art Writings*, Berkeley: University of California Press, 1991.

94 Sadakichi Hartmann, *A History of American Art*, 2 volumes, Boston: L. C. Page, 1902; reprinted London: Hutchinson, 1903; revised edition, 1932.

95 Sadakichi Hartmann, *Japanese Art*, Boston: L. C. Page, 1903; reprinted New York: Horizon Press, 1971, and Albequerque: American Classical College Press as *The Illustrated Guidebook of Japanese Painting*, 1978.

96 David Ewick, "Laurence Binyon, Matsushima (1932)," *Japonisme, Orientalism, Modernism: A Critical Bibliography of Japan in English-language Verse of the Early 20th Century*, 2003. http://themargins.net/anth/1930–1939/binyonmatsushima.html <accessed September 4, 2012> Originally published in Laurence Binyon, *Koya San: Four Poems from Japan*, London: Red Lion, 1932. Three poems were reprinted in *The North Star and Other Poems*, 1941.

97 See Ewick, "Laurence Binyon, Matsushima (1932)."

98 Laurence Binyon, *Painting in the Far East: An Introduction to the History of Pictorial Art in Asia, Especially China and Japan*, London: E. Arnold, 1908.

99 Ibid, third edition, 1923, p. 215.

100 Laurence Binyon, *The Flight of the Dragon: An Essay on the Theory and Practice of Art in China and Japan, Based on Original Sources*, London: John Murray, 1911.

101 Laurence Binyon, *The Spirit of Man in Asian Art: Being the Charles Eliot Norton Lectures Delivered in Harvard University, 1933–34*, Cambridge, Massachusetts: Harvard University Press, 1935.

102 *Museum of Fine Arts Bulletin*, 8/47, 1910, p. 39.

103 Warner, *The Enduring Art of Japan*.

104 Ibid, p. 7.

105 Ibid, p. 17.

106 Ibid, p. 80.

107 See John Rosenfield, "Dedication: Langdon Warner (1881–1955)," in Kurata Bunsaku, *Horyū-ji, Temple of the Exalted Law: Early Buddhist Art from Japan*, New York: Japan Society, 1981.

108 Among his better known publications that have been reprinted in the post-war period are *The Gardens of Japan*, London: The Studio Publications, 1928, and *The Lesson of Japanese Architecture*, London: The Studio Publications, 1936. On how his perspective about gardens differed from that of earlier writer Josiah Conder, see Toshio Watanabe, "The Modern Japanese Garden," in J. Thomas Rimer (ed.), *Since Meiji: Perspectives on the Japanese Visual Arts, 1868–2000*, Honolulu: University of Hawaii Press, 2012, p. 350.

109 Jirō Harada, *A Glimpse of Japanese Ideals; Lectures on Japanese Art and Culture*, Tokyo: Kokusai Bunka Shinkōkai, 1937.

110 Ibid, p. 6.

111 Ibid, p. 8.

112 Ibid, p. 9.

113. Ibid, p. 207.

114 Ibid.

115 Noritake Tsuda, *Handbook of Japanese Art*, Tokyo: Sanseidō, 1935; reprinted Rutland, Vermont: Tuttle Publishing as *A History of Japanese Art: From Prehistory to the Taisho Period* with a Foreword by Patricia Graham, 2009.

116 Andrew W. Tuer, *The Book of Delightful and Strange Designs Being One Hundred Facsimile Illustrations of the Art of the Japanese Stencil-Cutter &c.*, London: Leadenhall Press, 1892; reprinted New York: Dover as *Traditional Japanese Patterns*, 1967.

ACKNOWLEDGMENTS

As with all my writings, I am greatly beholden to my generous husband David Dunfield for his support and assistance throughout this project, including his careful reading of manuscript drafts and for his photography. I am very thankful to the many private collectors, artists, museum curators, and friends who arranged for me to use photographs at little or no charge, especially Colin MacKenzie and Stacey Sherman of the Nelson-Atkins Museum of Art. Thanks are also due to the many people with whom I had discussions about this project over many years, who helped in the procurement of photos and graciously allowed me to view and photograph their collections: Joan Baekeland, Cynthea Bogel, John Carpenter, Bill Clark, Sue Cassidy Clark, Ellen Conant, Gerald and Alice Dietz, Bob and Betsy Feinberg, David Frank and Kazukuni Sugiyama, Hollis Goodall, Philip Hu, Junko Isozaki, Lee Johnson, Janice Katz, Yoshi Munemura of Koichi Yanagi Oriental Fine Arts, Rob Mintz, Andreas Marks, Julia Meech, Joan Mirviss, Halsey and Alice North, Beth Schultz, Fred Schneider, Joe Seubert, Takishita Yoshihiro, and Matthew Welch. Lastly, I want to acknowledge Eric Oey, publisher at Tuttle, for his insightful suggestions for text revisions, and his editors, Cal Barksdale, Sandra Korinchak, and June Chong, for making this book a reality. Carol Morland served as a perceptive and enthusiastic reader of a preliminary draft of the entire manuscript, and Mary Mortensen again, ably, prepared the index. I dedicate this book to my Mom, Ruth, and in memory of my Dad, Arthur Graham, with gratitude.

FURTHER READING

Addiss, Stephen, Gerald Groemer, and J. Thomas Rimer, *Traditional Japanese Arts and Culture: An Illustrated Sourcebook,* Honolulu: University of Hawai'i Press, 2006.

Baird, Merrily, *Symbols of Japan: Thematic Motifs in Art and Design*, New York: Rizolli International, 2001.

Benfey, Christopher, *The Great Wave: Gilded Age Misfits, Japanese Eccentrics, and the Opening of Old Japan*, New York: Random House, 2003.

Calza, Gian Carlo, *Japan Style*, London: Phaidon Press, 2007.

Carpenter, John T., *Designing Nature: The Rinpa Aesthetic in Japanese Art*, New York: Metropolitan Museum of Art, 2012.

Dunn, Michael, *Inspired Design: Japan's Traditional Arts*, Milan: 5 Continents Editions, 2005.

Dunn, Michael et al., *Traditional Japanese Design: Five Tastes*, New York: Harry N. Abrams, 2001.

Faulkner, Rupert, *Japanese Studio Crafts: Tradition and the Avant-Garde*, London: The Victoria and Albert Museum, 1995.

Guth, Christine, *Asobi: Play in the Arts of Japan*, Katonah, New York: Katonah Museum of Art, 1992.

Hiesinger, Kathyrn B. and Felice Fischer, *Japanese Design: A Survey Since 1950*, Philadelphia: Philadelphia Museum of Art, 1994.

Isozaki, Arata and Virginia Poncirolli, *Katsura Imperial Villa*, Milan: Electa Architecture, 2004.

Keyes, Roger S., *Ehon: The Artist of the Book in Japan*, New York: The New York Public Library, 2006.

Kuo, Susanna, Richard L. Wilson, and Thomas S. Michie, *Carved Paper: The Art of the Japanese Stencil*, Santa Barbara, California: Santa Barbara Museum of Art, 1998.

Lee, O-Young, *The Compact Culture: The Japanese Tradition of Smaller Is Better*, Tokyo: Kodansha International, 1984.

Lee, Sherman E., *The Genius of Japanese Design*, Tokyo: Kodansha International, 1981.

_____, *Japanese Decorative Style*, Cleveland: Cleveland Museum of Art, 1961.

Meech, Julia, *Frank Lloyd Wright and the Art of Japan: The Architect's Other Passion*, New York: Harry N. Abrams, 2000.

Mizoguchi, Saburo (trans. Louise Allison Cort), *Design Motifs* (*Arts of Japan*, vol. 1), New York: Weatherhill and Shibundo, 1973.

Munroe, Alexandra (ed.), *From the Suntory Museum of Art, Autumn Grasses and Water: Motifs in Japanese Art*, New York: Japan Society, 1983.

Nara, Hiroshi, *The Structure of Detachment: The Aesthetic Vision of Kuki Shūzō*, with a translation of *Iki no kōzō*, Honolulu: University of Hawaii Press, 2004.

Oka, Midori, "The Indulgence of Design in Japanese Art," *Arts of Asia*, 36/3, 2006, pp. 81–93.

Okakura, Kakuzō, *The Book of Tea*, New York: Putnam's Sons, 1906.

Parkes, Graham, "Japanese Aesthetics," *The Stanford Encyclopedia of Philosophy* (*Winter 2011 Edition*), Edward N. Zalta (ed.), <http://plato.stanford.edu/archives/win2011/entries/japanese-aesthetics/ <accessed December 15, 2012>.

Richie, Donald, *A Tractate on Japanese Aesthetics*, Berkeley, California: Stone Bridge Press, 2007.

Rousmaniere, Nicole Coolidge (ed.), *Crafting Beauty in Modern Japan: Celebrating Fifty Years of the Japan Traditional Art Crafts Exhibition*, Seattle: University of Washington Press, 2007.

_____, *Kazari: Decoration and Display in Japan 15th–19th Centuries*, London: The British Museum, 2002.

Shirane, Haruo, *Japan and the Culture of the Four Seasons: Nature, Literature, and the Arts*, New York: Columbia University Press, 2012.

Sigur, Hannah, *The Influence of Japanese Art on Design*, Layton, Utah: Gibbs Smith, 2008.

Suzuki, D. T. (Daisetz Teitaro), *Zen and Japanese Culture*, Princeton, New Jersey: Princeton University Press, 1938; reprinted with an Introduction by Richard M. Jaffe, 2010.

Tanizaki, Jun'ichirō (trans. Thomas J. Harper and Edward G. Seidensticker), *In Praise of Shadows*, New Haven: Leete's Island Books, 1977.

Tsuji, Nobuo, *Lineage of Eccentrics: Matabei to Kuniyoshi*, Tokyo: Kaikai Kiki Co., 2012.

Warner, Langdon, *The Enduring Art of Japan, Cambridge:* Harvard University Press, 1952; reprinted New York: Grove Press, 1978.

Weisberg, Gabriel P., and Petra ten-Doesschate Chu, *The Orient Expressed: Japan's Influence on Western Art, 1854–1918*, Jackson: Mississippi Museum of Art, 2011.

Yamane, Yūzō, Masato Naitō, and Timothy Clark, *Rinpa Art: From the Idemitsu Collection, Tokyo*, London: British Museum Press, 1998.

Index

Bold page numbers refer to plates.